This is a story that I felt someone should write down. I somehow realised it really wasn't something for an art world academic or scholar. I wasn't sure it would be the chore for an established biographer. So, I thought perhaps I should do it myself.

Over the couple of years it took to write this book I threatened to throw it in the bin about a hundred times. But somehow I was compelled to carry on with it and even complete it.

I am most grateful for the constant support from Robert Delaney who would always be there with enthusiasm and in unflagging confidence that I could complete the journey. John Scofield was a fount of information, an ally and finally a friend. I would also like to thank Paul Keegan, a truly exceptional man.

The Dedalus Foundation were of great help. Jack Flam with his brilliant extended introduction to the Catalogue Raisonné, which was an inspiration to me; Morgan Spangle for many a leisurely lunch discussion about the man and his art; Tim Clifford with his excellent chronology which I used as a "map" of the artist's life and career; and Katy Rogers for quiet and useful assistance.

The artist's daughters Jeannie and Lise were a big support. I always enjoy dinner conversations, both in London and in New York, with Irving Sandler, who is so wise and generous. Dore Ashton was an asset through her writings and also her vast knowledge on the artist, which she imparted to me.

Robert Mattison shed considerable light on the subject and Robert Hobbs would make me constantly realise how much more I had to learn about the artist but without any sense of being patronising.

My friend Larry Rubin gave me a sense of perspective on the story, along with some fascinating anecdotes. Cathy Mosley very kindly gave me a few insights. Lewis Hyde made me grasp more the idea of the gift from an artist through his marvelous book *The Gift*. William Tillyer was great help when he explained, in his gentle unassuming way, what it really is like to be alone in the studio and how the artist deals with the blank canvas. My dear friend Bob Hughes whom I consider the most powerful writer on this artist, only was of help through his stunning writings on the subject of my book, as we stupidly never discussed the artist in real depth during Bob's lifetime. And thank you to Sasha Tuulos, who by now can probably recite the book by heart. Another thanks goes to Gill Polonsky who very generously read my text with great care and made some very useful adjustments.

But, most importantly, the man I never knew, who was constantly by my side, while I was writing every single word and I hope he would have liked my effort.

2⌐

First Published in 2015 by
21 Publishing Ltd
28 Duke Street St. James's
020 7734 3431
info@21publishing.com

British Cataloguing-in-Publication Data
A catalogue record for this book is available
From British Library

ISBN: 978-1-901785-15-9

Coordinated by Robert Delaney
Designed and printed by C A Design

Cover: *In Plato's Cave No. 1*, 1972 (detail of p. 100)

Robert Motherwell

The Making of an American Giant

Bernard Jacobson

Contents

Introduction 7

Prelude 11

1907: Aix-en-Provence 27

1915: The World of Appearances 31

1929: Great Expectations 35

1935 Only Connect 41

1948: The Voyage Out
 Part I: Mexico 51
 Part II: The Return to New York 55
 Part III: We Band of Brothers 62
 Part IV: At Five in the Afternoon 68
 Part V: The Road Not Taken 74

1956: They Liked it Cool, We Liked it Warm 77

1967: Second Acts 93

1974: In Plato's Cave 101

1983: The Greatest Adventure 109

1991: The Heart is a Lonely Hunter 112

Coda 116

For Karin

Introduction

In 1968, while in my mid-twenties, I gave up my fairly lucrative job as a gossip writer for the *Daily Mail* in London to move to Los Angeles and write my second novel (my first had already been rejected by many major publishers).

I had recently interviewed the American pop group, The Beach Boys, and wanted to chuck it all in and write a novel set among the free-spirited surfers of California. But as I would be flying over New York, I decided to make a short stopover there, to see the skyscrapers and perhaps accidentally or on purpose bump into Jack Kerouac or Norman Mailer or Truman Capote in Greenwich Village.

My weekend in that city lasted a year. I switched from becoming a new Ernest Hemingway (my hero, who like me began his writing career as a journalist, or so I reasoned), to working in a small gallery on Fifty Seventh Street at the corner with Lexington Avenue.

In the early sixties I had already got to know David Hockney and Robyn Denny and Peter Blake and Patrick Caulfield. I would buy prints by these and many other artists but now I was meeting Roy Lichtenstein, Claes Oldenburg, James Rosenquist, Andy Warhol, Frank Stella.

One day, in this cute little gallery that specialised in prints, a very tall and elegantly dressed gentleman came in. He wanted us to frame a collage of a Gauloises cigarette pack of a delectable pale blue. It was to be a gift to the *maitre d'hotel* of the Four Seasons restaurant. 'That's Robert Motherwell,' my boss said. I had just met the famous Robert Motherwell, whoever he was. I later understood he was a friend and colleague of Jackson Pollock who was already dead, and also of Mark Rothko and Barnett Newman, both of whom I had met that year through my friend John Hoyland, who had an exhibition at the Robert Elkon Gallery on Madison Avenue. (I discovered many years later that John was an extremely close friend of Motherwell, so I could at that time have got to know the artist well).

But I did not get to know him, either through John or the Picture People. (The art world was so much more innocent and friendly in those days, and such a name for a gallery was perfectly acceptable). I had got my head turned by doing a Happening with Oldenburg, hanging out at Warhol's Factory, becoming a regular at Leo Castelli's Gallery on Seventy Seventh Street (the director there, Ivan Karp, forced me to buy a Lichtenstein print although I had no money). Everything was so glamorous and exciting and attainable, and Motherwell, along with his even more famous friends, was history.

Soon the sixties became the seventies and I was successful in the art world. I had progressed from starving writer to thriving art dealer. Then it was the eighties and just about everyone in the art world was successful. Then it was the nineties and just about everyone was decimated by the colossal downturn, which seemed to go from boom to bust overnight.

When the art world pulled itself together in the mid nineties, this former writer and now winded and wounded art dealer returned with a vengeance and became the dealer, and in many cases

the world dealer, for a great many major American artists, such as Sam Francis, Frank Stella, Bob Rauschenberg, James Rosenquist, Helen Frankenthaler, Jules Olitski, Ken Noland, Tom Wesselmann, Morris Louis. And yet one name had been nagging away in my subconscious.

In 2004 I visited the Dedalus Foundation in Manhattan, the trust set up by Robert Motherwell before his death in 1991. I was greeted with open arms by the man who set it up with the artist, Richard Rubin, brother of Larry Rubin, a good friend of mine. Under the mighty auspices of the Knoedler Gallery, Larry had become Motherwell's world agent until the artist died.

As a cub dealer in the late sixties I knew the very grand Knoedler Gallery with the plush red carpeting on its Fifty Seventh Street walls. As a cub journalist, ten years earlier, I knew Larry when he was a virtual brother to my art dealer hero, Kasmin.

I think Richard had heard good things about me and I was given the agency without any unpleasant vetting. This was indeed a thrilling day for me. After decades of learning my trade I felt I had arrived! My London gallery made regular exhibitions of Motherwell, arranged shows elsewhere in other cities and other continents. We bought and sold, bought and sold, bought and sold. Sometime around 2006 or 2007 or 2008 I came to the happy conclusion that I was dealing with not just another Abstract Expressionist artist but perhaps the greatest of the movement.

During the eighties, when for a short period I doubted abstract art, I spent time with Francis Bacon and Lucien Freud, who both saw everything through the eyes of Goya and Rembrandt and Velasquez, or so it seemed. Their interest in the challenge of the past hundred years of abstract art seemed non-existent. One day, in fact, when Freud was in my gallery he remarked on a huge canvas by William Tillyer. Freud was genuinely enthusiastic and said it looked like a vast image of a painter's palette. To Tillyer it was an abstraction. Once, walking down Park Avenue, Pop artist Richard Hamilton looked across the street to a massive abstraction by John Walker and once again a figurative artist looked in earnest for the figurative elements which were not there.

Across the hill from where my wife Karin and I lived, on the opposite side of the lake in Umbria, Lago di Trasimeno, there lived a wonderful man, Bob Maione. He was American, discreetly gay, a virtuoso landscapist in the style of Corot, highly intelligent, represented by one of the most prestigious New York galleries, exceptionally civilised and a great cook. I loved his paintings and wished I could take them seriously in art historical terms. Corot produced hundreds and hundreds of magical landscapes, so beautiful that you want to steal one and take it home, just to cherish it. In this perfectly idyllic setting we would argue about art and painting for hours on end, a pro-Modernist wrestling with a pre-Modernist. Was I right, just because art history was on my side, or was it he who was in fact right? Of course there is no right or wrong in art, in the final analysis. His was a perfect untouched world, or so it seemed to me. A few years later he died of Aids.

The commonest criticism of Robert Motherwell is that he was unable to make it new, to break the ice, as de Kooning said of Pollock, or as everyone said of Rothko and Barnett Newman. Unable to push art forwards in one great leap. But this is in fact his strength, to continue from Matisse and Picasso, just as they carried forward from Cézanne. The Motherwell trajectory is seamless, unlike those of his New York School colleagues, where the rupture between old and new is dramatically present for all to see. Art is a continuation of what came before. The new eventually settles into

conversation with the old. In retrospect it is easy to see Fitzgerald as continuing from Henry James, Hemingway continuing from Tolstoy, all of them seated at what E. M. Forster called the round table of fiction. The pulse of Stravinsky is just a step beyond Debussy. And when Newton was innocently asked how he became a genius he replied that he simply stood on the shoulders of giants. So easy, if you are handed the baton in the first place! As Motherwell wrote, 'I don't think history is only serial; I think events exist side by side, and that the various generations are to some extent simultaneous.'

The second and closely related dismissal of Motherwell concerns his privileged upbringing, which equipped him with a superior education. Yes, like Cézanne and Piero della Francesca and so many others, he was from a privileged background and was a highly educated man! And yes, this relates to his eventual greatness, and it gave him the opportunity to see the workings of the world past and present, gave him a deeper perspective with which to see connections. But he had the inner powers to make use of it and, because of what he knew, to drive forwards into the unknown. There are of course other routes. Art can be born of not knowing, and failure can be born of knowing too much and lacking the resources for the journey.

I eventually got to thinking that Robert Motherwell was the greatest of that heroic group of post-war American artists, and so possibly the greatest painter America has produced.

So, I discreetly bought every Motherwell I could get my hands on, paintings, drawings, collages, prints, and quietly read every word written on him and by him.

With the artist's centenary so close on the art world horizon, in 2015, I decided to go the whole way, and write a short biography of Motherwell. I am no academic and I am no biographer, but I give you my book on a great American and a great artist.

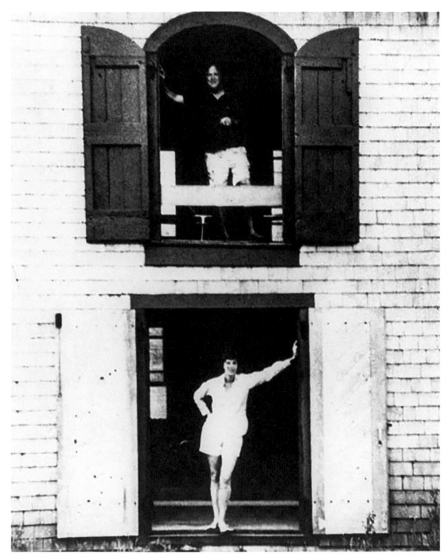

Motherwell and Helen Frankenthaler at Days Lumberyard, Provincetown, Mass., summer 1961.
Dedalus Foundation Archives.

Prelude

'I was born in a seaport, and have always preferred to live in one.'

– Robert Motherwell

'Until, one day, Europe itself was exiled to America'

– Meyer Schapiro

The way to the beach is just through the alleyway. You can see it glittering between the privet hedges, as the tall and lean man in his mid-forties ambles down to the water, to look back at the promontory, a narrow curving spit of land surrounded by sea, where he will buy a stretch of bay side, to build himself a house with a large windswept studio.

He turns his powerful head again, to face the Atlantic Ocean and gather his thoughts. The house will be a ship that he and Helen will live in for the summers, away from the humidity of New York. He will have a studio on one floor and she will have a studio on another.

It is 1959, and this is Provincetown, at the Eastern tail end of Cape Cod, where the Pilgrims landed in 1620 to start a new world, or at least a New England. Almost immediately they realised that they could not farm here, with no decent earth to grow fruit and vegetables, or raise cattle – with sand for ground and dunes that went on for miles. So they moved on to Plymouth, just across the unnamed bay.

Robert Motherwell had already known considerable success with an extensive and on-going series of paintings, powerful works in black and white with the collective title *Elegy to the Spanish Republic*. Exploring the most fundamental of shapes, ovals and vertical bars or bands, these images were so strong and so archetypal, but equally so protean, their mood and formal resources so various, that they captured and held his attention from 1947 until the very end of his life, resulting in over two hundred paintings, from the small and maquette-like to the magisterial. The most instantly recognisable of all his works.

His recognition and stature had indeed risen steadily, from the mid-1940s onwards, so that in 1965, in his fiftieth year, he would be given a retrospective at the Museum of Modern Art (MoMA) in New York. It must have seemed a confirmation, if not a crowning achievement, proof positive that here was that rare and accomplished thing, an American master.

In Cape Cod he would produce so much that was new and different, in the privacy and seclusion of a stretch of coastline that has the feeling of an island, with a radiant summer light to rival the Aegean. And although he had summered for years in the more fashionable Hamptons, with friends and colleagues, it was here that he felt comfortable and at peace. He had come to hate the frantic social anxiety of the Hamptons, a couple of hours north of New York City, which over the

years became increasingly status-conscious and superficial. Here was tranquillity, amid the ever-changing Provincetown bay with its tidal flats and diffuse brilliance, and no hint of the fast lane. Down the road, at the other end of Commercial Street, which runs the length of Provincetown, was the home and studio and school of German expatriate Hans Hofmann, who had been the most influential teacher of modern art in America in the 1930s. The two artists were friends, and Helen had once been a student of Hofmann.

By this time, 1959, many of his friends from the forties, when he and they had burst onto the stage, to challenge the Europeans and above all Pablo Picasso, were now dead. These figures, who, as Meyer Schapiro observed, learned from the European wartime artists-in-exile how to be 'heroic', did indeed change the course of art, creating a vast body of work – paintings, sculptures, drawings, etchings, lithographs, collages – which in Ezra Pound's words 'made it new', and of which America could eventually be proud. This was their century too.

In the summer of 1962, a few years before the MoMA retrospective, Motherwell had embarked on a series of free works on paper, very different to the *Elegies*, and collectively entitled *Beside the Sea*, inspired by the savagery of the waves as they crashed over the concrete sea wall of the property he was to purchase in Provincetown, rebounding high into the blue Cape skies. These wild arcs of splashed and impacted oil paint, set above emphatic horizon-like horizontals in ochre and blue, are not in the least descriptive or topographical but spare and austerely lyrical, spontaneous but tenacious in exploring their original impulse and occasion. In all, they form a concentrated group of forty or so works, forty decisions and revisions: 'new points of attack, ponderings, changes of mind, of duration, of endurance.'

A series can be thought of as one problem, constantly reworked and unfinishable, or as a set of different and finished solutions to the same problem, the two sides of this painter's philosophical pursuit of variousness. Within five years of *Beside the Sea* he was to develop a further group of closely related works, the second largest after the *Elegies*, and which he referred to as the *Opens*. This group also obsessed and haunted him to the end of his life, yielding more than two hundred works. While his early discovery in the *Elegies* produced visceral images of power and violence, death, grief and sexuality, the *Opens* are calm and intent explorations of line and colour and rectangle: inside and outside, figure and ground, even and uneven, window and wall. Pared down, they are also rapid and gestural, 'a one-shot throw of the dice', closely and passionately painted.

Cape Cod is where Motherwell produced much of his best work. From his first visit there, driving up from New York with the Surrealist Max Ernst in 1942, until his death in 1991 while being rushed to the local hospital, he made his spiritual home in Provincetown. He was a summer resident, but Cape Cod summers lasted for months on end, time to absorb the light and the sea air into his eye and mind and hand.

There was Hans Hofmann along the road, a ten minute walk or a three minute drive in Motherwell's Bentley. Norman Mailer was just two doors away. And Edward Hopper, the most American of American artists, two towns away in Truro. At an earlier period Eugene O'Neill had lived about twenty houses away. Thoreau came here repeatedly in the eighteen fifties and wrote the notes for his happiest and sunniest book, *Cape Cod*, describing a single walking tour up the Cape to Provincetown, the sea a continual backdrop for his thoughts, far from the citification of the East Coast and its obsession with creating wealth by taming nature. And if you walk beyond

these well-kept Provincetown houses and kempt gardens you reach Cape Point, where the pious Jacobeans landed in 1620.

Along the seashore, and farther out along the hypnotic dunes, you sense the presence of those courageous Puritans, few in number, who arrived on the winter shores of the Cape to establish their Plymouth Colony. And the white clapboard houses with their blue plaques evoke the names of strangers who would make their very different fortunes two centuries later, as the whaling industry grew out of the Cape Cod fishing industry, and spread from Wellfleet to Nantucket, from where Herman Melville's *Pequod* set sail with the unseen Captain Ahab secluded in his cabin, on its amazing journey into so much death and destruction.

And then we may imagine Robert Motherwell, facing into the past, with his acute sense of what had gone before, for whom Modernism itself was in the first place a tradition to be absorbed, and with his instinct for what would come.

––––––––––

From the late eighteenth century until the Second World War, France taught the Western world what art was and what it should look like. From David to Delacroix, from Corot and Courbet to Manet, from the tentative experiments of Pissarro and the Impressionists to the great Post Impressionist masters, Cézanne, Seurat, Gauguin, Van Gogh. As if to strengthen this monopoly, reinforcements arrived from outside the citadel. The vastly ambitious young Picasso from Barcelona, in 1900, his friend and sometime partner Georges Braque from Le Havre, also in 1900, and a modest introverted figure from Picardie, Henri Matisse, in 1897. And others who added to the Parisian mix, Léger and Modigliani, Soutine and Chagall, Gris, Brancusi and Giacometti, descending on the city from all over France and, increasingly, from all over the world.

But during the thirties Paris, the home of exile, started to become a net exporter of émigrés, as what Auden called 'the age of anxiety' secured its hold. Before the fall of France and the Occupation of Paris in 1940, the lead-up to war already dispersed many of the greatest talents, and the City of Light was steadily depleted. The exodus of European artists to New York during the war years, Fernand Léger, Piet Mondrian, the Parisian Surrealists, is central to any account of the advanced American art of the forties. The centre of balance shifts, the needle begins to tremble, 'until, one day, Europe itself was exiled to America'.

––––––––––

When Saul Bellow writes, in *The Bellarosa Connection*, that 'Billy was as spattered as a Jackson Pollock painting, and among the trickles was his Jewishness, with other streaks flowing toward secrecy – streaks of sexual weakness, sexual humiliation,' he confirms that Pollock has become part of our vocabulary and our mental landscape. And, being wise about such things, Bellow knows that this is not a passing phase but a cultural fact, that future generations will know Pollock. And we can imagine Bellow's heir, Philip Roth, for whom Bellow was none other than 'Columbus', writing that 'after a night of deep carousing, Lennie stared out across the ocean and it was all fuzzy and mellow, Rothkoesque'. But what we would not come across in any major American novelist is this: 'He felt oppressed and beaten, saw in his mind's eye a mute procession of black shapes, oblong and spherical, as in a Motherwell.' Not because Motherwell's name is unfamiliar,

but because Motherwell's vision has not acquired such easy symbolic currency. This is not to detract from Pollock's greatness, or Rothko's greatness, but their brief lives and violent deaths have become the stuff of legend, have entered our modern mythology. Moreover their vision was insistently singular and easily recognisable, where Motherwell's was plural, various, questing.

I'm not sure if Bellow knew of Motherwell, but they were born 'in the exact same year', as Motherwell remarked. As were Orson Welles, and Frank Sinatra, and Arthur Miller, and Billie Holiday. And I would place Motherwell where he belongs, with these American giants who are not merely his contemporaries but his peers.

The workings of myth, like those of Fate, are blind or bewildering, and myth feeds upon exclusion as much as inclusion. Piero della Francesca was considered a great artist in his day, cherished by religious Italy on account of his altarpieces and frescoes on the walls of churches and private chapels in Umbria and Tuscany – his birthplace Sansepolcro, the hill-top village of Monterchi, his mother's birthplace – far from the artistic centres of Rome, Florence or Venice. Then, from shortly after his death in 1492, at a time when Italy was the home of art, he was forgotten and the world knew him not. Piero's *Nativity* was acquired by the National Gallery in London in 1874 for rather less than the average cost of a landscape by English Pre-Raphaelite John Everett Millais. In eclipse for four hundred years, Piero's reputation fully recovered only in the late nineteenth century, kick started by scholars, when Cézanne and others began to grasp his profundity and significance.

The admiration grew, through the writings of connoisseurs like John Pope Hennessy, Roberto Longhi, Aldous Huxley, Kenneth Clark, Ernst Gombrich, Bernard Berenson, and an array of other critics and scholars, until today his cool volumes and lucid geometry are cherished more than ever, and many artists rank him among the greatest. As the American connoisseur Berenson observed in 1932, Cézanne discovered a 'colleague' in Piero della Francesca, and it is only since Cézanne that Piero has been considered great in the wider world, 'for it has always taken contemporary interest to shed light on forgotten art.'

In the nineteenth century Bouguereau and Meissonnier were championed and loved by *le grand public* in France, including and especially Napoleon III, who used his power to commission or collect these outsized and visually stunning pseudo-classical creations, even if he was equally responsible for inaugurating the anti-institution which became their nemesis, the *Salon des Refusés*. This sort of historical public art arrived like a thunderbolt in the France of post-revolutionary reaction, but disappeared with a whimper by the end of the century, exposed to the light of common day by the modest vision of Courbet or Manet. Matisse studied briefly under Bouguereau at the Académie Julian in Paris, in the early eighteen nineties, but left in disgust. Official art still lines the overlooked corridors of the Louvre, or is safely hidden from view in the permanent collections of the Metropolitan Museum and the National Gallery.

In 1913, a year before the First World War, New York hosted The Armory Show in Manhattan. By showing the new Parisian art in such concerted form it inadvertently demonstrated the provinciality of the local scene. Even if American contributions outnumbered foreigners, it was Kandinsky, Duchamp, Matisse, Brancusi and fellow Europeans, and their precursors Cézanne, Gauguin, Van Gogh, who stole the show. If the New York exhibition was a huge success, with nearly a hundred thousand visitors (largely for the controversy aroused by works like Duchamp's

Nude Descending the Staircase), it was an outright sensation by the time it reached Chicago, where the attendance doubled.

At this moment American art was tame and tepid, a polite step behind Europe, despite the growing interest in advanced European art which had preceded the Armory Show. Those earnest vernacular masters such as Charles Demuth, Alfred Maurer, John Marin, Marsden Hartley, Arthur Dove, Charles Sheeler, some of whom had been abroad and absorbed what was new, remain to this day merely local names, their regionalism often self-conscious and defensive. There were some exceptions, like Georgia O'Keefe with her sexually-suggestive flower paintings and mysterious New Mexican landscapes, or Stuart Davis whose use of lettering and signs and cityscapes bridged reality and abstraction, as if to pre-empt Pop art. And of course there was Edward Hopper with his lonesome compositions immersed in their strange introspective light, either washed by bright sun or picked out by the glare of electricity, as in that stark café scene *Nighthawks*. But even the considerable Milton Avery, described as an American Matisse, was wholly eclipsed by Matisse himself, despite Rothko's emotional testimony to Avery's influence from the thirties onwards (Avery summered in Provincetown in the late fifties with Rothko and Gottlieb, who would visit his studio almost daily to see what he had been doing), and despite the undoubted achievement of this artist who alone succeeded in treating local subject matter in an international idiom.

What the Armory Show did was to expose cruelly such gaps, and by so doing it set ticking an enlarged historical present, in which American and European cultural destinies were newly synchronised. The European art displayed by the Armory Show simply became the unavoidable model for art in the United States. There was no going back, and hard European lessons must be learned if parity was to be achieved.

It is strange that the dynamic new world produced so little important art in the twenties or thirties, given the confident vernacular imagery of the previous century, not least the superb landscapes of the Hudson River School and the Luminists. But even then there had been no proper equivalent to Melville or Whitman or Henry James. Nor, more recently, was there anything to equal masterpiece after masterpiece by Scott Fitzgerald or Hemingway, Faulkner or Steinbeck, or to match the first flowering of jazz genius from the likes of Duke Ellington, Louis Armstrong, Fats Waller, Art Tatum or Count Basie.

Perhaps the earliest American to create an individual style of more than local interest was the sculptor Alexander Calder, with his 'mobiles', baptised as such by Marcel Duchamp. But Calder's maverick art and *bricoleur* sensibility were innately more European than American, and he went straight to Paris from Philadelphia via New York in 1926, aged twenty-eight, armed with a mechanical engineering degree, where he was promptly assimilated and came under the spell of Mondrian and Miro and Arp. He shuttled back and forth between old and new worlds, returning in 1933 with an established identity as an artist, as both an American original and a finished European.

In effect, the first artists to bring the European Modernist creed to New York were foreign-born. Arshile Gorky, who was born in 1904, arrived from Armenia in 1920, and after making Cézanne-like paintings he progressed in the thirties to Picasso-like paintings and then to Kandinsky-like paintings. When in 1937 some of Picasso's canvases with drips were exhibited in New York, an acquaintance said to Gorky, 'Just when you've gotten Picasso's clean edge, he starts to run over.' –

'If he drips, I drip,' replied Gorky proudly. But as the art historian Meyer Schapiro pointed out, to be a disciple of Picasso in New York in the twenties and early thirties was an act of originality, in equal measure humble and contentious.

But although he seemed the eternal apprentice, moving from one hero to the next with paradoxical mastery, Gorky was to arrive quite suddenly at his own imaginative conclusions, and become an original artist of crucial importance in the jigsaw of American modernity. He did so by finding a Northwest Passage between Surrealism and abstraction. A new spontaneity of form, both primitive and refined, producing strange and fantastical pulsating landscapes, with their own flora and fauna, bodiless shapes which relied on the promptings of free-association. Gorky was the first naturalised American artist to entrust himself to such 'automatism', under the tutelage of the New York based Chilean, Matta, and he was the first to place his trust so entirely in Europe. Or, put differently, the last important disciple of Old World Surrealism, and the pioneer of American images that no longer seemed rooted or provincial. Belonging to old and new, as Irving Sandler has remarked, his pictures have 'a pathos unprecedented in American art', not least because tragically he hung himself in 1948, aged forty-four.

The other major early immigrant, who did not arrive until 1932, aged fifty-two, came primarily as a teacher. When Motherwell was born, in 1915, Hans Hofmann was already running his own art school in Munich. A fountainhead of ideas, his variety of styles and inventiveness, and commitment to experiment, were his most important contribution for those American artists, including a good proportion of the avant-garde, who learnt from his teaching and example. It seems unlikely that he was not a major influence on Pollock, and when you look carefully at some of his paintings from the early forties he seems in one of his virtuosic modes almost to have anticipated Pollock. One of his students, the great Helen Frankenthaler, loved him. And it shows.

The essential but paradoxical truth about movements in art, as indeed with artistic friendships, is that each member needs the others. It was obvious that Picasso and Braque needed each other to undertake the Cubist adventure, about which Braque said 'it was like being roped together on a mountain'. The Impressionists worked alongside each other, as did the Post-Impressionists. And the same was true even of the Pop artists, despite their cool stance and their self-sufficient impassivity. All these groups, starting with that unruly *ur*-group, the Surrealists, would fight and argue, and some members would leave or be expelled. So too with the Abstract Expressionists in the forties and fifties. Individualists to a man, they also needed each other, and in time they turned away from each other.

Not only the prime movers, Pollock, De Kooning, Still, Newman, Motherwell, but also the less familiar figures were essential to the proper functioning of the organism. Motherwell, in many respects the key witness by his writings and through his organisational genius, referred to it not as a movement but an underground network of awarenesses. From the outset, the Abstract Expressionist artists scrutinised each other's work. The solitary studio was their primary reality, but they were by turns artists and viewers. As Jack Tworkov remarked around 1949, 'Suddenly we realized that we were looking at each other's work, and talking to one another, not about Picasso and Braque.' This sense of shared or competing purpose was short-lived, but it created an identity, all the more so since this was not a movement shaped by manifestoes or public statements, but by personal interaction. A movement of many conversations and few texts, which is what makes Motherwell's role as thinker, writer and intermediary so central.

One of the true originals of the venture and perhaps the one most ahead of the project was Mark Tobey. He was born in 1890. In his late twenties Tobey converted to the Baha'i faith, which teaches oneness of mankind, and in the early twenties he began to study Chinese brush painting. The mystical world in which he steeped himself took over increasingly, and in the early thirties he travelled through China and Japan, studying Zen Buddhism. He brought what he learnt in his art from East and West to his everyday fascination with the noise and bustle of the big city, especially New York and Chicago. By the mid-thirties all of these aspects came into play, resulting in luminous, quasi-mystical works in tempera on Masonite board, showing the city as a hub of energy and light, interlacing thousands of fine white lines or 'white writing' to express the pulse of Manhattan.

In the forties he was to process what he learned from the works and writings of Kandinsky and Klee, Mondrian and Picasso, moving on to entirely abstract images with no hint of subject matter. He abandoned all his earlier props, and the work took on an impersonal calm, as if turned aside from the world of appearances.

Bradley Walker Tomlin also studied Zen Buddhism and even Japanese brush painting. Born in 1899, his works from the thirties and forties showed no sign of what was to come, owing more to Picasso, Braque and Gris. But in 1948, aged fifty, he began to experiment with a form of free calligraphy, and his later work links him with Motherwell in the use of automatism – Zen rather than Dada, in keeping with his refined restraint. He died relatively young, in 1953, and was something of an outsider and a dandy. The stylistic flux in his later paintings makes it difficult to see where his ideas might have led, but his lyricism relates to the work of Philip Guston and Ad Reinhardt, and it influenced painters of the next generation such as Helen Frankenthaler. In a posthumous note of homage, Motherwell said of Tomlin: 'I believe the struggle that his lifework portrays was an effort to overcome the sense of style that every dilettante has with the sense of existence that every artist has . . . We all in turn were moved by him.'

Jack Tworkov was born in Poland in 1900. Perhaps a minor figure in the Abstract Expressionist movement, he nonetheless made beautiful paintings that are clearly indebted to Willem de Kooning – they met in 1934, became close friends from 1940, and shared adjacent studios in the late forties and early fifties – in his use of broad gestural marks and swathes of contradictory colours. The later geometric compositions are quite different, subdued rather than spontaneous, and replacing his earlier extroversion with a cool neutrality. He seems to have been a presence for younger painters who emerged in the sixties, especially the Color Field artists. Although born in 1900 he outlived many of his peers and died in 1982.

Some artists seem both blessed and cursed by too strong a signature style. Adolph Gottlieb, who was born in New York, three years after Tworkov, in 1903, had interesting and ambitious earlier phases, like his magic-realist paintings from the late thirties and particularly the 'pictographs' that followed, from 1941 onwards. These were large canvases loosely organised by schematic grids, whose quirky and richly associative invented language of archaic signs and hieroglyphs owed much to Paul Klee. They are suggestive of automatist doodlings, and the broader front of contemporary experiment. But it was his series of radically simplified paintings entitled *Bursts*, dating from the fifties, for which the art world remembers Gottlieb, monumental works consisting of two shapes: a haloed disc, often red, floating above an extravagantly tangled or writhing mass of black strokes, whose dialogue of geometric and organic forms invites a range of associations, a theatrical or even cosmic confrontation played out with distilled economy.

Of the artists who developed the most powerful idioms, having explored several earlier styles, calligraphic, biomorphic, symbolic, before he settled upon it in the late forties, Mark Rothko, born in 1903, is the outstanding case. It was in these large canvases, with their floating loosely painted oblong shapes, and after that their translucent rectangles of colour and indeterminate edges, that he found his voice. Once he had arrived at this formula he lived inside it, painted canvases serially, sometimes with two horizontal bars, sometimes with three bars, their surfaces soaked by washes and tiers of colour. Rothko was a deeply honest, intelligent and passionate artist, who insisted that 'there is no such thing as a good painting about nothing'. He really meant these paintings, and he wanted the viewer to work equally hard. Which is perhaps why the history of their reception, and its rhetoric of transcendence, has played so central and even coercive a role in our understanding of them. It is also why the myth of their significance has an underlying uncertainty, as to whether these paintings frame the meaning of life in their rectangle or are merely a sumptuous mirage. As Motherwell remarked, Rothko himself persistently doubted, fearing that he was merely 'a charlatan conjuror of color'. The Rothko myth insists that these are indeed ineffable events, whether for collectors who pay fortunes for them, or for students who hang posters of them on their walls swimming behind glass. Time will prove the chief critic here, more so perhaps than for any artist before or since.

The mature paintings of Clyfford Still, who was born in 1904, were equally reliant on open forms and sheer scale, and were equally assumed to contain ineffable meanings. Still's work had become decisively abstract by 1947, and his two exhibitions of that year had a profound influence upon both Rothko and Barnett Newman, even if his subsequent reputation was eclipsed by theirs, with the result that the myth of Still is even now in the ascendant. This delayed reaction was partially of Still's own making. He owned most of his work, only rarely allowed it to be shown or reproduced, and famously detested museum directors, curators, art critics and collectors. Which must have made things difficult for his dealer, the great Betty Parsons, especially since he forbade her to show his work to anyone who would not understand it! Moreover, following his death in 1980 all the works that had not previously been shown or exhibited were put into storage and sealed off from public view for the next thirty years, until a dedicated Clyfford Still Museum opened its doors in Denver in 2011.

Nonetheless, Still's posthumous reputation has improved steadily, and he is now regarded by many in the art world as a great American painter. In his outsized canvases, the application is intentionally crude and flayed, while the palette is basic and even bland, and the jagged verticals look like the ruins of something rather than the thing itself. And these abstract landscapes are informed by an austere and absolutist spirit. Still was after all capable of writing, to the editor of *Artforum* in 1963, that 'a single stroke of paint, backed by work and a mind that understood its potency and implications, could restore to man the freedom lost in twenty centuries of apology and devices for subjugation.'

Someone who could not possibly have written such a sentence was Willem de Kooning, the down-to-earth Dutchman, born in tough, working class Rotterdam in 1904, where almost by chance he received a grounding in commercial design, as a guild apprentice, and a night school education at the city's Academy of Fine Arts. In 1926 he left Holland as a penniless stowaway on a freighter bound for Virginia, with no papers and no English. In those first years in New Jersey and New York he found work as a commercial artist and occasionally painted in his spare time. But he was taken on by the Federal Art Project and earned a living wage during the Depression, and crucially he met Arshile

Gorky, whose austere example led him to commit to being a full time artist. During the thirties they were inseparable, as de Kooning worked and reworked his canvases, trying to reconcile his classical training with his convictions and acute responsiveness to modern American reality. He was also clearly influenced by Fernand Léger, with whom he had worked on a Federal Art Project mural in 1936. Like Léger, and like his good friend Franz Kline, de Kooning loved industrial America.

De Kooning remained on the margins during the war, after which the Federal subsidy ceased and the market for American art was yet to materialise. It was at this point that he began his series of black and white abstract paintings, and in 1948, aged almost forty-four, he exhibited these at the small Charles Egan Gallery. It was his first solo show. Few of the pictures sold, but MoMA purchased one of them, and the paintings were noted and admired by artists and critics alike.

By the early fifties he was a painter of growing renown with an established abstract style. But in one of the most apparently wilful decisions in the history of American art, he abandoned abstraction to return to the figurative struggle, working at a single canvas for almost two years. Only the intervention of Meyer Schapiro, who asked to see it during a studio visit, persuaded de Kooning that he had in fact finished the discarded *Woman #1*, which was to become probably his single most famous image. Then, in rapid succession, more of the *Woman* paintings followed – explosively vulgar depictions, oversized and sexually fierce, as if intended to overturn American domesticity.

Despite his extraordinary influence, de Kooning paid the price for his unwillingness to follow the trend. His volatile and changeable art was dismissed by critics for not following the path of progress towards an increasingly refined abstraction. Even MoMA tended to disregard de Kooning after 1950, as is evidenced by the museum's present day collection, which is considerably stronger in Pollock, Rothko or Newman. And in the sixties Pop and Minimalism brokered a coolly knowing and ironical consensus with little room for de Kooning's rich painterly sensibility, or its inclusive sense of the historical past.

Of the painters who emerged in New York during the late forties and early fifties, de Kooning remains the most difficult to define, a figurative painter largely miscast as an Abstract Expressionist. Even his most abstract works incorporated figural elements. He crossed and recrossed boundaries over the course of five decades with no concern for the niceties of either conservative or advanced taste. He was, in his own typically foreign turn of phrase, 'a slipping glimpser'. De Kooning died in 1997 from Alzheimer's, at his Long Island studio, at the age of ninety two. He had covered enormous distances, literally and artistically, during his long life, in the conviction that 'you have to change to stay the same.'

An artist who at times pronounced on his art as portentously as Clyfford Still was Barnett Newman, born in 1905, a year after de Kooning. Newman's reputation remains cloistered within the art world, whereas that of Rothko – the artist most closely linked with him – has entered common currency. Newman was a late starter. Even in the mid-forties he had not quite reached his stride, producing canvases of loose horizontal and vertical organic shapes, still searching for images adequate to the age and reaching back to primitive arts for inspiration. At this time he curated exhibitions of pre-Columbian and Northwest Coast Indian painting in New York galleries for which he wrote the catalogue introductions.

By the late forties, Newman, like Still and Rothko and Pollock, had moved away from these preoccupations and broken through to his essential style. Narrow vertical lines or bands on a field

of single *matte* colour, with an immediacy which was neither strident like Still nor inward and nuanced like Rothko. These works, which he referred to as his Zip paintings, became progressively more elongated or upright, with little activity on the canvas other than a chaste dialogue of colour and line.

Late on in his short career Newman was taken up by various factions of the sixties art world as an honorary Minimalist. For a much younger group of artists like Larry Poons, Frank Stella and Donald Judd, Newman's austerity anticipated two of the three main strands of sixties art, namely Minimalism and Color Field abstraction, even if his work would have meant relatively little to the third group, the Pop artists. Moreover, the sixties rehabilitation of Newman and other 'field' painters of the New York School was conducted on formalist grounds that were quite foreign to their way of thinking, just as the gestural painters were reconfigured as spontaneous free spirits unburdened by existential concerns. In fact, Newman's work is animated by dread and by collective fears of an atomic future, but tested on his own pulses, so that 'the self, terrible and constant, is for me the subject of painting'. It is significant that when Rothko, Motherwell and Baziotes founded their short-lived academy in the autumn of 1948, they adopted Newman's suggestion for it to be called the 'Subjects of the Artist' School, to assert that art always has a subject, and that this subject is none other than what Auden called 'the human clay'.

Newman was to become a godlike figure to many contemporary art historians and museum curators, and his work seems uniquely capable of dividing opinion amongst viewers and causing provocation amongst painters. He certainly had the courage and intellectual conviction to narrow his canvas to a non-dogmatic nothing, with little foothold for the eye, and today museum goers will either stare into that void or walk on by. These works, like those of his peers, were made over half a century ago, are at once old and young, and only time will tell whether they convey meaning to future generations. The dilemma, in a sense, can be summarised by two quotations from Robert Hughes, from 1971 and 1997 respectively: a) 'One of the hidden forks in American art history was reached on January 29, 1948, when Barnett Newman painted a thin, rough orange stripe down the exact center of a small dark red canvas, and left it alone.' b) In response to Newman's remark, 'I thought our quarrel was with Michelangelo', there was Hughes's dead-pan reply: 'It was not a quarrel anyone could win with a stripe.'

James Brooks was born in 1906 and was the last of the Abstract Expressionists to be born in the first decade of the century, a year after Barnett Newman. He is probably the least talked about of the group, along with his friend Bradley Walker Tomlin. Brooks attempted a loose continuation of Cubism, which had officially run its course by the time he got there in the late forties. On his return to New York, after serving as a combat artist during the Second World War, he turned towards abstraction. Starting with his first one-man show in 1949, and sustained by his close friendship with Pollock from their days in the Works Progress Administration (WPA) Federal Art Project. Pollock encouraged a more expressive style, in which, for example, stains made on the reverse side of the canvas were frequently used to generate spontaneous shapes on the front. From this blending of Cubism with gestural abstraction a new impulse was evident in Brooks' works of the late fifties onwards, which use lyrical colours and a rhythmic composition to create not hugely innovative paintings but superb mid-twentieth century American art – monumental, accomplished, full of energy and life.

In a short span of time, Franz Kline, born in 1910, created some of the most powerful and defining images of any of his Abstract Expressionist peers, after an early career as a figurative painter. In 1949 he happened to experiment with a Bell-Opticon projector in de Kooning's studio, magnifying one of his already fluid and calligraphic ink sketches to a size that rendered it 'unrecognisable', accidentally revealing the dramatic and expressive potential of the sketch when enlarged to monumental effect. Strokes were blown up into gestures, and the image released its abstract power. The shapes of Kline's art became dynamic and architectonic, and figurative resemblances were jettisoned.

This transformation was immediate and revelatory. In each case, from an array of preliminary sketches Kline selected one image and repeated it in oil on a larger canvas, the improvisations of the one becoming the fully acted gestures of the other, a drama of black and white, figure and ground, rawness and monumentality. It is no coincidence that Kline used housepainter's brushes and ordinary hardware-store paint, high-gloss and quick drying. He was raised in the coal country of eastern Pennsylvania, and the vision of his art is one that relishes urban and industrial America. The poet and curator Frank O'Hara recorded Kline as saying that 'half the world wants to be like Thoreau at Walden, worrying about the noise of traffic on the way to Boston; the other half use up their lives being part of that noise. I like the second half.'

Kline stayed on his chosen path, or the path that had chosen him, for just one decade, from when he first exhibited his black and white gestural abstractions in 1950 to his sadly premature death in 1962. In a characteristically graceful *Homage to Franz Kline*, Motherwell acknowledged the 'black and white' kinship that had existed between them, and makes two observations. He notes the verve and tension of these images, 'as of a taut bow', and secondly how their sense of scale, 'the *sine qua non* of good painting', was marvellously precise: 'His big paintings can be as good as his small ones, a rare mastery in this period concerned with the power of magnitude.'

The Chilean artist Roberto Sebastián Antonio Matta Echaurren, better known as Matta, moved to New York from Paris at the outbreak of war in 1939. Born in 1911, Matta was a generation younger than expatriates like Gorky and Hofmann. The temerity of youth allowed him to associate with figures like André Breton, Max Ernst, André Masson, and Yves Tanguy in the Manhattan émigré art scene. But he had much to offer. Before leaving Paris Matta had already been anointed by Breton, the Surrealist 'pope', in the May 1939 issue of the movement's house journal *Minotaure*, which led directly to his exhibiting at the prestigious Julien Levy Gallery within a year of arriving in New York in October 1939. He also spoke English, which together with his energy and enthusiasm made him an essential go-between.

Matta's visual language was clearly that of Surrealism, to which he added a swirling personal lyricism and the sensation of being, so to speak, in outer space. He had links to many of the younger American painters but was perhaps most closely linked to Motherwell, whom he initiated into Surrealist automatist practices on their joint trip to Mexico in 1941, transforming Motherwell's sense of what art might be and how he might make it. A mercurial and charismatic fixer, Matta was able to interpret European Surrealism for a generation of young American artists and provoke them into experimenting with its techniques. So, in the forties Motherwell and Matta bridged the gap between European Surrealism and what was to become 'Abstract Expressionism'. This was a title of convenience, which failed to encompass the full spectrum ranging from engagement with the European Modernist past on the one hand, for Motherwell,

de Kooning or Gorky, to a more self-sufficient American grain on the other, bent on finding a single definitive image or gesture, as with Newman, Rothko and Still. The messier and more clamorous reality was more appropriately renamed the New York School by Motherwell himself.

Interested in everything, in mathematics and science, which he discussed frequently with Duchamp in the early forties, in astrology and magic, in psychoanalysis and the social function of art as an agent of change, Matta managed over the course of his long life to extend the inchoate Surrealist biomorphism of Masson and Tanguy into a most fantastical world of deep space, strange machines and even robotic contraptions.

In 1912 Jackson Pollock was born into a struggling and impoverished farming family on the great plains of Wyoming, a year after Matta with his cosmopolitan background and three years before the upper caste Motherwell. They were all equals in later life, comrades in their love of art and the making of art, but it was Pollock to whom history accorded the spotlight. There is no doubt that if one name is synonymous with 'Action Painting', it is Pollock. The phrase was coined to define him, and he defined the terms. Really no other painter came close. After years of experiment and agonising false starts, he developed an art, delicate, rhythmic, 'on the edge of chaos, but still ordered' in Motherwell's words. It was even produced differently from other art, on the floor of a studio rather than on an easel or wall, the painter dancing over and around the canvas, with buckets and sticks loaded with paint or just old brushes stiff with dried-out paint. At once matter-of-fact and Dionysian.

It was indeed a breathtaking step forwards, and as compelling as the antics of his hero and source of all anxiety, Pablo Picasso. The dripped and spattered paintings were sprung rhythm and energy and newness. Within a short time of perfecting his technique in 1947, he was plucked out by *Life* magazine, *'Is he the greatest living painter in the United States?'*, to embody all that was now in the arts. *Time* magazine would later refer to him as 'Jack the Dripper', suggesting both the menace and the transgression. De Kooning simply called him, in homage, 'the icebreaker'.

From 1948 onwards Pollock's paintings were increasingly viewable, through the efforts of Peggy Guggenheim, heiress to a family whose copper fortune would later help to build a museum for their great collection of Impressionist and modern art. A coterie of dealers, fellow artists and commentators, and eventually collectors and curators, began to assemble around Pollock. And some of his paintings were even finding buyers. Friends supported him and were crucial witnesses to the troubled and erratic behaviour, the womanising and drinking, the myth in the making.

If Pollock had stopped working in 1947 he would have been no more remembered than his early associates, to whom he remained stubbornly loyal, figurative Regionalist painters and Mexican-inspired Muralists whose names are now familiar only to specialists. Raised in Arizona and California, he had come to New York from the limitless spaces of the American southwest in 1929, three years after de Kooning arrived from Rotterdam and these two great figures would rule and divide opinion through the late forties and fifties, and be seen raging at each other in the Cedar Tavern, while the towering Robert Motherwell would calmly remove himself and get on with his editing and writing on art.

What Pollock achieved from 1947 onwards, for the following five years – the all-over paintings, the action paintings, the drip paintings – captured the public imagination, and the press had

a field day. As someone said, it was as if America could not get over its amazement at having produced someone like Pollock. The story took hold, and from then until now he has been the existential saint of art, the laconic James Dean of art, the frontiersman, the outlaw, the native genius of American painting. None of which was planned. Pollock in fact tried genuinely to keep to himself, to hold it together. In the history of publicity his reticent absence dwarfs the heat-seeking presence of Warhol. In the history of art his paintings remain to this day authentic and indomitable. And in the confused space where the histories of art and publicity meet, his works are sometimes cordoned off by ropes, and are, in effect, priceless.

In the last five years of his short life he used mainly black paint on un-primed canvas, and started to return to a new kind of figuration which troubled his admirers. Whether he would have come up with anything as unprecedented as the drip paintings we do not know, for in August 1956 he drove his car into a tree on Long Island, where he lived, and died.

Pollock's acquired skills were slight, likewise his formal education. Not being a natural draughtsman in the tradition of Michelangelo through Ingres to Picasso, he made up for it by a kind of savage innocence and energy. A complex and self-destructive man, like Gatsby he believed in an American destiny. As the Dutchman de Kooning remarked from the sidelines, 'it's certainly burdensome, this Americanness.' Pollock left the wild horizons for New York and enrolled with the Regionalist Thomas Hart Benton, attempting painfully to study drawing and composition and mural painting, and spent the years 1939 to 1941 in Jungian analysis, which in tandem with his drinking led to an early breakdown. The pattern was established, from drunk and dangerous to calm and sweet-natured, from manic to morosely silent, loved by fellow artists, increasingly irrational, resorting to zinc injections and copper injections, then less radical treatments such as soybean paste and mineral emulsions, gallons of it, and endless salt baths, and so on and on, being told by one critic that his work was worthless and by another that he would belong in the history books, so petrified by fame that he would sprint to the studio or alternatively have to drag himself there on hands and knees, veering from self-doubt to furious conviction – with Peggy Guggenheim not selling the paintings whilst at the same time Clement Greenberg was telling the art world that Jackson Pollock is great. And yet Pollock and his wife Lee Krasner were for much of the time flat broke. Aggressive, angry, violent, pathetic, noble at the canvas and ignoble at the Cedar Tavern – and given to driving too fast. A year after his death, Pollock's *Autumn Rhythm*, for which a few years earlier he could not find a buyer, was sold to the Metropolitan Museum of Art for the unprecedented and barely thinkable sum of thirty thousand dollars.

Also born in 1912, William Baziotes knew Pollock from their early days working for the WPA Federal Art Project in the thirties, and introduced him to Motherwell in 1942. At the instigation of Matta, who was fomenting what Motherwell called a 'palace revolution' within Surrealism, which was still ruled by Breton, these artists came together in the belief that a new creative principle was to be found through spontaneous techniques which derived from the Surrealists. At the same moment, Peggy Guggenheim opened the *Art of This Century* gallery in mid-October 1942, to present her personal collection of Modernist art cheek by jowl with new American work. A year later, she decided to mount a collage exhibition with her retinue of European artists, Ernst, Picasso and Braque, and to include three young Americans, Baziotes, Pollock and Motherwell, some of whose work she had already encouraged and whom she now invited to turn their attention to making collages, a little-explored medium with a high Modernist pedigree.

These exercises proved revelatory for Motherwell, confirming decisively his innate gift for abstract composition, and less so for Pollock and Baziotes. Baziotes' art maintained its figurative qualities to the end, in the irregular lyrical shapes that fill his canvases, redolent of natural and plant forms, abstracted rather than abstract. To some extent these derive from Surrealism and other European examples, in particular that of Miró. But Baziotes was instrumental as a New York School presence through the forties and fifties, helping to naturalise the 'original creative principle' which Motherwell felt to be lacking in American art, namely the specifically modern possibilities released by free association.

In 1913, just before the outbreak of the First World War, three very different figures with links to the Abstract Expressionist movement were born, and they precede the entrance of our subject proper, the youngest of the whole group.

Philip Guston, born in 1913, had three distinct phases over the course of a long career. There are the Social Realist style paintings with strong political overtones from the forties. Followed by a mid-career period in the fifties, not so much Abstract Expressionist as Abstract Impressionist works, with luminous patches of overlapping colours, whose impasto is laid down with whispering delicacy and tends to converge upon the centre of the picture. In the sixties and seventies by a much brighter palette, in which an established abstract style gives way to figurative canvases crowded with cartoonish images of the Ku Klux Klan or Richard Nixon, or farcically candid portraits of the artist smoking in bed, whose exploration of the 'impurities' of image-making was greeted with shocked disapproval by his peers, but whose crude Pop vitality and painterly refinement was not lost upon younger artists. Guston's career was to end in a loud tug-of-war over what he was doing, and for whom. But all of his styles had in common a true idiosyncrasy, and by the time of his death in 1980 he had remade himself as a figurative artist of considerable power.

Born to a family of Italian immigrants in Boston in 1913, Conrad Marca-Relli moved to New York in 1926. Like many of the future Abstract Expressionists, he worked during the Depression for the WPA, where he met Franz Kline and Willem de Kooning. By 1949 he was a key figure, whether organising the 'Eighth Street Club', a discussion group that encompassed a broad swathe of New York artists and intellectuals, or assisting Leo Castelli in mounting the *Ninth Street Show*, the first comprehensive display of Abstract Expressionist work. He was a neighbour of Pollock in Springs, Long Island, and they remained close friends through good times and bad. Indeed, it fell to Marca-Relli to identify Pollock's body at the scene of his car crash on August 11th 1956.

Marca-Relli began as a figurative painter, influenced by the metaphysical melancholy of Giorgio de Chirico, the solitude of Giorgio Morandi's still lifes, and by a lifelong preoccupation with architectural and tectonic forms, but he moved into pure abstraction in the fifties, where he stayed, sometimes reluctantly, until his death. His monumental abstract collaged paintings are as crowded and edgy as the most violent gestural canvases of his colleagues, but he achieved an effect of restraint, through the careful orchestration of forms and contours and tonalities, following his passion for Japanese calligraphy. A lifelong migrant between America and Europe, he eluded easy classification, to the detriment of his reputation, and died in Palma in 2000.

A child of German immigrants, Ad Reinhardt was born in 1913 in New York City. He started painting as an undergraduate at Columbia, becoming immersed in radical politics. After college he

supported himself as a cartoonist and graphic designer, mostly for leftist newspapers, and would continue to do so long after becoming a teacher and painter. His graphic work led to an interest in collage, which he took to with zeal, creating a cut-and-paste world at once erudite, eclectic, absurd and combative. By nature an oppositional figure, Reinhardt at the end of the forties was the first observer or participant to see the prospect of American avant-garde art morphing into a marketing phenomenon, a consumerist spectacle, in which a handful of individuals were ostentatiously rewarded and the rest ignored. Using collage to satirical or polemic effect, he fired off at everyone – curators, critics, dealers, even fellow artists – from a position of betrayed ideals. In 1954 he published an article titled *The Artist in Search of an Academy, Part Two: Who Are the Artists?* In which he proposed 'four general categories of artist-types,' classing Newman as an 'artist-professor and traveling-design-salesman, the ArtDigest-philosopher and Bauhaus exerciser, the avant-garde-huckster-handicraftsman and educational shopkeeper, the holy-roller-explainer-entertainer-in-residence.' Newman was so offended by the article that he unsuccessfully sued Reinhardt, for libel.

Like Motherwell, Reinhardt was one of the few New York School artists to have been an abstract painter from the start. To him abstraction was not a style so much as an ethics and a destiny. Like Motherwell, too, Reinhardt embraced what he saw beyond the American scene. He too had studied art history under the eclectic tutelage of Meyer Schapiro at Columbia, and his borders remained permanently open from then onwards. During the fifties, at a time when American artists seldom ventured beyond Europe, Reinhardt was to be found in India, Southeast Asia, Syria, Iran and Iraq, studying Buddhism or Hinduism, noting the role of abstraction in Islamic art, and taking photographs. In the sixties he photographed constantly and photographed everything. Often holding impromptu slide lectures, Reinhardt's influence as a teacher and writer was significant. Basic abstract forms, repeated across different cultures, were for him demonstrably art's historical essence, and they challenged the obsession with newness that he saw as both fuelling and impoverishing the New York art world of the fifties and sixties.

In his mature work, Reinhardt created the subtlest paintings of the entire New York School. Like Motherwell he was a follower of Mondrian, but whereas the immediate influence is difficult to see in Motherwell's art, it is clearly visible in Reinhardt. Not least in his final canvases, the black paintings, dating from the sixties, during his last decade. Each is a five-foot square of stretched linen covered with black oil paint, but energised by grids of red, green or blue worked into the black and giving chromatic life to his canvases: an intimation of colour, a hint of ghostly geometries. Reinhardt routinely drained off most of the oil from the paint to create these powdery *matte* surfaces which absorb all light, show no brushwork, and are works of vibrantly uncommunicative abstraction.

Reinhardt himself felt abandoned by his own generation and when a younger group of artists embraced him in the sixties, it was as usual for the wrong reasons. He was no Minimalist, nor was he meant to be. He died in 1967 at the age of fifty-four.

Born in 1915, Robert Motherwell was the youngest of the Abstract Expressionist group which transformed the story of American art. He made well over a thousand paintings, nearly a thousand collages, many hundreds of drawings and etchings, lithographs and screen prints, from 1941 until his death in 1991. Among this outpouring of works, over the course of five decades, the most recognisable images were the *Elegy to the Spanish Republic* series, at which he worked until he died. They are the closest he came to a signature style, and perhaps had he

concealed all of his other styles and series, he would have become as renowned as his friends Pollock, Rothko and Newman. Motherwell's other mistake was to live to the productive old age of seventy-six, outliving all of his peers, who ended their days in car accidents, or as suicides, or simply from premature wear and tear.

Rather than the myth of Motherwell, there is the anti-myth of Motherwell, dedicated to misinterpreting his strengths as weaknesses. He was faulted for being too eclectic, or too intellectual, or too European. Too travelled, too fluent, too French, too elegant. Or, despite being only three years younger than Pollock and producing work of the quality of the first collages in the early forties, he was 'the shy young man from San Francisco'. Genteel, brainy and west-coast, a scholarly amateur instead of a 'proletarian blue-collar paint-flinger bellying up to the bar at the Cedar Tavern', in Robert Hughes's vivid caricature of the standard-issue Abstract Expressionist.

In reality, Motherwell always stood slightly apart from the rest, even in standard tellings of the New York School story. Neither a cowboy nor a swashbuckler, he arrived in New York in 1940 as a philosophy graduate, to study art history with Meyer Schapiro at Columbia. And he managed to do a considerable amount of writing on art, as well as editing other artists' writings for his seminal *Documents of Modern Art* series, all of this contributed to his aura of being more spectator than creator. But the truth was that he possessed boundless intellectual energy and aesthetic ambitions, and that he put them to effective use. Which did not prevent the young Motherwell being ticked off by his then dealer, Sam Kootz, for wasting so much valuable time on this academic stuff. Kootz's hidden anxiety was that negative perceptions might circulate about a painter who was also a writer. To which Motherwell politely but firmly replied, would Kootz prefer him to be hanging out at the Cedar Bar? 'My editing is a way of dealing with minds that interest me, in the same way that Baziotes likes to talk with people in bars, and I don't see why that should bother you. If I were by nature a painter who would really rather edit, I would be a much better editor and a much worse painter than I am in fact.'

Cutting though the stereotypes and straw men, the poet Randall Jarrell remarked that 'Robert Motherwell is both quintessentially American in feeling and European in form and function.' Or, to adopt T. S. Eliot's words in his encomium to Henry James, which were equally the self-portrait of a fellow outsider, 'It is the final perfection, the consummation of the American to become, not an Englishman, but a European – something which no born European can become.'

1907: Aix-en-Provence

'All reality is on his side: in his dense quilted blues, in his red and shadowless greens, in the reddish black of his wine bottles. And the humility of his objects: the apples are cooking apples and the wine bottles belong in the bulging pockets of an old coat . . . I remember the puzzlement and insecurity of one's first encounter with his work. And then for a long time nothing, and then suddenly one has the right eyes…'

– Rilke, letter to Clara Westhoff, after seeing the Cézanne Rooms at the Salon d'Automne in Paris, 1907

The summer of 1906 had been blisteringly hot in Aix-en-Provence, as the solitary figure of Paul Cézanne climbed to the foot of his mountain, the Mont Sainte Victoire, to paint it once again, as he had done so many times before. The rocks lining the road from Le Tholonet would burn your fingers, were you to rest them there.

But now it was mid-October and the landscape had cooled a little, which made it so much easier to climb the road from the studio to the clearing, with its view of the mountain whose broken silhouette dominates the town of Aix. That day, the fifteenth, there was even a surprise thunderstorm, and Cézanne was caught up in it. He turned back, but on the way down he collapsed, and lay unconscious in the rain for several hours.

Earlier that morning he had written to his son Paul to order two-dozen mongoose-hair brushes and not to worry on his account, for he felt in good health and was eating well.

He was found by a local worker, who brought him back to town on his laundry cart. Within two days Cézanne was in the studio again, at work on a portrait of his gardener and odd-job man, Vallier, seated under a lime tree. He also started work on a watercolour titled *Still Life with Carafe, Bottle and Fruit,* and found time to complain to his paint supplier that the ten Burnt Lake no. 7 pigments had not yet arrived and that he needed them urgently, although under strict orders from his doctor to stay in bed.

Several days passed, and his condition worsened rather than improved. He had contracted a lung congestion of some sort, pleurisy perhaps. The details were never recorded, and early on October 23rd he died, in his studio residence at Les Lauves, overlooking his beloved mountain. He was sixty-seven years old.

All his life Cézanne had been ridiculed and misunderstood by family and friends. Motherwell recalled how 'Cézanne once fell in love with a young woman, and agreed to a rendezvous thirty miles away, and then the whole family comes, and takes him back like a child, aged thirty eight.' Even his closest friend from childhood, Emile Zola, who at one point rescued him from financial dependence on his father, used Cézanne in the novel *The Masterpiece* as the thinly disguised original of an artist doomed to failure by 'heroic madness', a medicalising of Cézanne's mule-like stubbornness, and who ends by hanging himself in front of one of his own unfinishable canvases.

After his death Cézanne's son promptly got rid of twenty-nine paintings and nearly two hundred watercolours for an indifferent quantity of French francs. His earliest collectors were fellow artists. Monet owned fourteen works. Degas disputed with Renoir over one particularly cool and sensuous watercolour sketch of *Three Pears*. Gauguin owned six paintings, including *Still Life with Compotier*, which he would carry to his local restaurant to discuss its merits with friends and strangers alike. And Cézanne's loyal ally Camille Pissarro owned twenty-one works.

In 1895 the art dealer Ambroise Vollard acquired an entire studio of nearly one hundred and fifty canvases from Cézanne, who shrugged that no one else seemed to want them. Because of his financial security, especially after the death of his father, an indulgent if overbearing banker, he was able to continue painting in virtual obscurity, and learn the tenacity to do so, doggedly, year after year. Creating an art whose strongest conviction is doubt.

But then a different story starts, almost in parallel. Exactly one year after his death, in October 1907, the first retrospective of Cézanne's paintings opened as part of the annual *Salon d'Automne*, occupying two huge rooms of the Grand Palais on the Champs Elysées. Fifty-six works were exhibited, more than had been seen in one place during his lifetime, and all of Paris came to stare. Some came to make fun, or merely to act quizzical in front of these unfinished-looking works of 'refined savagery', in the words of Pissarro. Rainer Maria Rilke watched their reactions, 'amused, ironically irritated, annoyed, outraged', the women comparing themselves favourably to Cézanne's two portraits of his wife. But others saw the future, and came every day. Not least the steady stream of fellow-artists, Matisse and Picasso, Braque, Duchamp, Modigliani, Derain, Gris, Léger. And especially Rilke, who visited the exhibition every single day and wrote home almost every day to his wife about it.

In the same year, 1907, over the course of nine months, Picasso was to paint *Les Démoiselles D'Avignon,* a large and ungainly canvas which the young artist was himself uncertain about, showing it to his closest friends, but turning it to face the wall in his studio for nine years. It was a work that his hero Cézanne would certainly not have liked. But without Cézanne and his *Grandes Baigneuses*, completed in 1905, this painting, described by Breton as the 'core of Picasso's laboratory' and executed a couple of years before the Cubist breakthrough, could not have happened.

Matisse had bought Cézanne's *Three Bathers* in 1899, paying the dealer Vollard in instalments, and he lived with it for thirty-seven years before donating it to the Musée des Beaux-Arts in Paris in 1936, with these words: 'I have come to know it quite well, though not entirely, I hope. It has sustained me morally in the critical moments of my venture as an artist; I have drawn from it my faith and my perseverance.' Many years later Motherwell in turn would buy a cut-out collage by Matisse and that too would be placed in his studio for inspiration.

The point is that nowhere else possessed such vitality of transmission from one artistic generation to the next, each briefer and more explosively different than the last, or possessed a comparable dynamism and hunger for the new, as did Paris, art capital of the nineteenth century, whose reign arguably began in 1863 when Manet showed his *Déjeuner sur l'herbe* at the Salon des Refusés. Or possibly it began in 1855, when Courbet's monumental canvas, *The Painter's Studio* was rejected by the jury of the Exposition Universelle, and he retaliated by mounting his own exhibition in a separate 'Pavilion of Realism', within sight of the official venue. Or perhaps

the reign of Paris began as early as 1784, when Jacques-Louis David completed his *Oath of the Horatii*. Or even earlier, when chief minister Cardinal Mazarin started importing vast quantities of Italian art in the 1640s, to form the basis of the state collection in the Louvre. There is no simple answer as to when Paris became the global workshop for the making and showing of advanced art. But it did take centre-stage, and held this position for an epoch. Until avant-garde American painters began to sense that what they were doing was different in kind to what their European confreres were doing, and began to wonder if this difference might be characterised as specifically and newly 'American'.

In New York Alfred Stieglitz was exhibiting drawings and photographic reproductions of Cézanne paintings at his 291 Gallery from as early as 1910. In 1913, within 7 years of his death, the first extensive selection of Cézanne's oil paintings in the United States would appear in the Armory Show. In 1929 the Museum of Modern Art opened its first loan exhibition, entitled *Cézanne, Gauguin, Seurat and Van Gogh*, organised by Alfred Barr and viewed by fifty thousand people. These exhibitions were the Trojan horse. They ushered in the triumph of French Post Impressionism, and it took American art more than a decade to recover from the shock. Seven years later the 1936 exhibition *Fantastic Art, Dada, Surrealism* at the MoMA, curated by Alfred Barr, would have an equally resounding impact, granting Surrealism a decisive American presence. MoMA, the most influential of all American museums, opened its doors in November 1929, nine days after the Wall Street Crash, and its project was to show the passing of the torch from a failing Europe to vigorous America. If Modernist art first appeared in Europe, its progress was first narrated in the US, and abstraction was its name.

It took two world wars and an exodus of European artists to unseat Paris. Duchamp had been to New York and gone, and then came back and stayed. Mondrian fled Nazi Germany for London but moved to New York when his Hampstead home was bombed, where he painted *Broadway Boogie Woogie* in 1943. Picasso had visited. Matisse had visited. Max Ernst came, plus many other Parisian Surrealists. Jean Helion, Josef Albers, Hans Hofmann all came, even before the war, as did Moholy-Nagy and Ozenfant. Fernand Léger made three trips to New York and finally stayed on after the outbreak of war.

The paintings themselves had likewise migrated. Picassos, Braques or Miros had been turning up in New York galleries for years. Today, almost a third of Cézanne's oil paintings are in America, not least in the great collection amassed by Dr Albert Barnes of Philadelphia which now forms the Barnes Collection. It took all of this plus the German occupation to topple Paris. By the early forties the tipping point had been reached. At the end of that vital decade, the critic Clement Greenberg could state as a matter of fact that 'the main premises of Western art have at last migrated to the United States.' All that was now needed was for America to grow some artists of its own.

The Motherwell-Hogan family, ca. 1918. Clockwise from left: Marion Hogan, John C. Hogan,
Margaret Motherwell, R.B. Motherwell II, Katherine Hogan, Robert Motherwell, and Mary Motherwell.
Dedalus Foundation Archives.

1915: The World of Appearances

When I see a newsreel from 1915, the year I was born, or a movie that takes place then, like Jeanne Moreau's Mata Hari, I cannot believe that my life span has been from that moment until the present: I have had the same perspective throughout, while the appearance of the world changed. When I was born is another universe, and I am fifty. As though one were born in what is now a museum.

– Robert Motherwell (1965)

Robert Motherwell was born on January 24th in 1915, in the little town of Aberdeen, Washington State. Its main claim to fame was that it was considered the greatest lumber port in the world. He was born one year after Robert Motherwell II, the banker father of the future painter married Margaret Lillian Hogan in 1914. That very same year of his birth Marcel Duchamp would arrive in New York. That year the Russian artist, Kazimir Malevich painted the revolutionary *Black Square*, just a few years after Picasso smashed open the visual world with his friend Georges Braque and gave the world Cubism and Matisse down in Collioure in the South of France invented Fauvism. And that same year Robert Frost had returned home from England to discover he was unexpectedly famous and his two collections of poems were being read by what seemed like the entire American nation and so he bought a farm in his beloved Vermont on a poem that surely meant the world to the future young Motherwell, *The Road Not Taken*. And the year of Robert Motherwell's birth James Joyce published *The Dubliners*, one year before he completed *Ulysses*, the very book that would completely change the future artist's life.

The huddled masses kept arriving at Ellis Island terminal in New York harbour, and the balance was shifting even before the Second World War, even before the nation became rich and powerful at the end of the nineteenth century. It began when the country began, when the Pilgrim Fathers set foot on Cape Cod and the realm of individual human possibility was enlarged by several degrees. When the tipping point was finally reached, quite suddenly it was America's turn: the American Century and all who sail in her. You could make a D.W. Griffith movie of it, opening with a young man labouring in the fields, staring straight into the camera with pioneer candour, his long Jacobean hair blowing gently in the early morning Massachusetts wind, his pale blue eyes covered from the sun by his right hand held at a right angle to his tanned forehead. The camera pans across to the Atlantic Ocean, then pans back to the same spot and we see the same young man, still full of hope and confidence, now saluting the world with a crew-cut.

In this year of Motherwell's birth, 1915, D.W. Griffith did in fact make such a movie, a flawed masterpiece called *The Birth of a Nation*. Flawed because although cinematically amazing, Griffith himself was a complicated autodidact, and he set out to rewrite the historical facts of slavery and reconstruction according to his own pro-Confederacy beliefs. The movie depicts slavery in a benevolent light, presents blacks as good for nothing but labour, and the southern whites who formed the Ku Klux Klan as defending themselves against abominations to restore order and civilisation to the South. At the same time, *Birth of a Nation* was a decisively original work of art, the foundation stone of cinematic realism, whose open frames, multiple stagings and planes of action all encompassed far more of American reality than Griffith's silent subtitles would allow. He filmed a world according to his point of view, but his movie transcended that original vision.

In the new medium of celluloid, American art had quickly become a match for American reality, however contested that reality might be, and however unpredictable. The stock market bubble of the twenties first made and then destroyed Griffith, as the Jazz Age gave way to breadlines.

The American Dream was manifold and it could take radically different forms. Born in the same year as Motherwell, a few months apart, was Sam Walton, who became the richest man in the United States – the type of individual that Motherwell senior, President of Wells Fargo Bank in San Francisco, would have preferred his son to emulate, instead of associating with drunks like Pollock. With the building-bricks of a small-town mentality Walton erected the vast edifice of Wal-Mart, whose two thousand stores eventually covered the land. He employed half a million people and left a respectable fortune at his death in 1992, nine months after Motherwell. All of which was of about as much interest to the artist as darning his socks. These contemporaries had nothing in common, except their dates, their pursuit of the American Dream and their love of hunting duck and quail.

The art that the young New York painters wanted to make was not just a rejection of the father, of Picasso and old Europe, but something which was born out of its own American moment, the thirties Depression, took shape in the forties and had the resilience to propel the story into the fifties and beyond, finding new equivalents for a lost sense of manifest destiny. When, decades later, de Kooning said to Warhol, 'You ruined it for us' – according to Robert Indiana, he in fact screamed 'You destroyed art!' to Warhol's face – he said it with a clear head and a heavy heart. For all the drinking and the wayward lifestyle, the first New York School painters were a brave and committed group. Motherwell, the youngest, became their unspoken spokesman, as the most articulate, the most educated, the most critically aware. But however inarticulate they might be, they were all, as Motherwell said of Pollock, 'wholly articulate in the studio', and they held the deepest belief about capturing the reality of the New World on their terms, irrespective of an audience. As Motherwell remarked, early on, 'the audience for modern artists is other artists'.

But Motherwell's career as an artist was characterised and to some extent dogged by his unusual capacity to imagine an audience. By his role as a thinker, a writer and an editor. As such, he is in good company. Piero della Francesca, also from a wealthy background and a small town, was known as a mathematician, one of whose treatises established the basis for later studies of perspective, or 'the science of things seen at distance', including those by Leonardo and Durer. Even for Giorgio Vasari, in his *Lives of the Artists*, a century later, Piero was to be remembered primarily for his contribution to geometry and the art of drawing regular bodies, rather than for his 'excellence in painting', which is merely noted in passing. His art was eclipsed by his role as a Renaissance man.

Piero's panels and frescoes became relevant and modern again only when their example was needed – by Cézanne, for whom Piero was a true contemporary, or by Picasso and Braque for their Cubist purposes, or by Seurat for his great Post Impressionist canvases whose simplicity of forms and regular shapes defined by light so strongly recall Piero.

Whereas in the preliminary sketches for Seurat's *Bathers at Asnières*, of 1883, ordinary life is revealed as chaotic and unbiddable, in the final work he discovers a formal solution in which what is seen and what he wants to show are reconciled. It was a friend of Motherwell, the young scholar Jack Flam, who wrote in 1983:

Somewhere a balance must be struck between the tension of life as it is lived and of life as it is conceived. In the history of painting the most awesome resolution of this tension is perhaps that found in the art of Piero della Francesca – in the almost inconceivably fine balance Piero achieves between the incidental and the essential, the commonplace and the cosmic. No form or shape is too small to escape the relentless order and patterning of the whole, yet the whole itself is rife with eccentricity and surprise, and constantly allows free play to even the smallest form or shape. . . Motherwell's regard for Piero relates to the balance of thought and feeling in this art, and how utterly pictorial its expressive means. These qualities were at the core of Motherwell's own ambition, from the outset of his venture as an artist.

As with Piero and mathematics, or with Seurat's scientific turn of mind, so too perhaps with Motherwell's early apprenticeship to philosophy. His training made him acutely aware of the tension between life as it is lived and as it is refracted in art. In particular, it gave him to understand that abstraction, his chosen medium, required the exclusion of much of what counted as life – his own life, the surface life of his times – if it was to include the felt experience and the intensities he looked for in paint. In 1951, he described abstract art as 'an art stripped bare. How many rejections on the part of her artists! Whole worlds – the world of objects, the world of power and propaganda, the world of anecdotes, the world of fetishes and ancestor worship . . . An innovation as drastic as abstract art could only have come into existence as the consequence of a most profound, relentless and unquenchable need. '

It is sometimes suggested that abstraction took hold in America because of the historical 'thinness' of American experience, as noted by Henry James in 1897, in his mischievous checklist of what was missing from the American scene of his childhood:

> No State, in the European sense of the word, and indeed barely a specific national name. No sovereign, no court, no personal loyalty, no aristocracy, no church, no clergy, no army, no diplomatic service, no country gentlemen, no palaces, no castles, nor manors, nor old country-houses, nor parsonages, nor thatched cottages, nor ivied ruins; no cathedrals, nor abbeys, nor little Norman churches; no great Universities nor public schools – no Oxford, nor Eton, nor Harrow; no literature, no novels, no museums, no pictures, no political society, no sporting class – no Epsom nor Ascot!

'The American knows that a good deal remains,' concluded James. 'What it is that remains – that is his secret, his joke, as one may say.' What remained, and the joke would be relished above all by Pop Art, was the amorphous ahistorical present, in all its heterogeneity. Or what Andy Warhol a century later called 'all the great modern things', the world of imagery and commodity which was so overwhelmingly 'there' in American life as nowhere else. 'The Pop artists did images that anybody walking down Broadway could understand in a split second – comics, picnic tables, men's trousers, celebrities, shower curtains, refrigerators, Coke bottles – all the great modern things that the Abstract Expressionists tried so hard not to notice at all.'

The argument goes that America embraced abstract art as providing a means to leave behind the incidental and the temporal, to deal directly with the universal and the timeless. To deal with life on art's terms. But this oversimplifies the reality of Abstract Expressionism's engagement with the age, and with resisting the age when it became too tyrannous. In Motherwell's case, we shall see how much of his world he managed to include in his art.

Robert Motherwell, 1930. Dedalus Foundation Archives.

1929: Great Expectations

We were somewhere in North Africa when we heard a dull distant crash which echoed to the farthest wastes of the desert. –'What was that?' –'Did you hear it?' – 'It was nothing.' – 'Do you think we ought to go home and see?' – 'No. It was nothing.'

– F. Scott Fitzgerald, 'May Day'

Actually the Roaring Twenties, or the 'Jazz Age', Fitzgerald's term for Fitzgerald's decade, began in 1919. The War to end all wars had ended, and American soldiers came back from a traumatised Europe to start their lives. After such carnage they were bound for 'the greatest, gaudiest spree in history', whether they felt like it or not. *Tales of the Jazz Age*, published in 1921, includes Fitzgerald's longest and greatest story, *May Day*, set during the so-called May Day Riots of 1919 and written by the twenty-four-year-old in 1920:

> Never had there been such splendor in the great city, for the victorious war had brought plenty in its train, and the merchants had flocked thither from the South and West with their households to taste all of the luscious feasts and witness the lavish entertainments prepared – and to buy for their women furs against the next winter and bags of golden mesh and varicolored slippers of silk and silver and rose satin and cloth of gold.

John Winthrop's original puritan vision of the 'city upon a hill' had come to pass, not as a shining example to lead the world into the millennium, but as a glittering and shameless Babylon. Speed was of the essence. As Duchamp remarked in 1950, 'only a century ago Twenty Third Street was open country'. The machine of prosperity and optimism was gathering pace. Women got the vote, baseball came to stay, as did Broadway and Hollywood, prohibition and gangsters, the personal automobile and the flapper. Consumer goods needed captive populations. America, born in the country, moved to the city.

Less than a decade earlier, Robert Motherwell II, father of the painter, had left his native Ohio and headed west, impelled by the dream of becoming a banker and living in California. He halted in Aberdeen, Washington State, found a job as a cashier, and a year later married the daughter of a local lawyer, just as war broke out in Europe. The following year Robert Burns Motherwell III was born, and a year later his sister, Mary Stuart Motherwell. The family would move house frequently, following work and promotions. To Seattle in 1918, to San Francisco in 1919, to Salt Lake City in 1920, then on to the Federal Reserve Bank in Los Angeles and finally back to San Francisco, where Motherwell senior came to rest as President of Wells Fargo Bank, his twin ambitions fulfilled in fairly short order.

Aberdeen remained the pivot of Motherwell's childhood, a small town with a claim nonetheless to being the greatest lumber port in the world, with twenty thousand inhabitants surrounded by virgin pine forest and a magnificent harbour. 'All through my childhood there would be

a hundred or a hundred and fifty ships from Japan, Finland, Russia, Greece, France, from everywhere, loading up with lumber to take all over the world,' a hive of human activity proceeding from a single industry. A seaport, small yet cosmopolitan, with a family barn on the shore, Aberdeen was a prototype of Provincetown.

Or perhaps the prototype was Westport, a settlement of houses constructed in Scandinavian wooden style, fifteen miles along the coast, where the Motherwells had their summer barn, as did the painter's grandfather, a lawyer of Irish extraction whose library was filled with the works of Turgenev, Dostoevsky, Tolstoy and Darwin. 'In those days you got complete sets', and Motherwell acquired a lifelong preference for reading twenty books by one author rather than the same number by twenty authors. Another neighbour was Lance Hart, a local artist and professor at the University of Oregon, who taught the teenage Motherwell about painting and how to play poker.

There were other influences. Motherwell's mother was a voracious reader and she cut a cultivated figure, assembling over time a major collection of eighteenth century French provincial furniture. Her son accompanied her to auction houses, and later attributed his passion for earth colours to an apprenticeship of looking closely at waxed fruitwood furniture, and his sense of form to an eye trained in following 'the exact undulation of a curve'. She had an instinct for what was authentic, and used to read a lot at the dinner table. 'Sometimes she would read a passage, a very emotional passage. And my father would get very upset, and say, "now Meg, now Meg…" ' The Motherwell household was a well-off suburban home where the aesthetic sense was dangerously alive.

There was a dark side, even if Aberdeen and Westport were a refuge from the world. 'My mother was a hysteric and used to beat me terribly as a child, until the blood ran out of my head. And my father would on occasion, too. So that I grew up terribly nervous and anxiety-ridden and suffocating.' Motherwell developed severe asthma in San Francisco, from the age of twelve, and aged fifteen he was sent to a boarding school in the Californian desert, weeks before the 1929 crash. He would forever afterwards dislike San Francisco, finding it 'stiff and reactionary, like Boston or Philadelphia; and the fog was just literally death to me'.

In the desert he developed an eye for clarity, for dry light and sharp shadows, which would shape his graphic sense, his understanding of black and white, his predilection for ochres and umbers, and his metaphysical affinity for the harshness of Mexico, the *mezzogiorno* of Italy and the abstraction of Spain. He came to believe that Mediterranean light was an essential element in shaping modern art. One might equally speak of the Californian clarity of Motherwell's prose.

His sense of removal was compounded by asthma, which increased his aptness for concentration and withdrawal, his watchfulness, and, later on, a preference for working at night. The schoolboy Motherwell was already drawing and copying from whatever came to hand, from marble statues in the local catholic church to Rubens, the Sistine Chapel frescoes, Rembrandt, or making dozens of renditions of a Cézanne landscape from an Encyclopaedia Britannica reproduction he had come across at school.

Written in 1932, from a position of stunned hindsight, *My Lost City* is the witty and jaundiced summary of F. Scott Fitzgerald's personal relationship with New York. How he arrived there, how his dreams were fulfilled, and how the fallout from the 'boom days' became the inescapable 'second act' to American lives which he had portrayed so brilliantly in his fiction as having only a single act, like fireworks.

On his return after an absence of three years in the mid-twenties, he noted the ominously accelerated tempo: 'The uncertainties of 1920 were drowned in a steady golden roar and many of our friends had grown wealthy. But the restlessness of New York in 1927 approached hysteria. The parties were bigger, the pace was faster, the shows were broader, the buildings were higher, the morals were looser and the liquor was cheaper.'

For a century the British Empire had been the engine of the world economy, and its largest economic unit in the pre-war decades. Sometime in 1916, the year of Verdun and the Somme, the combined output of the British Empire was overtaken by that of the USA. Having been the world's biggest debtor, borrowing from Britain at attractive pre-war loan rates to build a new world, America became the Old World's major creditor after 1918. New York replaced London as the central lender, and the axis of credit switched from London's Square Mile to Wall Street. America would finance post-war Europe, whose national economies had been enfeebled by war – France in particular had suffered devastating damage – and by war debts, or, in the case of Germany and other defeated nations, by the need to pay reparations.

The British economist John Maynard Keynes predicted distress on a scale likely to 'submerge civilisation itself', but in America the pace was picking up. The twenties were the decade of boom psychology and speculative euphoria, with record production figures for output, ever-increasing sales and exponential profits. By 1929 there were twenty million cars on the road, roughly one to every household. Profits meant high dividends and increased share prices, which encouraged investment in shares. By 1927, the stage was set for a Wall Street gold rush, as Americans hurried to take advantage of the booming share market. Many sold what they owned to buy shares, or borrowed heavily to do so. Insider trading was rife. Everybody was in the know, and even Fitzgerald's barber was able to amass, and lose, a small fortune: 'I was conscious that the head waiters who bowed me – or failed to bow me – to my table were far, far wealthier than I'. Unlike dull investment shares, speculative shares saw action on a daily basis, and the trend had only one direction – upwards.

Men as solid and careful as Robert Burns Motherwell II saw what was coming, with varying degrees of clarity, but no one could shout above 'the steady golden roar'. The government tried to cool the market by making money more expensive to borrow, so people simply borrowed money more expensively. The logic was as irresistible as that which precipitated the South Sea Bubble of 1720 when the South Sea Company's stock rose from £128 in January to more than £1,000 in August, or the tulip mania of 1637, when a single bulb of a sufficiently rare specimen could trade at values equivalent to the cost of a luxurious townhouse in Amsterdam.

For the boom days of the late twenties, the trigger for catastrophe was industrial and agricultural over-production. American manufacturing had grown so rapidly that it was making more goods than could be bought even by the most determined consumers, causing sharp falls in sales, in prices and in profits.

The investment bubble burst on 'Black Thursday', October 24th 1929, when share prices on the New York Stock Exchange suddenly and inexplicably plummeted. Panic selling caused prices to cascade further downwards. On two consecutive days the entire stock exchange lost one-eighth of its value, with long-term consequences for the American economy. Between 1929 and 1932 industrial production would fall by forty-five per cent. Companies went bankrupt or ceased trading or tried to cut costs by shedding workers in droves. By 1932 more than twelve million Americans were out of work. The collapse in economic confidence fuelled a run on banks, as people rushed to secure their deposits. Americans everywhere lost their investments and savings. And what started in the United States quickly became a worldwide economic slump, owing to the close ties which had been forged between the United States and European economies after the war. The flow of American investment credits to Europe dried up, hitting those countries hardest that were most deeply indebted to the United States, not least Germany, where the Weimar government failed to muster an effective response. Writing in the Nazi press, the apprentice agitator Adolf Hitler saw an opportunity: 'Never in my life have I been so well disposed and inwardly contented as in these days. For hard reality has opened the eyes of millions of Germans. . .'

This was the view from where Robert Motherwell the banker was standing. During this transformation his son was at school in the desert, removed from the world. Most of the other Abstract Expressionist painters, his future confreres, were born earlier, between 1904 and 1912, and consequently were either teenagers or young men in 1929, not least Mark Rothko and Barnett Newman, who would shortly have to put his art career on hold to help his father's slumping business. Abstract Expressionism could be said to have the Depression in its DNA. Decades later Rothko could still declare that he could not trust anyone 'who did not have one foot in the Depression.'

Motherwell had been raised with great expectations, and sent to the best universities – from preparatory or boarding school to Stanford, from Stanford to Harvard. As he later remarked, 'I had convertibles in college'. All of which was taken away by the crisis. When the young Californian moved to New York in the late thirties to make a living as a painter, he eked out the first ten years on a stipend of fifty dollars a week from his father, who like everyone else was ruined by 1929 and its aftermath, although he would recover financially by 1940. He had little appetite for his son's evolving wish to be a painter, particularly at such a time as this. But he knew what it was to follow an instinct, having done so himself. 'If you want to be a painter and New York is the place to be a painter, then go to New York and be a painter.'

In 1926, lately arrived in New York the Armenian-born Arshile Gorky, passionate and knowledgeable about the work of Pablo Picasso, began a painting which took ten years to finish, entitled *The Artist and His Mother*. It is based on a photograph taken in 1912, when he was eight years old. Gorky had experienced the horrors of war and genocide when the Ottoman Turkish army invaded Armenia. With his mother and younger sister he had been forced to leave home and walk to the Russian border. They survived, but Gorky's mother never recovered her health, and in 1919 died of starvation in a refugee camp in Yerevan. The following year, the fifteen-year-old Gorky and his sister emigrated to the United States to join their father, who was already there. For Gorky, the photograph was a treasured memory. The painting shows the eight-year-old standing beside his disembodied mother, his face full of wonderment, her face staring out as if from a Coptic funerary portrait. She is dead, for he has not been able to bring her across to the New World.

Robert Motherwell (front) with college roommates (left to right) Carlos Odriozola, John H. Steelquist and Manoel Cardozo, Palo Alto, California, 1934. Dedalus Foundation Archives.

1935: Only Connect

> *'Do I contradict myself? Very well, then, I contradict myself'*
>
> — *Walt Whitman*

On October 24th, 1934, the sixty-year-old Gertrude Stein returned to America, for the first time since settling in Paris in 1903, to give a six-month lecture tour. America decided at once to reclaim her as an American, and a famous one. En route to the hotel where she and Alice Toklas were staying on their first night in New York, after disembarking the *S.S. Champlain*, they saw the message 'Gertrude Stein Has Arrived' flashing across Times Square in neon. Criss-crossing the nation for six months, she gave seventy-four lectures in thirty-seven cities and twenty-three states. The occult 'Miss Stein' started out as a curiosity and ended a celebrity, a household name and a famous face.

The following spring she gave two lectures at Stanford University, just south of her native San Francisco. She pronounced on literature and painting, in her peculiar and cadenced idiom. She described the psychology of the creative act as a moment of 'recognition'. She said that the artist is a sensitive litmus, expressing what is contemporary but still dormant in the unconscious of society as a whole. She told her audience that the twentieth century was invented by America, 'now the oldest country in the world', because America began the business of being modern a century earlier, whereas other societies were only now slouching towards modernity after centuries of stony sleep.

The twenty-year-old Motherwell went to hear her, and was enthralled. He was already attuned to the age. Only a couple of months earlier he had heard Igor Stravinsky perform and conduct his own compositions at Stanford. To encounter Stein was to meet the ambassador of the Modernist moment, the broker of such reputations as Picasso and Matisse, Fitzgerald and Hemingway. Although her own style with its blunt subtleties was inimitable and hard to digest, she convinced Americans by the force of her personality that Modernism mattered, and that it mattered for America. She put a face on Modernism that people liked. The President of Random House, who met Stein during this trip and would later become her publisher, reported with relief that she spoke 'as plain as a banker'.

Plainness was one way of making it new. Only a decade earlier in Paris, Stein had taken the twenty-two-year-old Ernest Hemingway under her wing, freshly arrived from the American mid-west, and encouraged him to produce good sentences, forcing him to think about words and phrases, pauses and prepositions, punctuation and paragraphs, crispness and clarity. Hemingway's terse economy would influence literature for nearly a century. His self-apprenticeship complete, Hemingway arrived on the American scene in 1926 with his first masterpiece, *The Sun Also Rises*, framed by an epigraph from Stein, 'You are all a lost generation'. Its account of post-war disillusionment and uncertainty was followed by the semi-autobiographical *A Farewell to Arms*, set in the ambulance corps during the Italian campaign of the First World War, which appeared in the year of the Wall Street Crash, and for which Hemingway wrote dozens of alternate endings

in his attempt to 'get the words right' – as if those were the only honourable terms on which to engage with contemporary experience.

> 'In the late summer of that year we lived in a house in a village that looked across the river and the plain to the mountains. In the bed of the river there were pebbles and boulders, dry and white in the sun, and the water was clear and swiftly moving and blue in the channels. Troops went by the house and down the road and the dust they raised powdered the leaves of the trees. The trunks of the trees too were dusty and the leaves fell early that year and we saw the troops marching along the road and the dust rising and leaves, stirred by the breeze, falling and the soldiers marching and afterward the road bare and white except for the leaves.'

'In the late summer of what year? *What* river, *what* mountains, *what* troops?' as Joan Didion would later wonder, confronted by the opening sentences of *Farewell to Arms* and the compelling strangeness of Hemingway's plain style, whose marriage of context, history, politics, with an intense focus on the materials to hand was a lesson with the broadest applications.

The tall young Californian of good breeding, Robert Motherwell had enrolled at Stanford in October 1932 to study literature, consumed as he was by art, music and writing. But in the middle of his junior year he switched to become a philosophy major. Perhaps because art departments were still the arch-conservative citadels of provincial values, or because the literature studied in universities was Victorian, and Motherwell was on the brink of discovering Joyce's *Ulysses*, or because the psychology taught at Stanford was stolidly behaviourist and vested in observable phenomena, whereas Motherwell was already interested in psychoanalysis and its perilous exploration of the unobservable. His senior thesis at Stanford would be a study of psychoanalytic theory in the plays of Eugene O'Neill, who happened to be one of his mother's favourite authors.

He also moved across to philosophy because in those days the Stanford philosophy department was small and concentrated. Motherwell sensed that for his purposes philosophy included everything, and that the study of philosophy transformed a large university into a small Socratic school. He took a broad range of courses, the most notable being contemporary philosophy. Here he encountered the writings of John Dewey, whose recently published *Art as Experience*, with its emphasis on direct experience as essential to artistic creation, would have an abiding influence on his thought, not dissimilar to the workings of Stein upon Hemingway. He called it 'one of my early bibles'.

Motherwell had realised two things about learning, for which he was both apt and avid. Firstly that contemporaries teach each other, which he would continue passionately to believe as a painter, and secondly that mentors matter more than teachers. What you were studying was less important than with whom you were studying it. This was as true of Stanford as it would be of Harvard, and the young Motherwell had a gift for finding the guides he needed at each step of his way.

Perhaps more significant than his brief encounter with the larger-than-life Stein, in the spring of 1935, a few months later he was invited to a cocktail reception at the home of 'some people who had pictures' in Palo Alto. This turned out to be Michael Stein, older brother of Gertrude

and Leo, who had himself recently moved back to the Bay area from Paris. The Steins were a distinguished Jewish family from San Francisco, who did more to support avant-garde painting than any other collectors or institutions in the first decade of the new century. Here the twenty-year-old Motherwell set eyes on the earliest important collection in America of works by Henri Matisse, the first twentieth century paintings that he had seen in the flesh. He fell for them at a glance, with an absolute sense of inner conviction, and later wrote that 'they went through me like an arrow, and from that moment I knew exactly what I wanted to do.' Throughout his life Matisse mattered to Motherwell more than any other modern painter.

Between the encounter with Gertrude Stein in the spring and with Michael Stein in the autumn, Motherwell and his sister were taken by their father on an extended tour of Europe for the summer of 1935, while their mother remained behind to oversee the restoration of a new country home in Marin County, California. After years of struggle, and Depression austerity, Motherwell senior was now in an established position as President of Wells Fargo Bank, and had never been to Europe. He decided to remedy this defect with a 'grand tour', to be repeated every five years. They started their first European foray in Paris, drifted methodically south to Amalfi, then all the way up into Switzerland, Germany, the Low Countries, followed by London and ending in Motherwell, Scotland, the place of their origin.

It was the first time the young Motherwell had seen the Mediterranean. A sunlit place, a drama of ochres and blues, a set of cultural ideas, and the historical origin of Western art. His sister and father were more drawn to Britain, Switzerland, Holland and Germany, where there was no counterfeit money, where the bathrooms were clean and the people well-organised. But Motherwell fell for France and Italy, 'where the food was better, the art was better, the people were juicier, the climate was sunnier.'

The suffusing light was also a memory of childhood and adolescence. Motherwell's father had a small vineyard in the Napa Valley, and Motherwell was formed by a landscape not dissimilar to Provence, or to the central plateau of Spain, or to parts of Italy and the Mediterranean basin. 'In such landscapes the colours are local, intense, and clear; edges are sharp, shadows are black.' So that Motherwell's at-first-sight love of the Mediterranean was the return of an earlier visual reality. In these physical conditions 'painting was not only something to love, its radiance meant *everything*'. Moreover, Cézanne and Matisse, his beacons in Modernism, had an upbringing in nineteenth century Provence that was not so dissimilar to that of Motherwell in pre-war California. Sunlit landscape, bourgeois placidity and inner torment.

What enchanted him above all about Southern Europe was the human scale, a relation between men, buildings and a cultivated landscape which seemed as ideal as the background of a Sienese painting. And this combination created something ordinary yet transcendent, a vision of pleasure as organic rather than accidental, and of society as a mutuality, organised so as to nurture well-being. It was an unforgettable lesson. Many years later he remarked in an interview that American Puritanism is averse to pleasure not on moral grounds but only on practical grounds, because pleasure takes time! A small distinction with large consequences for his sensibility, which remained otherwise unmistakably American, open, practical and full of common sense.

Motherwell senior was a connoisseur and a gourmet, but of an outward-looking cast of mind, entirely in the American grain. Interested in manufacturing, in agriculture, in modern methods

of doing things. Acutely aware that war was coming and, as an international banker, acutely concerned. 'In each place he would meet bankers, in London, Paris, Rome and so on, and would come back shaking his head saying "Europe is crazy. They're going to go to war. They all accept it as inevitable."' While he looked at Europe pragmatically, his son was looking at it aesthetically and humanistically. So it seemed a sign or confirmation, while wandering in Paris, that Motherwell should come across a copy of a book called *Ulysses*, published thirteen years earlier, in which he immersed himself for the remainder of the trip, to the exasperation of his father, a Modernist epic and a blueprint for the son's voyaging sense of where his future might lie, and where it did not lie.

On returning to Stanford he began an independent two-semester study of French Symbolism with poet and critic Yvor Winters, where he read for the first time the works of Baudelaire, Rimbaud and Mallarmé, all of profound importance for deepening his sense of the contexts of modern art, and in setting the terms for his own practice. He was also reading contemporary American poets such as Hart Crane and e e cummings, Eliot and Pound, Wallace Stevens and Marianne Moore. His room mate during the last couple of years at Stanford was Henry David Aiken, a philosophy major with whom Motherwell studied, and with whom he then moved to the graduate school of philosophy at Harvard. 'We taught each other. Each term we'd take a subject like *Ulysses*, or Hegel's *Theory of Tragedy*, *The Waste Land*, Russell's *Theory of Knowledge*. We'd both read all the books and then argue for ten weeks about whatever the subject was. It was a fabulous education.'

By April 1937, when he graduated, Motherwell had laid the groundwork for an informed understanding of modern art and its debates. A late starter in many respects, of intellectual habits and academic *formation*, he nonetheless came to art with some advantages over contemporaries who had found their calling earlier and perhaps more impulsively. His philosophical training, and interest in French Symbolism, would give him a sense of paintings as relational structures, and of meaning as a product of these relations, so that abstract structures can be seen as meaningful. Whether figurative or abstract was not the real issue. For painters with art-school backgrounds, on the other hand, to make the transition to abstraction was difficult, inducing a crisis of sorts, and requiring something like 'permission' or self-permission. There was a wall of doubt as to whether abstraction meant anything, whether such art could be the bearer of meaning. But as Motherwell said in retrospect, 'I was able to be an abstract painter right off the bat, if I so chose. Which I did.' More generally, the study of philosophy gave him the confidence to dismiss ideas that were *not* relevant to painting, and to focus on those ideas which could be 'played out' only in paint.

In January 1937 the New York art historian Meyer Schapiro published an essay on *The Nature of Abstract Art*, in the first issue of *Marxist Quarterly*. It was written in response to a catalogue introduction to the 1936 exhibition of *Cubism and Abstract Art* curated by Alfred Barr at MoMA. The show was intended to introduce and explain recent developments in European art to Americans, many of whom had never seen works by such artists as Picasso, Mondrian, Malevich or Kandinsky. Arguing against Barr's version of art as sealed off by its own logic, and arguing for the importance of historical context to understanding the internal story of art, Schapiro dismantled the opposition of figurative and abstract, considered as a choice between the passive mirroring of nature *or* a pure aesthetic governed by its own laws. He insisted that these are not distinct destinies, but that *all* form is shaped by experience – even the 'random scribbling of the hand'. The phrase is pregnant, if we think of Motherwell's lifelong investment in automatism. Schapiro situated abstract art amid the conflicts of modern history, and he highlighted the combative impulse that drives it. His essay explained, a decade in advance, why Abstract

Expressionism had to happen, and why it must happen in America. Its effect on Motherwell was salutary.

By now his European trip was two years in the past and the American graduation ritual was at hand, a major initiation rite. Motherwell's father was duly anxious to know where the twenty-two-year-old saw himself as heading next. Is it to be law school or business administration, doctor or banker? What do you want to be, and where do you want to learn it?

Nothing was clearer to the young man than that his future lay elsewhere, in an artistic setting, even if he had never known such a thing. But Motherwell senior had only one son. 'You're well-educated, you're well-dressed, you speak well, you get along with people well, you could have a marvellous career.' – 'I want to be a painter.' – 'That's impossible.' At the same time, his father sensed that the wish was real, and had been impressed by his son's apparent omniscience and unmistakable passion for the paintings they had seen together in Europe. The filial stand-off was eventually resolved, with Motherwell rejecting his father's offer of a well-paid job, during a world-historical Depression, and accepting his other proposition. That in return for going on to Harvard and getting a doctorate as 'insurance policy', enabling him to teach if all else failed, his father would pay him fifty dollars a week for the indefinite future, to do what he wanted to do. On the assumption that on fifty dollars his son would not starve but would have little inducement to persist. In which case the President of Wells Fargo Bank made a rare miscalculation. 'On that amount I spent ten years in New York, married, during the entire nineteen forties.'

In the autumn of 1937 Motherwell entered the graduate school of philosophy at Harvard. He had the good fortune to be assigned to study with Arthur O. Lovejoy, the distinguished intellectual historian who was a visiting professor that year, and with a charismatic young professor named David Prall, whose books had titles like *Aesthetic Judgment* and *Aesthetic Analysis*. A passionate teacher and active member of the Teachers' Union, Prall soon became Motherwell's mentor. But the most powerful presence in Harvard philosophy was undoubtedly the outgoing Alfred North Whitehead, who had just retired but was still lecturing at nearby Wellesley College. Motherwell attended this series of six lectures, which were published a year later as *Modes of Thought* and which made a profound impression on him. He would return to Whitehead's ideas throughout his life, and credited Whitehead above all others for preparing the way for his intuitive grasp of abstraction.

Motherwell took tutorials with Prall on Spinoza's *Ethics* and on aesthetics, but it was Lovejoy's year long history of ideas seminar on 'The Concept of Romanticism' that counted, and which led him to the *Journal* of Eugène Delacroix, only recently translated into English, as a senior thesis topic. By the spring of 1938, Lovejoy and Prall were encouraging him to spend a year in France to complete his work on Delacroix, and Motherwell needed little persuasion. He was miserable at Harvard, which was the first encounter of this Californian Candide with the East and its nuances, 'the subtle snobbism, the anti-Semitism, the Yankee Puritanism, the hierarchies, the formalities'. When he got to Paris in the autumn of 1938 it seemed more familiar than Cambridge and Boston, and more intelligible, despite his knowing barely a word of French.

Motherwell went to Paris to work on a thesis, and he got as far as amassing a substantial library on Romanticism. Instead of libraries, he enrolled in the Académie Julian, to have a context in which tentatively to paint, but found its academicism politely irrelevant to his needs, however obscurely

these were intuited. Then he spent several weeks overseeing the set design for a production at the American Little Theater, which convinced him to rent a studio on the rue Visconti and begin painting regularly. His time in Paris ended with a solo exhibition of sorts at the Raymond Duncan Gallery, in June 1939. The influences upon his work were firmly in evidence, laid out as on a stall, and included artists as disparate as Ozenfant, Signac, Laurens and Dufy. Perhaps more significant than the exhibition was his purchase of a small watercolour by Rouault, as dense and primitive as a woodcut, depicting a prostitute in black stockings.

Motherwell spent less than a year in France, until the summer of 1939, when his father insisted that he return to America as Europe geared up for war. Before Paris he had spent the summer in a *pension* in Grenoble, to improve his French, 'which remained awful', and where he met four English undergraduates. Before he returned to New York they now invited him to spend time with them in Oxford during the summer holidays. 'We all knew that war was going to start, and that they would be caught up in it. In fact all four of them were killed in the first year. It was a strange, tense, melancholy, beautiful time, those two weeks with those four guys.' Motherwell's time in Europe was infused at every turn with what the Spanish philosopher Unamuno called 'the tragic sense' of life. In Grenoble he went out with a Czech Jewish girl, who shortly before the Munich Crisis received a notice from the Czech government ordering her to return home. 'I remember putting her on the train and her weeping – and I am sure she never did survive the war.' Everyone he met lived under a threat of extinction that was strangely stirring for an American with an affinity for European realities but who had hitherto known only the vast shelter of a remote continent, and who would later remark on being 'profoundly moved by the continual presence of sudden death in Mexico.'

By the end of June the twenty-four-year-old was on the SS *Ile de France*, on his way back to New York. Returning to Harvard in early July he was offered a position by David Prall as his teaching assistant, but turned it down for the decision to paint, hoping that the commitment might translate into action. After that he spent time with his family in Washington State, where their friend the painter Lance Hart helped him to secure a one-year appointment as a teaching assistant in the art department at the University of Oregon, 'provincial as hell aesthetically, but very nice people'.

At Oregon he tried in effect to teach aesthetics, but the head of the philosophy department would have none of it, so Motherwell taught contemporary architecture and the history of modern art, and he continued to paint. Near the end of this time, under renewed pressure to plan for his future, he remembered that in Paris he had met an American composer named Arthur Berger who was studying with Nadia Boulanger, and who knew about Motherwell's pact with his father. 'Well,' he said, 'you're more interested in art, and your father doesn't mind what your Ph.D. is in, and at Columbia there's Meyer Schapiro who knows all about the things you're really interested in, so why not go to Columbia and study with Schapiro?'

'And so I did. And that's how I got to New York. And that was the end of my youth.'

In autumn 1940 he sailed from San Francisco to New York via the Panama Canal, having got himself accepted provisionally in Columbia University's graduate programme in the Department of Art History, and took an apartment on West Eleventh Street. With Meyer Schapiro he studied Romanesque sculpture and European painting since 1860. Schapiro was a myriad-

minded scholar with a photographic memory, an authority on the Romanesque whose interests encompassed mathematics and politics, the classics, psychology and psychoanalysis, Hebrew studies and philosophy, contemporary art and aesthetics. A historian of imagination and deep erudition, he had an unshakeable belief in art and its centrality to human affairs, was a convinced though independent socialist, and as a teacher was hypnotic and inspiring. In art historian Irving Sandler's words 'Two or three minutes into a lecture and he would seem to levitate several inches off the floor'.

Motherwell seems to have found the Schapiro experience a little overwhelming, pedagogically, but he remained enduringly grateful to Schapiro as an individual, not least for being the spur to his coming to New York, which otherwise it would not have occurred to him to do, and at precisely the right moment for an aspiring modern painter, when the city was filling up with European émigré artists of all persuasions. Intensely lonely in the city, Motherwell kept painting and, in his far western innocence, having no idea of how busy celebrated New Yorkers were, he would sometimes knock on Schapiro's door late at night, as they were close neighbours in Greenwich Village, to show him work in progress.

Finally Schapiro, no doubt exasperated, decided that Motherwell was clearly determined to be an artist rather than an art historian, and suggested introducing him to some actual practitioners. 'It takes me two hours to tell you as best I can what any painter could tell you in ten minutes.' Schapiro had a wide connection among contemporary artists in New York, particularly the Europeans:

> So, he said, 'You're really a painter at heart. You need to meet some artists.' So I said (making it clear that I wanted nothing to do with social protest painting, or Regionalism, or naturalism in any form), 'Well I'd want to study with a modern artist.' So he said, 'Well you should meet the Surrealists.' And I said, 'But I don't like Surrealism' (thinking of its academicism). Then he said, 'Well I can understand that. But you like the Symbolist tradition in France, and they're the latest flowering of that. And you're interested in ideas, and they're interested in ideas.' So he introduced me to one of the Surrealists, who spoke English very well. And I realised that they were an entire Parisian clan, and that sooner or later you would meet them all.

It was a generous and shrewd suggestion. The artist in question was the Swiss Kurt Seligmann, the first European Surrealist to arrive in New York, with whom Motherwell now started to study engraving. It was a pretext, mutually agreed, to help him enter a little into the French milieu. He saw Seligmann twice a week for the following six months, paying twenty-five dollars a week, half of his disposable income. The path led to André Breton, but also to Max Ernst and Marcel Duchamp, to André Masson and Yves Tanguy, and further afield to Fernand Léger and Piet Mondrian. 'The Surrealists were the most closely-knit group of artists I think that has probably ever been. If you knew one – as I did, working in Seligmann's studio – presently every one would pass through.'

These artists were more than merely emblems of art. They were, as Frank O'Hara put it, 'emblems of experience'. For a slightly younger generation than Motherwell, 'World War II was simply part of one's life. One went to war at seventeen or eighteen and that was what one did, perfectly simple.' Modern artists were the witnesses and natural enemies of the authoritarian state,

and their exile was an exemplary modern condition. In particular, the relations of individual Surrealists to each other were intricately structured and ideological, as well as personal. It was 'a complicated system of ideas and attitudes, having to do not only with art, but ramifying into politics, psychology, poetry, painting, chance, magic, tarot cards, in fact a whole vision of life', as Motherwell later remarked. And the young Motherwell soon found a small but important liaison role within this group of displaced persons, who were in varying degrees nonplussed by the brave New World in which they found themselves. Being a native, but imbued with French culture, he was in a position to help, to explain what was puzzling, to provide frames of reference.

American artists generally held back, out of wariness or jealousy, since many of the Europeans were already held in high esteem by gallery owners or dealers and critics, and already established in their careers – were in their own 'voice', as Motherwell would say. And whereas Americans tended to go their own ways, the Europeans were curious, gregarious, and encouraging to younger painters. In fact, the Surrealists were proselytisers with a particular investment in the notion of youthful genius. Their heroes were Rimbaud, Lautreamont, Seurat, all of whom died young, or the early de Chirico, whom they thought of as peaking while young. And Motherwell as a westerner possessed one additional and inestimable attribute: he took everyone at face value, which helped him as a go-between among Europeans and Americans in New York. 'I was relatively unsuspicious, among suspicions on both sides.'

The Surrealists were a tribe, with their own rituals. Two or three times a week they all had lunch together in a cheap restaurant on Fifty Fifth Street. They roamed the streets together. They edited magazines together. They shared an ideology which overcame individual differences, at least temporarily. No doubt the war and the displacement from Europe made their cohesion last longer, even if in the course of things it also rendered Surrealism obsolete. Plus the personality of Breton as undisputed arbiter. At one gathering Motherwell asked Max Ernst to define Surrealism. Ernst pointed at Breton and said: 'That is Surrealism'. The Prospero of their floating island, Breton would march his crew of survivors into the lost world of Third Avenue junk shops, requiring them to declare on the spot which object among the brass beds, curios and broken cabinets was 'the essence of Surrealism'. Decades later Motherwell recalled with panic the effort to overcome his aesthetic conditioning. 'My mother's passion was antique-collecting, after all, and I had learned to look at the world aesthetically or as a connoisseur. From a Surrealist standpoint this was to be a dilettante, a castrato, a blasphemy.'

The Surrealist who mattered most for Motherwell, and who was closest to him in age, 'we were in our twenties, they were in their forties', was Matta, whom he met in spring 1941, at a lecture given by the young British painter Gordon Onslow-Ford. Treated as a loved but wayward son by the Surrealists, Matta was 'the most energetic, enthusiastic, poetic, charming, brilliant young artist that I've ever met', and he would have a galvanising effect on Motherwell and on others of his generation. As a Chilean in New York, Matta was another natural go-between among Parisians and Americans, added to which were his natural enthusiasm, his good English and American wife, his upper-class confidence and irrepressible openness. He seemed to know everyone who walked the streets of wartime New York.

Photograph of Maria Motherwell by Erwin Blumenfeld, "Marua," ca.1941, Gelatin silver print, 20 x 16 inches. Dedalus Foundation Archives.

1948: The Voyage Out

Part I: Mexico

June 1948 may well be the most important moment in the career of Robert Motherwell as painter. With all its fits and starts and with all the transgressions, he would now finally reach his first true great pinnacle and to most of the art world cognoscenti, his finest painting. But first of all the road had to be travelled.

So, before the sensational moment of the summer 1948, there was 1941.

Matta and Motherwell quickly became friends, meeting frequently during the spring of 1941, at which point Matta was desperate to get out of America for the summer, where the talk was only of war. It was finally arranged that a small group would go to Mexico: Matta, his wife Anne, and Barbara Reis, another protégé of Seligmann and teenage daughter of collectors Bernard and Rebecca Reis, who hosted a prominent salon for the European artists in New York. Originally Seligmann and his wife were to be in the party, but in May 1941 France fell to the Germans. The Seligmanns, who were Swiss Jews, were tormented by anxiety about their relatives in Europe. Nobody knew if the Nazis were going to invade Switzerland. To be out of telephone contact with Europe was unthinkable, and they decided not to go.

Motherwell accepted, to his father's chagrin, and they sailed on June 7th by way of Havana where they paid their respects to the Cuban Modernist Wilfredo Lam. This voyage was Motherwell's own rite of passage, or wager. It proved to him that he had in effect dropped out of Columbia to pursue painting full-time, and that in so doing he had finally moved out beyond his family and into uncharted waters. The urgency about going to Mexico at this moment was to be close to Matta, who had temporarily become Motherwell's guide, and his most important to date. 'In the three months of that summer of 1941, Matta gave me a ten-year education in Surrealism.' And there was something seductive about Matta's pied-piper mobility, his contradictions, his aristocratic Marxism ('Neruda in a Mercedes-Benz') and sheer frivolity. 'There was in Matta a streak of sybarite, of Chanel, of Catholic decadence, a fascination with the idea of sin,' that was both mysterious and irresistible to a young American who at this point felt stiff, Protestant, clumsy, depressed and un-socialised. 'Joyless', to use Motherwell's term.

The second reason for going to Mexico was Motherwell's new passion for the Mediterranean. The war was on, and Mexico presented itself as a surrogate for Europe, although it turned out to be something far different, indeed a separate reality.

On the third day on board ship he met Maria Emilia Ferreira y Moyers, an aspiring Mexican actress who was travelling back home to obtain a divorce and visit relatives in Mexico City. Motherwell instantly fell in love. She was a quarter Portuguese, quarter Spanish, quarter German and quarter Mayan Indian, with the characteristic cheekbones, rope-like black hair and slender legs. On their arrival in Mexico City Motherwell began painting *La Belle Mexicaine,* his earliest mature oil painting, and it was in Mexico, with a newly crystallised sense of direction, that he began to paint for his life.

In the months that followed, he created the ink drawings in the so-called *Mexican Sketchbook*, his first engagement with the fearful freedoms of automatism. But he also apprenticed himself to Mexican reality, instructed by Matta's enthusiasm for popular culture and folk art: papier-maché bulls filled with fire-crackers, brightly coloured objects made from wood or tin, skulls in spun sugar, masks and fetishes. And all things made of paper, which was already one of Motherwell's obsessions and would be the material of choice for so much of his art.

His immediate response was to the colours themselves, as entities, which became the colours of his inner eye. The warm earth colours, but also the shocking folk colours of Mexican Indian art, magenta, lemon yellow, lime green, indigo, vermilion, orange, pink, deep ultramarine blue. And black, of course, for Motherwell was preternaturally receptive to the darker aspects of Mexican reality, the pervasive iconography, the presence and vitality of death in the folds and textures of everyday life. Shortly after arriving there he wrote a remarkable letter to Seligmann about encountering a child's funeral procession, as if through Mexican eyes, described with intuitive acceptance. 'One evening at dusk we were on the highway, and we came over a hill suddenly to a little Indian procession. They were wearing flimsy white cloths with flowers in their hair, and carrying white candles which burned brightly in the grey light, like fireflies; and in the centre was a tiny white pine coffin covered with flowers. A couple of Indians were playing little tunes (like you hear at carnival sometimes) on strange instruments; the whole funeral was like a child's conception.'

His attention sharpened by his interest in Maria Ferreira, Motherwell also immersed himself in the history of the Mexican revolutionary struggle, which, by an intricate personal logic, he came to link with the defeat of the loyalist cause in Spain in the late thirties, 'that perfect mirror of all that was confused, venal and wrong', in Frank O'Hara's words. He had heard André Malraux speak at a mass meeting held in San Francisco in 1937 to raise money for the Republican cause, and never forgot 'his crumpled tailored suit, his Gauloise hanging from his lips, his weary intensity, his eloquent appeal for an end to neutrality'. The young Motherwell was equally affected by seeing Eisenstein's film, *Thunder over Mexico*, which played in New York in September 1940, or, slightly later, by the graphic photographs of victims of the revolution in Anita Brenner's *The Wind that Swept Mexico*, which he described as his 'constant companion'. His response to Mexico, 'I've never seen a race of people so heedless of life!' has its echo in the poet Lorca's description of Spain as 'the only country where death is the national spectacle'. These realities would yield some of Motherwell's paradoxically confident imagery on returning from Mexico, his first original works, not least in the medium of collage.

At the end of the summer the Mattas and Barbara Reis left for New York. Motherwell and Maria Ferreira moved to Mexico City at the invitation of the Austrian Surrealist Wolfgang Paalen, who was living there, and to whom Motherwell had been introduced by Matta. For many European writers and artists Mexico City was an alternative *capitale de la douleur* to New York, part of the cultural drama of European exile in the Americas during the war. Paalen was an intellectual, like Motherwell, who later said of him: 'It was with Paalen that I got my postgraduate education in Surrealism, so to speak'. This included translating from the French Paalen's essay *The New Image* for *Dyn*, the adventurous journal representing Paalen's circle of Mexican painters and photographers. Paalen subsequently renounced Surrealism, as would Motherwell, advocating automatism as merely the raw material for abstract art, arguing that it must be further shaped to be fully expressive, and anticipating in effect the transition from Surrealist ideas to what would became the underlying terms of Abstract Expressionism.

Motherwell's Mexican education in Surrealism was his initiation into 'psychic automatism', whose improvisatory practices radically loosened his ideas of what art could be and how he could make it. What the Surrealists called automatism was a form of magical thinking, or enhanced subjectivity, whose doodling or scribbling was characterised by Saul Steinberg as 'the brooding of the hand'. What Motherwell learnt in Mexico was that the core of all Surrealist activity was not the bizarre, or the morbid, or shock as such, but rather the practice of what the Freudians called free association. He was especially alert to such possibilities, because he had a psychoanalytic background and understood its implications, and not least as a means of escape from childhood terrors. He would later write that 'automatism is the dark wood through which the path runs.'

Pancho Villa, Dead and Alive, 1943
Oil, gouache, pasted wood veneer, pasted papers, and ink on paperboard
71.1 x 91.1 cms / 28 x 35 $^{7}/_{8}$ ins
Museum of Modern Art, New York

Part II: The Return to New York

In November 1941 Motherwell and Maria returned to New York and rented an apartment on Perry Street in the Village, which would also serve as a studio, not far from where Matta lived. The consolidation of Motherwell's 'life and contacts' in New York now proceeded apace. As well as the unprecedented convergence of artists, by the early forties more modern art could be seen in New York public collections, much of it abstract, than anywhere else in the world. From as early as 1929 the MoMA was showing French modern artists, while the Solomon R. Guggenheim Museum, later renamed the Museum of Non-objective Art, showed Kandinsky, Klee, Mondrian and others. There had been a Picasso retrospective in 1939, and more recently a retrospective of the Catalan painter Joan Miró, at this time detained in Franco's Spain, who was to be a decisive early influence on Motherwell's thinking, if not his practice, and for whom he always reserved a special place as being, in Motherwell's always exact sense of genealogy, 'the most original artist in the world between 1924 and 1929'.

The unprecedented congruence of works and their makers in New York gave the city at this moment its eerie sense of historical urgency. So Motherwell became aware of Mondrian's paintings for the first time and then almost simultaneously met Mondrian himself. He then went to see Mondrian's first one-man show, held in his seventieth year, at the Curt Valentin Gallery, 'nearly a dozen times, almost against my will'. His understanding of modern art and its premises was being daily expanded, in quantum leaps. His earliest important works date from these months and include *The Little Spanish Prison*, a deceptively simple composition of slightly irregular vertical stripes, interrupted by a single horizontal bar of red, its colours inspired by what he had seen of Mexican folk art, and already reflecting a desire to reconcile Surrealist automatism with the plastic integrity of Mondrian's work.

Through the ministrations of Matta he now encountered a new mentor, the collector and dealer Peggy Guggenheim, also lately settled in New York, having left Paris the previous spring, days before the German invasion, and bringing with her a collection of hundreds of contemporary works as well as her future husband Max Ernst. Equally important, in December 1941 Matta introduced Motherwell to the young William Baziotes, who became his closest friend and ally among American painters during the forties, and the crucial bridge to American artists. 'Matta introduced us. Baziotes was from a Greek immigrant family from the ghettos of Reading, Pennsylvania. He trained at the National Academy, looked like George Raft, and was interested in gangsters. We couldn't have been more different but we got along like a house on fire.' Motherwell had been in the strange position of knowing many European artists in New York but few if any Americans. Through Baziotes he now met de Kooning and Pollock.

It was Baziotes who encouraged Motherwell to take Mondrian on a couple of occasions to Harlem because Mondrian loved jazz and they would all dance to the early hours.

As a measure of his honorary membership of the European diaspora, on the other hand, Motherwell was asked by Breton in November 1941 to serve as American editor of *VVV*, a fledgling magazine of the Surrealists in exile. Shortly before publication he was fired, or quit, having fallen foul of Breton, who for good measure declared that Motherwell's French was not up to the mark, yet whose own English was more or less non-existent, which enriched

the possibilities for misunderstanding. But the first issue in June 1942 nonetheless included Motherwell's *Notes on Mondrian and de Chirico*. It was his earliest publication, and a sign of his aptness to become the most theoretically fluent and literate artist of his American generation.

War was coming closer and on December 7th it arrived, at once remote and viscerally close, with the deaths of over two thousand sailors, soldiers and civilians at Pearl Harbor. Conscription was stepped up, and Motherwell was called before the Greenwich Village draft board in spring 1942. He failed the medical because of his history of chronic asthma, and was classified as 'physically unfit for service'. But he had already insisted to Maria, on receiving a low draft number, that they get married, if only to secure her position as his legal heir.

They were married in Provincetown in August 1942. In his essay-memoir, *Provincetown and Days Lumberyard*, Motherwell recalled the atmosphere of that summer when they rented a house on Commercial Street before marrying. Blackout curtains, lights prohibited at night, air-raid drills and FBI intimidation of foreigners. 'The claustrophobic silent dark of those World War Two nights remains with me like a black stone. So does the Depression poverty of the town as it then was – the peeling paint, askew shutters, holes in roofs, primitive stoves and occasional kerosene lamps – as well as my own poor means.'

But Peggy Guggenheim and Max Ernst had arrived as a couple in late July for a prolonged stay in Provincetown, and the Mattas moved into neighbouring Wellfleet. In this anxious but convivial atmosphere the friendship between Motherwell and Guggenheim blossomed, until the FBI forced Peggy and Ernst to cut short their stay and return to New York, after briefly arresting him for failing, as a registered 'enemy alien', to declare his movements during that summer. The Motherwells returned to New York in the autumn and took an apartment on West Eighth Street, which was to be their home until 1945. They would often visit the Guggenheim townhouse, where many artistic currents crossed, and where Motherwell now met Marcel Duchamp. Examples of Motherwell's work were included in *The First Papers of Surrealism*, a small exhibition at the Whitelaw Reid Mansion in October and November, organised by Breton and Duchamp. It was the first exhibition in New York to include his work, as well as works by Alexander Calder and Joseph Cornell, whom the Surrealists already admired and had baptised into their church.

At this point Matta started hosting subversive sessions in his apartment on Tenth Street, where he tried to demonstrate and encourage automatist experiment to a group of young American painters. The sessions were held over several months beginning in the autumn of 1942 and Motherwell took them very seriously, acting as go-between and spokesman for the recruiting of new members. Matta had what Motherwell described as an Oedipal relation to the Surrealists. The son and heir apparent, he was also looked upon with a certain wariness, rather as the trickster Hermes is treated by the gods on Olympus. Matta in turn decided, half-playfully, to show up the Surrealists as a group of superannuated Olympians out of step with contemporary reality. To achieve his palace revolution and prove his point decisively, he needed to nurture an alternative artistic manifestation and manifesto.

He asked Baziotes to gather some likely young Americans with an interest in abstraction. Baziotes suggested a thirty-year-old mid-westerner named Jackson Pollock, and a Dutch expatriate named Willem de Kooning, among others, all of whom were on the payroll of the WPA's Federal Art Project. The WPA was part of Roosevelt's New Deal, which from the mid thirties had employed

the most gifted American artists to produce the most reactionary figurative art, often verging on Social Realism. In several lengthy sessions Matta, Motherwell and Baziotes patiently explained to Pollock the Surrealist position in general and automatism in particular. Pollock listened intently. De Kooning was less interested, although he became intrigued by the possibilities of automatism much later. Matta's clearest success was with Arshile Gorky, a year or two later, for whom automatism gave sudden and dramatic access to his distinctive lyrical gift, and released him from the cycle of imitation – 'passé Picasso' – to be the strikingly original artist he now became.

Motherwell was equally convinced that automatism was not a *style*, in the sense of an imitation of European styles, but an original unifying principle as had seemed lacking so far in American Modernism: a process, or in philosophical terms a revelation of 'being', preceding all aesthetic decisions. Those came afterwards, according to the shaping spirit of each individual artist, in the same way that what was 'American' could now perhaps be left to look after itself. As indeed it did, in the scale and energy of what was unleashed in New York in the late forties. Artists began to work more directly, more graphically, and on a larger scale than the Surrealists had done. Equally important, they began to have reasons for meeting and coming together. In a sense automatism was a European lesson for America, and a gift from Paris to New York in return for sheltering its men in dark times.

This form of uncovenanted brooding liberated Motherwell into making his first significant works. In a complicated image he later described his aspirations at this time as 'a vision of the Parthenon in the midst of the gothic novel that I was then living among the Surrealists.' Reflecting on the lessons of Paalen, in particular, he had reached the early conclusion that Surrealism, or Super-Realism as he preferred more accurately to translate it, was 'the born antagonist of abstract art'. Even Matta was mostly interested in the discovery of figurative forms within the automatist material, preaching that the initial marks need to be elaborated subsequently in figurative directions, and that whatever is unassimilable from the original impulse must be suppressed.

Surrealism certainly thought of itself as anti-aesthetic. Breton's definition in the first manifesto had included the phrase 'without *a priori* aesthetic or moral preoccupations'. Art was a secondary symptom or by-product, vision and ideology took precedence over paint. The point of automatism for Motherwell, as its first American adept, was that it could reconcile the least dogmatic and most receptive aspects of the Surrealist outlook with a commitment to painterly values, formal order, and a new openness to abstraction. He wanted to establish a connection between contingency and control, the involuntary modified by the voluntary, which for the Surrealists proper was a heresy as well as a contradiction in terms. Motherwell was interested in 'plastic' rather than psychic automatism, and now realised that he must come to terms with the formal achievements of Cubism, replacing its conventions of subject matter by a new and unformulated subject. Even if Picasso never went completely over to abstract art - nor did Braque - Cubism was the fountainhead of abstraction. In a sense, Miro, whose relations with the Surrealists were always uncomfortable, was the figure who showed that such a reconciliation of opposites was viable, which is why Motherwell described him from the vantage-point of 1965 as 'the godfather of modern American painting'.

As important as any new theory for unifying American artists and curing their sense of invisibility, was the increasingly visible fact of Peggy Guggenheim, who in October 1942 opened her small midtown gallery-museum-salon, *Art of This Century*, with its bespoke interior design, concave

walls and protruding wooden frames in the middle of the gallery space, giving an oddly free-floating effect to the exhibits. The Gallery was her passion rather than her business. As a result it had, in Motherwell's words 'an aristocratic and unbourgeois tone'. She also acted intuitively upon the enthusiasms of the remarkable individuals who surrounded her, such as Duchamp or Ernst or Alfred Barr. Here Motherwell began to see more and better abstract pictures ('a white Picasso which she told me Max Ernst persuaded her to buy, a beautiful brown Miró . . .') and here he was able to take the full measure of Mondrian's art, which gave him the sense that painting could be expressive in painterly terms without being expressionist in psychological terms.

Prior to Peggy Guggenheim, collectors and curators were reluctant to take seriously the notion of the contemporary American artist. Conversely, the Europeans were taken up and courted in closed session by the art establishment. As a result their main contacts with America were with smart dealers or Park Avenue hostesses. Rather than reducing their isolation, as unhappy and often despairing exiles in a foreign continent, many of who could barely speak English, these privileges exacerbated it, and made American artists shy or stand-offish towards their European counterparts. Motherwell later thought of this as a golden historical opportunity that was largely missed. 'There were twenty (I would think) celebrated European artists here during the war, and anybody who wanted to could join them walking the streets. Very few wanted to.'

The remit of *Art of This Century* was to show new work, whether by émigrés or natives, alongside Peggy Guggenheim's collection of Old World Cubists and Surrealists, and one of her earliest impulses was, at the suggestion of Duchamp, to curate the first exhibition in America dedicated to the medium of *collage*, a theme she had already explored in her earlier London gallery, Guggenheim Jeune.

Collage had been introduced by the Cubists and pursued by the Surrealists, admittedly, in the latter case, as an act of defiance against painting. The New York show must of course include the likes of Schwitters, Ernst, Arp, Gris, Picasso, Braque, Henri Laurens and Miró. And André Masson, who had produced beautiful and forward-looking collages in the late twenties, 'a fairly blank canvas with a few automatic lines and very often feathers or something like that pasted on', as Motherwell remarked. Guggenheim now suggested to Motherwell and Baziotes and Pollock that they too might try their hands, and if she liked what she saw she would include it.

None of her novices had worked in this medium, although Motherwell had seen some of Arp's collages in New York, and Miró's Surrealist collages, which combined an improvisatory content with a Modernist concern for abstract form, had recently been shown in his MoMA retrospective.

So intimidating was the prospect of exhibiting alongside the European masters, and so unfamiliar the task, that Pollock asked Motherwell in his diffident way if they might work together in Pollock's better-equipped Eighth Street studio. Pollock set to work with salutary violence, which included burning his collage with matches and spitting on it, and Motherwell produced two rather more polite attempts during the same session. It was perhaps the first time that two New York artists had witnessed each other's procedures. Motherwell was dismayed by the violence of Pollock's means, but he found the rhythmic intelligence and concentration that Pollock brought to his work inspirational, and it encouraged him afterwards to work in a more unrestrained manner. Matta examined Motherwell's first efforts and was intrigued enough to remark: 'If you can do them that well small, why not do them bigger?' It was a casually provocative response,

and in the weeks that followed Motherwell created the large and ground breaking *Joy of Living*, a compound of ink, gouache, oil, crayon, graphite, pasted Japanese paper, coloured paper, construction paper, printed map, and pasted fabric on paperboard. Guggenheim included it in her exhibition and it was acquired for the Baltimore Museum of Art, the first work by Motherwell to enter a museum.

The Joy of Living is a moody and violent collision of ink and perspectival geometry, punctuated by a scrap of military training map, itself a splintery shard of Europe at war. Reviewing the exhibition, Clement Greenberg pronounced that 'the big smoky collage *Joy of Living* – which seems to me to hint at the joy of danger and terror, of the threats to living – points to Motherwell's only direction, if he is to realize his talent, of which he has plenty.' Neither Pollock nor Baziotes were at ease with collage, but for Motherwell the experiment was a happy and extraordinary revelation. 'I took to collage like a duck to water', and he described it as 'the greatest of our discoveries' in an essay written the following year, *The Modern Painter's World*, published by Paalen in *Dyn*. The new medium became a beacon for his painting, and an integral aspect of his work over five decades.

Like the Surrealists, who ransacked the cultural world for untutored talent, Peggy Guggenheim had successfully encouraged her young Americans and now decided to give them each a one-man show. She invited Motherwell to exhibit the following spring, but he declined, feeling that his work was unready. Following the collage exhibition, in May 1943, he now travelled with Maria to Mexico for a planned six-month stay. But in mid-August he received word that his father was gravely ill with an aggressive and recently diagnosed cancer, and he immediately returned to San Francisco. His father died shortly afterwards, on August 29th.

On his return to New York Motherwell created a series of bold and dramatic works which filtered personal events through a public or historical lens. Collage in particular, with its shock tactics, its glancing references, its use of bits of material that make up the world, seemed to offer ways of grappling with anxieties ranging from grief to the conduct of a world at war. The 1943 collage-painting *Pancho Villa, Dead and Alive,* produced immediately after his father's death, is based on a specific image of death, a 1923 photograph of the corpse of Villa, the assassinated Mexican revolutionary. The body is shown twice, in cartoon-like form, firstly daubed with blood-coloured paint and dead, and secondly, alive against a sheet of patterned German wrapping paper. At the same time, and apparently remote from the turbulence of such images, Motherwell produced the cool and enigmatic *Mallarmé's Swan*, whose discreet intensities speak for something other, more condensed and oblique. Its original title was *Mallarmé's Dream,* but Joseph Cornell ('with whom I shared in those days a lonely preoccupation among American painters with French Symbolism') misremembered the title as *Mallarmé's Swan*, which Motherwell preferred. Whether in this work or in the *Pancho Villa* collage, the indirect route of the Symbolists was the one that Motherwell instinctively preferred to follow.

His easy acceptance of 'accident' would serve him in good stead. In its shifting, protean resourcefulness, collage suited the adaptive core of Motherwell's sensibility, which started out and would remain tentative and speculative rather than dogmatic and certain of itself. One of his grounds for distrusting Surrealism had been its chill formality in the rendering of dream-furniture, its academic transcription of the horrors and marvels of the unconscious. One might say that his spirit was revealing itself to be more in tune with Dada, and that chance worked

differently for the Dadaists than for the Surrealists. In Surrealism, the chance gesture is generated internally by the individual unconscious, and Breton tightened the bond between the self and chance with practices such as automatic writing. Dadaist chance on the other hand was more external and implicated with the world: seizing opportunities from outside the self and arranging them in one's personal manner, which was to become Motherwell's manner, in what Arthur Danto called his 'wooing of spontaneity'.

It was at this point, in the autumn or winter of 1943, that Motherwell and the bookseller George Wittenborn decided on a series of affordable paperback editions of key writings and primary texts by modern artists. Wittenborn asked Motherwell to edit the series, which they called *Documents of Modern Art*. They would publish eleven titles, including volumes by Kandinsky, Mondrian, Ernst, Moholy-Nagy. Motherwell's involvement was the start of five decades of editorial work. He volunteered to edit a volume dedicated to the Dada painters, as part of his effort to teach himself Surrealism and its historical origins systematically. With his patient care in such matters, he would work at this project for the next seven years.

A year after she opened Art of this Century Guggenheim gave Pollock his first one-man show, followed by Baziotes in October 1944 and Motherwell the following month. *Robert Motherwell: Paintings, Papiers Collés, Drawings*, with a catalogue essay by James Johnson Sweeney, curator of MoMA. 'It was here,' Motherwell would write, 'that I found my identity.' The exhibition showed seven of his oil paintings, six collages, two etchings and thirty-three works on paper. The collages sold out, and the response to the show, commercially and critically, surpassed all expectations. Greenberg's review concluded: 'Motherwell has already done enough to make it no exaggeration to say that the future of American painting depends on what he and a comparatively few others do from now on.'

He had at this point been a working artist for less than five years.

In January 1945 it was Mark Rothko's turn. While he was hanging his exhibition Motherwell came into the gallery and they met for the first time. Another link in the chain reaction of alliances or 'network of awareness' was forged. A grouping of New York artists was beginning to form, however loose, with no name, and even less sense of unity or purpose. The loners had become a group of loners. Now there was an 'us', and Motherwell, finally assimilated as a New Yorker, had quite naturally emerged as an energetic and articulate spokesman, and in many senses a common link, however little they might think of themselves as having formally in common. 'In those days everybody needed explanation, and because I was the most educated of the American artists I became the guy who inevitably wrote whatever had to be written. And also probably I believed more in words than the others.'

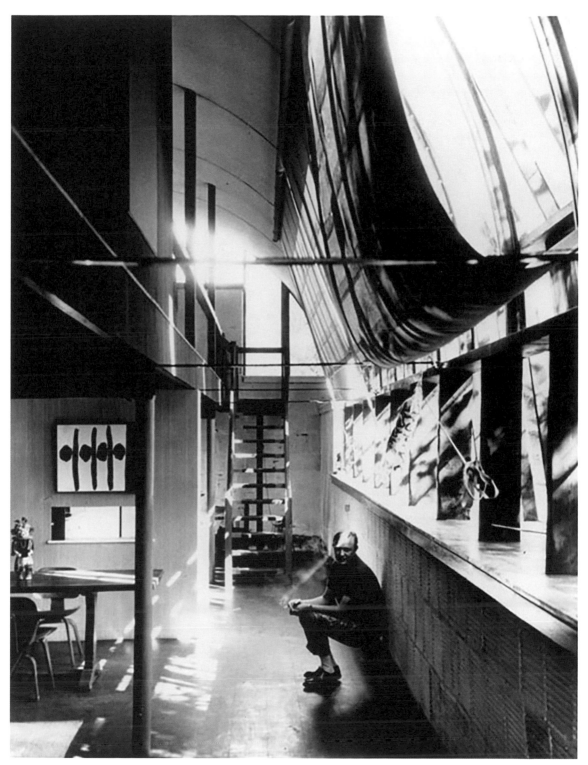

Motherwell in his East Hampton house, 1950. On the wall is a painting from the *Elegy to the Spanish Republic* series. Dedalus Foundation Archives.

Part III: We Band of Brothers

You had your searches, your uncertainties,
And this is good to know – for us, I mean,
Who bear the brunt of our America
And try to wrench her impulse into art.

— Ezra Pound, 'To Whistler, American'

We were not sure if what we were making was art

— Robert Motherwell

Motherwell spent the summer of 1944 in Amagansett, on Long Island, near to an assorted group of artists and writers thrown together by wartime circumstances. Here he was introduced by Anaïs Nin to a French architect in exile, Pierre Chareau, whose glass-facaded *Maison de Verre*, constructed between 1928 and 1932, is a work of unclassifiable and visionary Modernism, tucked away in a Parisian courtyard. Now a penniless émigré, Chareau was quite unknown in America. Motherwell befriended him and would characteristically entrust him with the design of a house on a two-acre plot which he was to purchase in East Hampton the following year. When they met, Chareau was sixty and Motherwell twenty-eight. Chareau knew scarcely any English, and Motherwell's French was that of 'a small child'.

Motherwell's gesture was inspired, and their collaboration was an innovative experiment in low-cost construction, despite taking a year to build and running wildly over budget. Chareau was fascinated by the possibilities of the Quonset hut, a prefabricated structure developed during the war by US navy architects, made from curved steel ribs and corrugated roofing, easily assembled and inexpensive. Motherwell purchased two surplus Quonset kits, along with thirty-six foot of salvaged commercial greenhouse windows, and Chareau set to incorporating these into the design of a house and studio. Structural elements were left exposed, and the crossbeams were painted the same bright circus red as Motherwell's acquaintance Alexander Calder had used on his sculptures. It was a marriage of the needs of the moment - a small budget, a scarcity of building materials, and a desire to do something unabashed with industrial structures. At one stage, when the costs had soared from the estimated 7000 dollars inherited from his father to a final 27,000 dollars, Motherwell expressed regret at having got them both into such an impossible economic situation, before being eventually and reluctantly bailed out by his mother. With tears in his eyes, Chareau replied vehemently: 'Regret nothing! You alone have given me life in America!'

The result, 'like living inside a Calder', was a flowing and multi-level hybrid home and workplace, by turns makeshift and perfectionist, alluding both to Chareau's Parisian Machine-Modernism and to the reality of war, the decommissioned naval base Quonset structures. With its cool surfaces, its charged undercurrents and its being 'inspired by its materials', the house was itself one of Motherwell's most successful collages.

As the first modern home in the Hamptons it attracted attention when it was finished in September 1947. Chareau's fee was for Motherwell to let him build a small cottage on the property for himself, named 'la petite maison de repos', using surplus materials from the main house. They were by now close friends, but three years later Chareau was dead, quite suddenly, from a cerebral haemorrhage, leaving Motherwell bereft. He said later that it was 'worse than losing a father', having recently lost a father, and he would subsequently move out of the house and away from East Hampton, to resettle in Provincetown. It was one of his characteristic gestures, a respect for chance and its consequences easily misunderstood as chronic restlessness. The house was sold a year later to the legendary Barney Rosset, who owned Grove Press, publisher of Samuel Beckett and many other literary greats. The house was eventually destroyed in 1980 after years of neglect. Motherwell once remarked that he painted the best pictures of his life there, and the Chareau house was indeed one of the crucibles for his Spanish *Elegy* series. Responding in 1984 to a French correspondent at work on a monograph about Chareau, he said: 'I never doubted Chareau's genius, his poetic sense, his total integrity, and a sweetness of character and *gentilesse* that are not describable. I only regret that being so young I did not fully comprehend that Chareau was the kind of man that one encounters very few times in a lifetime.'

In a sense, the *Elegies* grow out of this moment of bricolage, and a combined sense of aftermath and of on-going catastrophe, a shoring of fragments against ruin, on the margins of America. The post-war mood of the late forties was exhausted but apocalyptic, as if another conflict were just beginning, this time specifically American. The weapons testing carried out on Bikini Atoll in the Marshall Islands in July 1946 was indeed the largest peacetime military operation in US history, requiring a retinue of forty thousand personnel and inaugurating a decade of controlled thermonuclear tests, each of which was obsessively documented. Over a million feet of motion picture film were used, and more than a million photographic stills taken, causing a worldwide shortage of film stock for years to come. The saturation of everyday life with iconic images of destruction was accompanied by a colonising of ordinary language: 'mushroom cloud', 'cauliflower head'. The age of anxiety in its newest, blandest, most frightening guise.

The critic Dwight McDonald referred to a normalising of dread as the only possible sequel to Hiroshima and its aftermaths, a future-present in which peace was war by other means. 'The Bomb is the natural extension of the kind of society we have created. It is as easy, normal and unforced an expression of the American Way of Life as electric iceboxes, banana splits and hydramatic-drive automobiles.' Spick-and-span kitchens, an emergent drive-by universe, standardisation – the smooth and assiduously eventless *facture* of post-war American life.

This was the moment at which the new painting chose to part ways with the visible world, creating surfaces that were unfinished, brutal, slapdash, an aesthetic which demanded attention yet offered no clue as to the nature of the response expected. An art freed from resemblance to the world or function within it, unless as an antidote to the growing conformity of what was out there. An art which was moreover helped rather than hindered by the abstracting force of consumerism itself and the arrival of the mass-produced commodity. We tend to think of abstraction as a withdrawal from the world, but the opposite is equally true, that the modern world perhaps became too abstract to be represented in the old ways.

What was clear enough was that American abstraction was something new, deriving neither from School of Paris restraint, nuance, finish, nor from home-grown Regionalism, although it remembers American roughness as a quintessential quality. Jackson Pollock and Clyfford Still were both frontiersmen from the Great Plains, and they brought the limitless landscapes and 'wild horizontality' with them to the city. More generally, American artists were looking for adequate images in a time of the breaking of nations, and much of their apparent introspection was a compound of atomic fears and more mundane material uncertainties about their survival as the kind of artists they thought they wanted to be.

Meanwhile the *Fourteen Americans* exhibition at MoMA in the autumn of 1946 signalled the Museum's continuing commitment to American work. Motherwell exhibited thirteen works, paintings, drawings and collages, all in one room, in what resembled a one-man show. His inclusion was one of the defining moments in his early career.

On his father's death Motherwell had inherited seventy-five thousand dollars, to be placed in trust until his fiftieth birthday, and his mother announced that she would continue his financial support for one year only. Meanwhile Peggy Guggenheim was making it clear to her young artists that as soon as the war was over she would move her whole operation back to Europe, which she did, to Venice as it turned out. 'I will help you as long as I'm here, but the day I go you're on your own.'

The French Surrealists shared a similar view of the matter, and most of them returned home, unlike the German émigrés, who felt that there was nothing to return to. Before their departure, and the closure of her gallery in 1947, New York artists needed to find new allies or champions, notably the gallery owners Betty Parsons and Sam Kootz, and the critic Harold Rosenberg. In the years following the war, Kootz's gallery in particular became a hub for what was new. The WPA had ended, and Kootz was the only chance in town of being supported entirely by one's own work. Together, Parsons and Kootz gave their painters exhibitions on a yearly basis, Pollock and Baziotes, Hofmann and Motherwell, Still and de Kooning, Newman and Rothko. Indeed, Kootz insisted on doing so. He was a novice dealer, with few artists and 'having to borrow money from Chinatown at fantastic rates of interest', so it was imperative for each artist to have an annual show. Motherwell had only been painting for two and a half years when he was signed up in February 1945, Kootz opened his gallery in April of that year and Motherwell had exhibitions annually between 1946 and 1950.

By 1946 Motherwell and his peers had all put on one-man shows at the galleries of Guggenheim, Parsons or Kootz. De Kooning was an exception, in not having a solo exhibition until 1948. Accustomed as they were to marginality, the New York painters were less than ready for the cycles of preparation, hanging and reviewing, however small the scale and however limited the pressure of exposure. At the same time, they became regular artists by having regular shows, a regime which in Motherwell's case stood in for the discipline that might otherwise have been laid down by an art school background. As far as Kootz was concerned, the more his young artists painted the better, and the more they painted the better they painted. There was an undeniably heroic aspect to Kootz, as the first dealer who took it upon himself to convince the art establishment that modern American artists were worthy of recognition. As Motherwell said of him, 'he fought like a tiger for that.'

In fact Kootz had already issued a strongly worded call to arms in the form of a letter to the *New York Times* on 10th August 1941:

"Under present circumstances the probability is that the future of painting lies in America... We can expect no help from abroad today to guide our painters into new paths, fresh ideas. We have them hermetically sealed by war against Parisian sponsorship - that leadership we have followed so readily in the past - we are on our own... I probably have haunted the galleries during the last decade as much as have the critics... My report is sad. I have not discovered one bright white hope... Subject matter, that's the only thing the galleries are showing... True, some years ago, we had a rash of class-struggle painting, but the boys didn't have their ideas straight, and they killed what they had by shamelessly putting those ideas in the same old frames - they made no effort to invent new techniques to express their thoughts... Yet no new talent has come forward to challenge them... now is the time to experiment. You've complained for years about the Frenchmen's stealing the American market - well things are on the up and up. Galleries need fresh talent, new ideas. Money can be heard crinkling throughout the land. And all you have to do, boys and girls, is get a new approach, do some delving for a change - God knows you've had time to rest."

Motherwell signed a five year contract, with a monthly stipend of two hundred dollars in exchange for seventy five works per year: twenty-five oil paintings or collages and fifty watercolours, although this number was subsequently revised downwards. The gallery would be entitled to all the works he produced over and above, and he was allowed to keep one work a year for himself. The following autumn the Betty Parsons Gallery opened, near Kootz, and she took over the remainder of the Guggenheim protégés, with Pollock signing up for three hundred dollars a month. Between them, Kootz and Parsons briefly had the best artists of that time and place.

In 1947, the year that Motherwell moved into his Modernist Quonset house, the *New Yorker* art critic Harold Rosenberg identified this new breed of American painters who felt 'no nostalgia for American objects', cowboys, regions, oil wells, cornfields – the list is Rosenberg's – in their search for an international idiom, and who acknowledged no attachment either to community or even to one another. 'From the four corners of their vast land, they plunge themselves into the anonymity of New York.' From everywhere to the now and the nowhere of New York, giving birth to Motherwell's network of awarenesses, 'of who is painting what, where, and for what reasons; with the sense that this network in turn modified the individual artist's awareness.'

Rosenberg spoke up dramatically for freedom from American traditions and emancipation from European models, even if he overstated his case. Preparing for his role as a leading apologist for Abstract Expressionism, he had already befriended the painters in question, and was to be found discussing Kierkegaard with Motherwell in East Hampton as early as autumn 1945. Existentialism was in the air, but as de Kooning later remarked, 'I read the books – and even if I hadn't I would probably be the same kind of painter. I live in my world.' The spirit of the age could take the form of a resistance to what 'the age demanded'. Either way, high seriousness was the order of the day, and this un-ironic view of the artist's role broke with the cultural nihilism of the European line of Modernism, even if the latter underpinned so much of what was becoming Abstract Expressionism.

Motherwell was by now already entrenched in his particular style of commitment, wrestling to hold his personal and professional life together, exhibiting, writing and editing. Not to mention absorbing the work of other artists past and present, teaching, relocating, re-marrying. However diffident or ambivalent he might often feel about his role as a theorist and writer, thinking and writing and painting were for him a single manifold rather than activities to be separated out. His early recognition as both producer and interpreter gave him a pivotal role within the New York School, and over time his confidence increased as a writer, shedding its academic watchfulness, the style becoming freer.

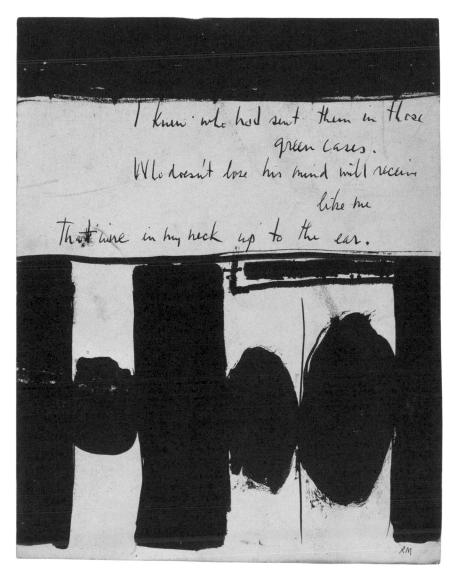

Illustration for Harold Rosenberg's poem *A Bird for Every Bird*. Later titled *Elegy to the Spanish Republic No.1*, 1948
Ink on paper
27.3 x 21.6 cm / 10 3/4 x 8 1/2 ins
Museum of Modern Art, New York

Part IV: At Five in the Afternoon

Motherwell's own artistic breakthrough came about, as so often in his account of things, by chance. During the winter of 1947, Rosenberg and Motherwell collaborated with the composer John Cage and Pierre Chareau to start a new cultural journal, entitled *Possibilities*, intended as a voice for contemporary arts, presenting new forms of expression without interpretation or separation into the different fields of art, literature, architecture, music. The lone-wolf manifesto in the first issue demanded 'an art for artists who practice their own experience without seeking to transcend it in group formulas.' In a sense, this was a political call to arms, or rather to lay down arms, a refusal to see a connection between art and society in an age of cold war ideologies, whether of the state-sponsored variety in the West (the propaganda war, the consumerist peace) or the state-enforced varieties in the East. For Motherwell and other artists, the only choice at this juncture was to abandon 'the political trap' and embrace their consequent isolation.

If there was such a thing as an American avant-garde, it defined itself partly by this breaking of ranks with the ideals of a previous moment, from Popular Front radicalism to the New Deal and the civic art of the WPA, which were seen as having painted American art into a provincial corner. Meyer Schapiro had defended abstraction in similar terms a decade earlier, on the grounds that art must seek its freedoms beyond nature and society, and that these refusals were the terms on which abstraction engaged with its context.

The new standard had to be international, not local or parochial. The most outward-looking of his peers, and the most attentive to the European story and its continuities, Motherwell yet believed passionately that the end in view was for America to stop imitating Europe. But Rome was not built in a day, and in the year 1947 Motherwell and Rosenberg wanted their new magazine to 'look French'. For the second never to be published issue, in the spring of 1948, they agreed to include a mysterious and 'brutal' Rimbaud-like Symbolist poem that Rosenberg had written, entitled 'A Bird for Every Bird'. Motherwell hand wrote the poem and worked around the words in brush and ink, words and images in a locked embrace. Working with black ink, as the magazine could not afford colour, he inadvertently blotted the shape he was making, creating 'a strong straight thick black line and a very strong oval', which reminded him momentarily of Picasso's play with linear and curvilinear forms. He set it aside.

A year later he remembered or came across it again, took the blotted image from his drawing pad, decided to enlarge its forms, painting a small canvas which he entitled *At Five in the Afternoon,* this being the refrain of Federico García Lorca's great poem commemorating the death of the famous bullfighter and fellow poet Ignacio Sánchez Mejías. This image, just three black oblongs alternating with three strong bands of vertical black, was slowly taking on a life of its own. Obscurely impelled by the fusion of ovals and verticals, and by their inherent monumentality, Motherwell set to work on a much larger canvas, which he would entitle *Granada*, after the city of Lorca's birth and violent death. He completed it in two sessions later that year, during one of the most violent snowstorms in New York's history, which trapped him in his Fourteenth Street studio during the winter of 1948, just a few weeks after his wife Maria had left him for another man, a neighbour on Long Island. He painted through the day and into the night, and two works emerged from this marathon - *Granada* (the first large-scale realisation of what would become the *Elegy to the Spanish Republic* series) and *The Voyage*. He was still so uncertain of his direction that

he nearly destroyed both canvases, but was dissuaded from doing so by Bradley Walker Tomlin, who came to the studio they both shared. These were the first intimations of the *Elegy to the Spanish Republic* series, which would occupy him for the next four decades. He would eventually re-title the Rosenberg drawing *Elegy to the Spanish Republic No 1, 1948*, and it now hangs in the MoMA.

One possible approach to modern painting was being announced by these images. A new sense of scale, an emphasis on process rather than finish, with the signs of revision and under-drawing left visible, as of an art that does not conceal the signs that show art to be involved. The surfaces are closely but freely worked, especially along the edges and seams, and there is a restrained economy of means, what Frank O'Hara would later call Motherwell's 'small family of forms', in this case a schema of ovals and rectangles. From the outset the restricted format allowed for free and spontaneous brushwork, marks whose plot could develop in many directions.

The reference to Lorca at the outset, the movement between Lorca's lament for the bullfighter and Motherwell's lament for Lorca, would define the series. Mexico had been a reality for Motherwell since his 1941 visit but Spain was an even earlier preoccupation, a region of the mind more than an actual place. He was twenty-one when the Spanish Civil War broke out in 1936, an event whose tragic unfolding was as significant for his generation as Vietnam would be thirty years later for their children, as something never to be forgotten. The death of the bullfighter Sánchez Mejías, and of Lorca, the larger loss of life in the struggle, the loss of collective social hope and the death of an ideal, these were things that preoccupied Motherwell for the rest of his life. As he remarked of the *Elegies* in an interview in 1964, 'I do not regret on the whole that I chose to honour that defeat… They are not political, but my private insistence that a terrible death happened and should not be forgot.'

The contrast of black on white in these images invoked Motherwell's recent experiments with collage, and reflected his metaphysical cast of mind. Most of his black-on-white works, his most 'threatening presences', to use one of his titles, are painted with a Spanish accent, including the *Iberia* paintings from 1958-59, and the many other canvases taken over by invasive or carnivorous blackness. This is partly in memory of how black had animated Spanish art from Goya to *Guernica*, and, via Goya, the art of Manet. It is an aspect of Motherwell's refined traditionalism, the filial and allusive spirit which allies him with a Modernist such as T. S. Eliot, equally preoccupied with continuities.

Eliot in 1922 had referred teasingly to *The Waste Land* as the foisting of 'a private grudge' upon the world. At *Five in the Afternoon* alludes to the death of a bullfighter, but is at some level about the end of Motherwell's marriage to a woman who came from a Hispanic culture, and to the polarities of that culture, taking in concerns that range far from the merely private. Like Eliot, Motherwell explored reticence, and reticence is the engine of allusion. One might say conversely that Motherwell found a private analogy for the great political drama of the thirties: that he translated Lorca's Spain into a powerful abstract imagery of sexual and metaphysical speculation, at a time of considerable turmoil in his life. When his marriage was collapsing; when the magazine *Possibilities* was beginning to seem like an impossibility, given a conflict of aims between its editors; when in June Samuel Kootz announced that he was closing his gallery, three years after it opened, in order to act as exclusive worldwide dealer for Picasso, leaving Motherwell and fellow artists without representation or a place to exhibit their work. And at a time when the spectre of

suicide was abroad. In July 1944 Arshile Gorky had hanged himself in a barn in Connecticut. He was the artist who had done more than any other to bridge the gap between European painting and what was to come, who was described posthumously by the poet James Schuyler as 'the Ingres of the unconscious', for his virtuoso touch and historical intuition, who shared with Motherwell and Willem de Kooning an understanding of the Modernist past and its lessons for the present.

In fact the exhibitions did continue at Kootz for a few more years, and in September 1949 Motherwell rejoined the Kootz Gallery – 'I like the risk' – when it reopened on Madison Avenue after the one-year hiatus. Sidney Janis, who took over the old Kootz space on Fifty Seventh Street, would eventually represent Motherwell and give him his first one man show there in 1957.

Motherwell's *Elegies*, their format repeated in over two hundred works, are silent massings of black against white ('those two sublime colours, when used as colour') in rhythmic and testimonial progress across the canvas. Heavy ovals alternate with verticals, their edges torn, against a flat white ground. All of which is ceaselessly worked, and in dialogue with the edge or frame, the scale and internal relations constantly shifting from one canvas to the next, the chromatic power of the blacks by turns subdued and amplified. Motherwell later said that he felt as if he were building a temple 'consecrated to a Spanish sense of death, which I got most of from Lorca, but also from other sources – my Mexican wife, bullfights, documentary photographs of the Mexican revolution, Goya, late Hispanic interiors…' In other words, he drew on his Mexican experiences to present an intuited Spanish experience, and to create a new American image. Which in turn stood in for other more immediate personal matters, it being part of Motherwell's principle of reserve that such things are latent and there to be uncovered by the viewer. Or, as T. S. Eliot wrote, 'There may be much more in a poem than the author was aware of ', a limitation to the reach of conscious control to which Motherwell the painter wholly assented.

The *Elegies* are not abstractions, if that is meant to suggest absence of content. Oblique, austere, suggestive, sensuous, their processional shapes seem like the protagonists in a tragic narrative. They derive their forms from such unlikely places as Piero della Francesca's *Flagellation*, a yellowing reproduction of which was pinned to Motherwell's studio wall, wherever his studio happened to be, and they inherit, in the words of Arthur Danto 'the very substance of agony' implicit in that picture's enigmatic geometry.

Motherwell would always be an abstract artist, but his concerns in art were never 'merely' abstract, any more than Piero's were merely computational. His commitment was to abstraction and to feeling, and his *Spanish Elegies* proved to him how a work might remain abstract and yet carry a human content, how quite simple forms and combinations could hold a powerful associative charge. They are a response, besides, to Mallarmé's injunction to 'describe not the object itself, but the effect it produces'.

Motherwell helped give voice to the Abstract Expressionist consensus that subject matter is crucial. 'We rarely, as I remember, talked about formal problems. It was about content problems.' The two primary apologists for the movement, Harold Rosenberg and Clement Greenberg, both underestimated this, for opposed reasons. Greenberg's programmatic talk of the 'autonomy' of art and his advocacy of a rational art for art's sake was to provoke the painters into insisting on

the importance of subject. Rosenberg on the other hand dismissed formalist explanations, and saw the new American painting as an open response to 'crisis', to existential context, so that what was transmitted to the canvas was not a picture but an 'event'. In reaction to which the artists protested their commitment to the specifics of their art and its painted world, however free and unrestrained their gestural improvisations might appear. As Mary McCarthy remarked drily, 'You can't hang an event on the wall'. But Rosenberg's term 'action painting' caught the public imagination, and it stuck.

As if to make their point, when Still and Rothko and Motherwell decided in August 1948 to found a school of painting, they named it at Newman's suggestion the 'Subjects of the Artist' school, to teach 'what modern artists paint about as well as what they paint'. It was their first collective venture, an act of allegiance, whose Friday evening sessions were open and vociferous, and evolved in the mid-fifties into 'the Club', an established forum for avant-garde solidarity. Motherwell was pivotal to both the school and the sessions. He moved back to New York, prompted by the new venture, which opened in a studio on West Eighth Street in October, and by his hopes of saving his marriage to Maria, who had felt increasingly isolated in East Hampton. They found an apartment on West Fourteenth Street, but as the autumn moved into winter it became clear that the marriage had stalled irremediably, and Maria departed abruptly for California. Motherwell began drinking heavily and later described this winter of bleakness as the only time in his life when he seriously contemplated suicide. It was in this frame of mind that he came across the illustration he had made for Rosenberg's poem, while unpacking materials brought back from East Hampton, and decided on impulse to make an enlarged version of it.

By the end of his life Motherwell had produced more than two hundred *Elegies to the Spanish Republic*, between 1948 and 1991, outlasting the bronze age of General Franco, some of them the same size as that original breakthrough work on paper, or smaller, others gigantic in scale, the largest being the *Reconciliation Elegy* commissioned for the National Gallery in Washington in 1978. From the outset of his career he was at ease with large works, and believed that size was one of the major American contributions to modern art, filling the viewer's field of vision. 'The large format destroyed the tendency of the French to domesticate modern painting, to make it intimate. We replaced the nude and the French door with a modern Stonehenge.' At the same time, with the exception of Franz Kline he was the only painter of his generation who also worked confidently to small scale, and with instinctive tact.

There were others. Most of his colleagues, in particular Pollock, Still and Newman, the primary innovators, developed and came to be celebrated for a single style or trademark image, dramatically staking out a new territory whose hinterland they then proceeded to explore intently and exhaustively. As Clement Greenberg said, approvingly, 'the public usually asks that a "difficult" artist confine himself to a single readily identifiable manner before it will take trouble with him.' If *Time* magazine in 1956 could so confidently label Pollock as 'Jack the Dripper', it was because Pollock had seemed so single-mindedly to stake out this terrain, over five intense years from 1947, producing large numbers of his fastidiously uncontrolled canvases. Never mind the fact that these works never repeat themselves, or that even individual paintings manage to be unified without repetition. When the crisis point was reached and he attempted to move in a new direction, it was so fraught that in the last years of his life he virtually stopped painting.

Again, once Barnett Newman established his field of broad monochrome planes separated by narrow vertical lines, or 'zips', the ramifications of this hieratic formula preoccupied him until his death in 1970. Likewise Still's huge canvases, torn by agitated patches or curtains of colour, succeeded one another in stately and solipsistic sequence until the end, in 1980. Just as Rothko had expunged his earlier signs and symbols by 1947, and established his repertoire of horizontal rectangles and translucent hues against a field of colour, the nuances of which he explored until his death in 1970, with an increasingly restricted and monochrome palette. Ad Reinhardt arrived at his essential style in 1951. Kline too would stick with his black and white gestural abstractions, angular and highly-charged, from their first appearance in 1950 until his death in 1962.

All of these artists created a mature body of work between the late forties and early fifties which for various reasons they were deterred from exceeding. In a sense, it was left to Willem de Kooning, shuttling between abstraction and figuration, the flat and the painterly, past and present, to develop a ferociously personal refusal of style, painting on his nerves, each series superseded by or morphing into the next. Until the dreadful Alzheimer's disease took its hold on him in his eighties. And it was
de Kooning, significantly, who, in the days before the term Abstract Expressionism acquired its fixed currency, remarked drily: 'It is a disaster to name ourselves', although the name as such was bestowed, by Alfred Barr of MoMA, only after the community to which it referred had formed.

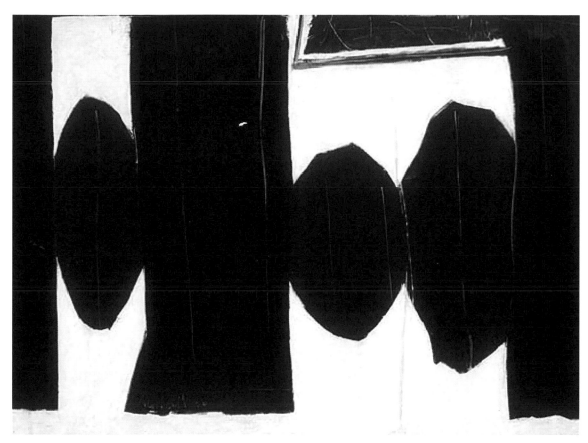

At Five in the Afternoon, 1950
Oil on Masonite
91.4 x 121.9 cms / 36 x 48 ins
Fine Arts Museums of San Francisco

Part V: The Road Not Taken

Both Motherwell and de Kooning resisted the notion, promulgated equally by Greenberg and by the acquisitions policy of museums in a sort of feedback loop that what mattered was the search for a definitive 'image'. Motherwell managed something quite as fearless as any of his peers, but different, more diverse, perhaps more classical in spirit. Rather than a single image, he evolved a syntax of forms and patterns, of palette and gesture, a language which could make different kinds of statement, explore very different kinds of image-making, using various media and adapted to different moods. Self-critical and experiential, without being narrowly autobiographical or explicit, whose constant subject was 'reality as *felt* in paint'.

This helps explains the importance of the series and of revision in general for Motherwell, who always speaks of process rather than of finished works, and whose *Elegies* were the first of the several major sequences that defined his career, each a surprising and distinct departure from the others, and upon which he often worked simultaneously. His philosophical interests taught that there is no single perspective on truth, that there is always another way of considering the case. The series is a matter of elaboration and consolidation as much as invention. As he wrote in his 1965 letter to Frank O'Hara, 'the series is not necessarily that of subject matter, but of sensitivity to findings in the motif which yield further discoveries in the material'. Motherwell's attitude to spontaneity was always complex, painting and then painting out, modulating the first impulse, correcting, so that the initial freedom yields to a shaping spirit which is more formal and architectonic.

Revision has a particular relevance here, in that each painting in a series revises and is revised by another. Repainting, revisiting, was a lifelong necessity for Motherwell, extending even to his collages, in ways that have little application to any of his contemporaries: 'The artistic struggle involves revision, new points of attack, ponderings, changes of mind, duration, endurance, and so on. Traces of this conflict often remain in paintings and collages, like the corpses on a battlefield, and sometimes enrich them with a terrible beauty.' He went so far as to define his art in terms of error, in the catalogue-statement for his 1947 exhibition at the Kootz Gallery: 'I begin a painting with a series of mistakes. The painting comes out of the correction of mistakes by feeling…' The correction of mistakes by feeling. It is one of his most charged statements.

As with Gorky and de Kooning, Motherwell's engagement or struggle with the past is permanent and continuous. Precisely the commitment to experiment and contingency, to finding new ways of dealing with what has already been achieved. Whereas in the case of the other Abstract Expressionists, the discovery of a single triumphal image or format ends history, so to speak, and, as Jack Flam says in the Preface to *Robert Motherwell Paintings and Collages: A Catalogue Raisonné*, 'neutralized the issue of artistic belatedness'. The *Elegies* were the one image to which Motherwell was compelled to keep returning, even after long periods of working through other preoccupations. It is the first and most famous of his signatures, from which the others proceed and to which they return.

Due in large measure to Motherwell's efforts, by 1949 there was a public sense of a 'New York School' with a formal identity. And for Motherwell automatism was the catalyst which allowed American artists to be themselves and therefore to be more adventurous than their European

counterparts. It was the measure of what made the new art both international and nonetheless American, what put America on the map of the contemporary. 'Automatism came out of Paris; the "expressionist" aspect has to do with a certain violence in the American character; the Surrealist tone and literary outlook were dropped, and the automatic gesture transformed into something *plastic, mysterious and sublime*.' Put differently, Motherwell linked Miró's belief in letting a painting find its own identity in the process of being made – 'to ride on its own melting', as Robert Frost said a poem must do, 'like a piece of ice on a hot stove' – to Rosenberg's homemade American aesthetic of 'action painting'. This sense of free but directed activity was the movement's special contribution to the vocabulary of modern painting – 'chance fixed' – and Motherwell was to be its most versatile practitioner.

Abstract Expressionism may have had few direct followers, but by the end of the forties what Rosenberg called 'the tradition of the new' was in place. What followed, even Pop Art, which was in all respects antithetical to the beliefs and principles of the New York School, would inherit a specifically American sense that art was without pre-existing foundations - that art was what artists made. It was an avant-gardism which embraced a specifically American and businesslike model of novelty and obsolescence.

Before his return to New York in the autumn of 1948, the five years spent largely in the Hamptons had been one of the most productive of Motherwell's career. During this time he had matured his ideas on painting – colours, themes, forms – and his sense of the limits of collage and automatism. He had painted the pictures for his first one-man show at Art of the Century Gallery, and for the annual Kootz shows, including his important one-man show in the autumn of 1950, which introduced the *Elegies* as a series. Above all, perhaps, he had established the rhythm between discovery and variation, invention and repetition, which would so distinguish his art from the broader – or narrower – Abstract Expressionist concern with originality. He had lectured and taught, published essays, produced a magazine, and overseen the publication of eight titles in the *Documents of Modern Art* series, for four of which he had written introductions. And he had been working on the Dada anthology from 1945 onwards, which offered him a way of thinking about the relation between art and destruction at a parallel historical juncture. Dada emerged immediately after the First World War, and its concern with how to make art in a devastated setting anticipated the concerns of Motherwell and his peers in the aftermath of a Second World War.

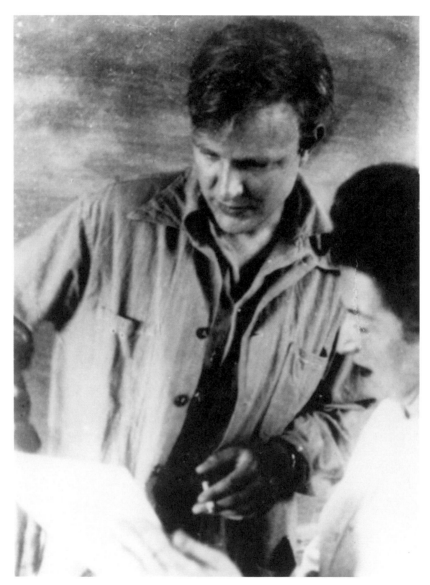

Robert Motherwell teaching at Black Mountain College

1956: They Liked it Cool, We Liked it Warm

In 1956 the hugely charismatic Leonard Bernstein promoted his new musical *West Side Story* on Sunday afternoon *Omnibus*, a popular television arts series of which he was to become a regular presenter and threw down the gauntlet for the future of musical theatre:

> 'We are in a historical position now similar to that of the popular musical theatre in Germany just before Mozart came along. . . What we'll get will be a new form, and perhaps opera will be the wrong word for it. There must be a more exciting word for such an exciting event. And this event can happen any second. It's almost as though this is our moment in history, as if there is a historical necessity that gives us such a wealth of creative talent at this precise time.'

Bernstein had already made an impact on the American musical scene in 1942 with his giant symphony *Jeremiah*. He would within a few short years colonise popular music with his jazz-tinged score for the ballet *Fancy Free* and its reincarnation as the musical *On The Town*, and the one-act opera *Trouble in Tahiti*, before triumphing in 1957 with *West Side Story*.

Bernstein's undergraduate years at Harvard, from 1935 to 1939, overlapped with Robert Motherwell's graduate year and they shared an influential mentor in David Prall, whose teaching emphasised the primacy of the individual work of art, the sensuous awareness of aesthetic 'surfaces', and the belief that knowledge and feeling are inseparable. Prall also argued for the political potential of art to create a coming community of artist and audience. All of which resonated with Motherwell and Bernstein, who shared a commitment to American forms for describing American experience, of which musical theatre was as true an example as Abstract Expressionism. *West Side Story*, which opened in New York in 1957, was Bernstein's version of the American melting pot, a tragic tale cast as musical comedy, treading a fine line between opera and Broadway, ballet and dance, abstraction and figuration.

In April 1953 a group of forty-three figurative artists, including Edward Hopper and Milton Avery, had written a manifesto challenging what they saw as their deliberate exclusion from the Whitney Annual exhibition of contemporary American painting, and to protest the inclusion of Abstract Expressionist work, which they dismissed as art for art's sake. But when Hopper approached the Regionalist master Andrew Wyeth to support their cause Wyeth refused, describing abstract art as 'the toughest neighbour realism has had to put up with for years', even insisting in private that he himself was an 'abstractionist'.

Motherwell summarised this same moment: 'If, as we believed, to make an authentic gesture without any *a priori* idea of how it would turn out was the real gambit, then everything – hard-edge abstraction with its ideology, social realism with its ideology, regionalism with its ideology, landscape painting with its sentimentality, portrait painting with its class background – they were all equally threatened by our premise.' Alfred Barr remarked to Motherwell that the coalition against Abstract Expressionism was perhaps the only time there had ever been agreement from left to right among American artists.

Put differently, all of the above was a measure of the acceptance of Abstract Expressionism, which in the early fifties began to be taken seriously beyond a small circle of supporters, to become quite unexpectedly the dominant mode of the decade. Starting with the 1951 MoMA exhibition of the Blanchette Rockefeller collection – which included Motherwell, Pollock and Rothko – and culminating in the *New American Painting* at MoMA in 1958, which toured eight European capitals and became museum culture's official endorsement of the movement.

After 1950 the New York School received a positive press. Rosenberg's influential essay 'American Action Painters' appeared in December 1952, and exhibition reviews were mostly supportive rather than sceptical, the critics accepting rather than questioning the artist's aims, and concentrating on the flair or lack of it with which these were pursued. It was as if the battle had been won at the first engagement. Motherwell's earlier writings on art are marked by the expectation of a coming struggle, just as the career of a painter like Rothko can be seen as a long preparation for a failure that eluded him, and which undermined his rightful claim to outsiderdom.

More generally, the fifties were years of accommodation. With the waning of the threat of imminent nuclear apocalypse, and the polarising of choice between democracy and its increasingly stark alternatives. 1956 was the year Soviet tanks entered Budapest. Artists and intellectuals became more reconciled to the *Pax Americana* and entered into a more willing rapport with the surrounding culture. Gestural painting was reclaimed for the virtues of spontaneity rather than anguish. Abstract Expressionism was embraced by critics on all sides, from Greenberg to Rosenberg, as a native American product expressive of self-reliance and the frontier spirit. It was as if their very solitariness helped to co-opt and incorporate these artists. The *New York Herald Tribune* soon dubbed Abstract Expressionists 'the Irascibles', and the now famous group photograph of the main suspects, scowling but successful, appeared in *Life* magazine.

It has been suggested that the potential of the new painting as a cultural export was recognised early on by the State Department. Nelson Rockefeller, President of MoMA and a keen supporter of Abstract Expressionism, referred to the movement as 'free enterprise painting', and even Pollock's all-over canvases could be recruited as a showcase for individual freedom. This simple equation had a calming effect on the more zealous government agencies, and none of the New York School artists were ever investigated by the cohorts of McCarthyism or the CIA.

On the other hand, there were those, including Harry Truman and the cold warrior Congressman George Dondero, author of a 1949 tract entitled 'Modern Art Shackled to Communism', who saw the new painting as subverting the American way of life rather than a prize exhibit in its imperial arsenal. In a speech to the House of Representatives of July 1956, 'Unesco-Communism and Modern Art', Dondero singled out Motherwell, Pollock and Baziotes as the puppets of European Modernism, bent on corrupting public morals. 'Cubism aims to destroy our standards and traditions by designed disorder; Futurism aims to destroy by the machine myth; Dadaism aims to destroy by ridicule; Expressionism aims to destroy by the creation of brainstorm; Surrealism aims to destroy by the denial of reason.' Never mind that the safe academicism promoted by Dondero and other servants of the people was also the official art of Stalinism, or that the artists Dondero attacked – Braque, Duchamp, Ernst, Miro – were also branded in Russia as bourgeois formalists. Dondero's strike-rate was not negligible. He had recently forced the cancellation of two international touring exhibitions of the new American painting organised by the State Department and the US Federation of the Arts.

Either way, in the fifties work of Pollock or Still or Newman, in the words of Irving Sandler 'buoyancy replaces claustrophobia, lyricism replaces turmoil, and canvases get bigger and bolder'. As if abstraction were now the mirror of a broader confidence, a rallying point for a public eager to embrace all things American. As early as 1950, a Cecil Beaton fashion shoot for *Vogue* chose the Betty Parsons Gallery as its location, posing a slender model against the backdrop of a huge Pollock canvas.

Confidence breeds confidence. The world at large, still in the grip of austerity and the aftermath of war, seemed to crave the consoling image of an American car with fins and huge tail lights parked outside Richard Yates' *Revolutionary Road* home, with Doris Day preparing hot pancakes in the shiny fifties kitchen while singing *Que Sera, Sera*. Glamour-starved Europeans got their fill of American popular music, from Rodgers and Hammerstein musicals to the Leiber and Stoller songs written for Elvis Presley. As if we all needed to know that Pan American or TWA could fly you from the cold of New York City or Boston or Chicago to Miami, or better still to the Caribbean. The periphery hungers for the centre, and the new notion of America as cultural arbiter in the fifties, setting standards for Europe and beyond, was based on the conviction that everywhere now aspired to be America.

But the new American gleam had its taproot in something more serious and unsettling, on the other side of the Atlantic, which had been taking shape since the end of the war. After two centuries Britain was losing its Empire. The burden of spreading civilisation was about to become a vision of the past. Decolonisation in Africa was underway, and adapting to a future beyond colonialism was the issue around which nostalgia and pragmatism clashed. The catalyst was the Suez Canal, the lifeline of Empire, where Britain still maintained its most visible standing army, a symbol of Imperialist oppression hated by the Egyptians. In the early fifties General Nasser was voted into power and became an insistent voice on the world stage. Britain disliked him, America was impressed by him, and the Egyptian leader was soon insisting that Britain withdraw its Suez presence. Agreement was reached and by mid-1956 the troops were gone. Nasser then announced the immediate nationalisation of the canal, in which Britain and France still had substantial shares from a deal going back to the nineteenth century. Shortly after leaving the region the British were back again, with a large ostensibly peacekeeping force, this time alongside the French. In reality, with the assistance of Israel, the British Prime Minister Anthony Eden had covertly decided to seize the Suez Canal and topple Nasser. It was a conspiracy, the discovery of which outraged parliament and the majority of British public opinion.

America also disapproved and said so. Eisenhower was fearful of upsetting the Arab world and seeing Nasser shift allegiance to the Soviet Union, which was now threatening to intervene on Egypt's behalf. The day after British and French paratroopers landed on the Egyptian coast as the advance guard of a hastily planned ground invasion, sterling came under intolerable pressure on the exchange markets. With dwindling gold and dollar reserves Britain turned to its friend and ally, but now America had the power to name its terms. The recurrent weakness of the pound gave Eisenhower the weapon he needed, and he agreed to a loan on the understanding that Britain would leave the canal – this time for good. Britain was forced to accept, the military advance was halted, and Eden resigned. It was an unprecedented humiliation, the greatest diplomatic fiasco in British history, the moment when the Empire ceased to matter as an international force and when a new 'special relationship' was enshrined at the centre of Anglo-American foreign policy.

Subsequent British governments were mostly conscious of the dangers and cost of commitments east of Suez, in what seemed a steady diminuendo of past ideals. The Empire at the core of Englishness was being progressively dismantled, for what seemed to many Britons the lack of any surviving rationale other than cost. Whatever the talk of togetherness and boundless horizons, the reverse of the American coin was decline – the end of an empire in which English soldiers in foreign parts still decided and secured the minimum of order and civilisation. The roles of Britain and America on the world stage had been reversed, and Britain had become a client state as well as a net importer of American culture in its shiniest and most consumerist forms.

––––––––––––––––––––––––

On August 11th, 1956, Jackson Pollock died in a car accident in Springs, Long Island, driving a girlfriend and her companion back home in his Oldsmobile, hitting a tree on a road he knew like the back of his hand. His wife, the gifted painter Lee Krasner, was not in the car. He died instantly and she went on living until 1984. Pollock was forty-four years old. In a retrospect written in 1967, Motherwell recalled Pollock's attributes. He touched on Pollock's political innocence and lack of chauvinism, his rhythmic intelligence, the 'large and airy lyricism' of his work, its fastidiousness, its fulfilment of Breton's prediction that the art of the future must be 'convulsive', its discovery of the floor as the horizontal means for creating a vertical art, with extraordinary results when stood up to face the viewer, for which Motherwell found just six pointed words: 'what a beautiful all-over space!'. And beneath all of this the essential aloneness of the individual who made these images.

Life magazine's famous 1949 photo-essay on Pollock portrayed him in jeans, arms crossed, cigarette dangling, looking, in de Kooning's words 'like a guy who works at some service station pumping gas', or like a cowboy. In other words, like an all-American icon. Two years later the photographer Hans Namuth made his fly-on-the-wall documentary of Pollock at work dancing around the canvas, brooding over it with buckets of paint in hand, riding on the moment. It was an unforgettably transgressive image, whose publicity in turn fractured Pollock's fragile and hard-won equilibrium. His career was as brief, almost, as these representations of it – lasting from 1947 until 1952, by which time the all-over paintings, with their progressively bolder methods and scale had come to a halt, and the way ahead was wrapped in uncertainty.

Perhaps the movement itself stalled at the moment of Pollock's death, for both internal and external reasons. On the face of it, Abstract Expressionism was at the height of its game, which coincided uncannily with the arrival of the modern art market. The year after his death, Pollock's nine by eighteen foot *Autumn Rhythm* was bought by The Metropolitan Museum. Abstract Expressionism started to make money, and the dilemma of a painter like Rothko was merely more representative than most. The more he voiced his distrust of the art world, as a system, the more praise and rewards were heaped upon him.

The original New York artists, as Franz Kline liked to remind everyone, 'had lived where animals would die'. In the late forties Betty Parsons could still complain about the slow sales of their work, and in 1948 Samuel Kootz was effectively forced to close his gallery for a year due to financial pressures caused by his commitment to his group of artists. In December 1953 Motherwell made a profit from the Kootz Gallery of just over two hundred dollars. But by December 1956 his

earnings for the year were five thousand dollars, and by 1960 his income from sales at the Sidney Janis Gallery, which he had joined along with de Kooning, Gorky, Kline, Pollock and Rothko, would approach fifty thousand dollars a year.

Success created its own uncertainties. They had conditioned themselves to expect failure, and their sense of themselves was vested in the idea of a healthy mutual distrust between artist and public. There were other side effects of success; serial fallings-out between the artists, anxiety about a possible loss of vitality, by a lack of talented new adherents and by adverse criticism of the movement which started to be voiced towards the end of the decade. It was as if everyone wanted the scenery to change just a little, rather than dispense with it altogether. A slow tug-of-war between influence and rejection ensued. How Pollock would have negotiated these nuances, which replaced the clarities of the Abstract Expressionist moment, its conviction and authenticity, we shall never know. Even Motherwell, with his antennae and his instinct for survival, needed guidance at this juncture, needed a Virgil-figure to steer by.

For much of the decade, since his one-man show in 1950, Motherwell's productivity had been affected by the flow, or rather the ebb, of his personal circumstances. In 1950 he married Betty Little, whom he had met in Reno while both were obtaining divorces. She already had a daughter and they would soon have two daughters of their own, Lise and Jeannie. Needing financial security, he joined the faculty of Hunter College early in 1951, and began to devote more time to writing and lecturing, which meant less time for painting. And he came to acknowledge that this marriage too had serious underlying problems. His predicament was that, in the words of the art historian Catherine Craft, 'he had become again an unhappy man who wished that his unhappiness not enter his work.'

The most arresting group of paintings to emerge from these years relate to this condition, and became known by the words he scrawled across their surfaces: '*Je t'aime*'. These brashly coloured and freely worked canvases relate to his marriage, but perhaps equally to his calling as an artist and its increasingly neglected claims upon him. The words are written into the paint, as he put it, 'sometimes tenderly, sometimes in a shriek.' Here was a road not subsequently taken by his art, but Motherwell was the first American artist to use words or verbal signs structurally in paintings. Frank Stella's rapid response, in a series of ironically graffitied canvases containing phrases such as 'Your Lips Are Blue', both salute a new idea and are proof that parody is the sincerest form of imitation. Motherwell's Black Mountain College student Cy Twombly would later incorporate scrawled inscriptions, lines from poetry, into his paintings.

In summer 1956 Motherwell returned definitively to Provincetown, buying a house just as his marriage was falling apart. He was in the trough of a two-year depression, by his own reckoning, living in a changing art world and acutely aware of the fact. And he was forty-one years old.

Late in 1957 he was introduced to the painter Helen Frankenthaler, a New Yorker from a solid and sophisticated Upper East Side Jewish background who had studied briefly with Meyer Schapiro and Hans Hofmann. She was younger than Motherwell, part of a second wave of gestural painters, an acknowledged member of the Abstract Expressionist circle and a favourite of Clement Greenberg, with whom she had been romantically involved. Her work had by this point

evolved into large canvases with translucent layers of oil paint diluted in turpentine, with an atmosphere of watercolour-like suspension, landscapes of massed colour wash that were moving or drifting towards pure abstraction.

In April 1958 Motherwell and Frankenthaler were married in New York. Her work and example would have a decisive impact on the direction of his own art. In the first place, by her simple and intuitive insistence that they must immediately travel, above all to Spain, which Motherwell like so many others had resisted visiting on account of the Franco regime. In the summer of 1958 they sailed for Europe to celebrate their honeymoon. This interlude marked a turning point, after which Motherwell would resign from his teaching duties at Hunter College the following year to concentrate on painting full time. These months in Europe gave him the immediate visual experiences with which to ratify some of his most cherished intellectual and emotional preoccupations, and they restored his confidence.

His first visit to Spain, not merely the Prado, and Goya's black paintings, and Lorca's Andalucia, was also a confirmation of Motherwell's palette in the ochres, whites and blacks of the landscape, which more than anything else gave him a sense of reconnection to the past. There were other less palatable reminders of the past. In Madrid Motherwell was informed that the Spanish government had refused to allow his *Elegy to the Spanish Republic XXXV* to be included in *The New American Painting* touring exhibition, unless the title were changed. He refused. The US embassy informed him that he was now *persona non grata* as far as the Spanish authorities were concerned, and suggested that he leave the country immediately. Motherwell in turn proposed withdrawing all of his paintings from the exhibition. The impasse was negotiated on his behalf from New York, and eventually resolved, but it was a sinister reminder in a minor key of an earlier reality, a generation after the Civil War had ended.

Motherwell and Frankenthaler left Madrid and settled in Saint-Jean-de-Luz, a small fishing village across the border, on the French Atlantic coast. Here they rented a villa where they could both paint, and from which they visited the caves at Altamira, crossing back into Spain to do so. The prehistoric paintings were lit for their benefit by candlelight. 'The animals moved, as the candles flickered, and I have never gotten over that impression'. The couple also attended a cathartic and disturbing bullfight in Biarritz, which gave rise to Motherwell's *Iberia* series, in which a massive and threatening blackness progressively invades each canvas. Back in Saint-Jean-de-Luz he worked on the *Iberias* and other paintings, using sheets of Basque linen because it was impossible to source any canvas locally. The couple returned to New York at the end of August. Motherwell shipped back fifty-five paintings and collages and many drawings, more new work than he had created over the past three years combined.

Frank Sinatra, born in the same year as Motherwell, also re-invented himself in the 1950s, moving to the high-powered recording label of Capitol, where he linked up with the great Nelson Riddle, a wonderful conductor and arranger, creating a string of albums such as *Songs For Swinging Lovers* and *Come Fly with Me*. Through the jet plane the world was getting smaller and smaller, while America seemed to get larger as well as faster and cooler.

The backdrop if not the foreground to the mid-fifties was of course the movies. Elia Kazan had just released *On the Waterfront* starring Marlon Brando, with a soundtrack by Leonard Bernstein. William Holden had gone animalistic and upset an entire Kansas town in the great romantic drama *Picnic*. James Dean, inventor of the existential teenager, with a reticence as eloquent as Pollock's, was killed aged twenty-four while driving his Porsche 550 Spyder at a hundred miles per hour along Route 466, just as his three great movies, *East of Eden, Giant* and *Rebel Without a Cause* were hitting the screens across America. 1956 was when the delectable Grace Kelly, soon to be married to Prince Rainier of the diminutive and fabulously wealthy Monaco, made *High Society* with her pal Frank Sinatra, in which she had to choose between three men and discover that 'safe' can mean 'dull' when it comes to husbands. Sinatra in turn had just completed filming *The Man With The Golden Arm*, the brooding and narcotically daring Otto Preminger vehicle. The elder statesman of American cinema, Cecil B. DeMille, gave the world something safer in *Ten Commandments*, in which Egyptian Prince Moses learns of his true heritage as a Hebrew and his divine mission as the deliverer of his people. Marilyn Monroe released *Bus Stop*, in which a naive but stubborn cowboy falls in love with a saloon singer and tries to persuade her to get married and live on his ranch in Montana. Meanwhile Monroe's husband Arthur Miller, possibly America's greatest playwright, was sweating away scripting *The Misfits*, featuring a divorcee, a cowboy Clark Gable, his friend Montgomery Clift and a desert, in which Monroe would reappear, vulnerable, tragic and beautiful, to give the most disturbing performance of her life, before her tragic death in 1962. But the dream factory kept moving along, and seduced the greatest singing sensation since Frank Sinatra to come to sunny California and make *Love me Tender*, in which twenty-one-year-old Elvis Presley plays Clint Reno, who stays home while his brother goes to fight in the Civil War for the Confederate army and then proceeds to marry his absent brother's girlfriend Cathy. Elvis was the new Rudolph Valentino, who could behave badly, sing, act, dance and altogether give the thinking teenager a year or two of troubled dreams and aspirations. The stoical Gary Cooper gave us *Friendly Persuasion*, about a pacifist Quaker family in southern Indiana during the Civil War. John Ford enlisted his friend John Wayne in *The Searchers*, the greatest of their collaborations, also with a Civil War backdrop. And Kirk Douglas made *Lust for Life* as the tortured genius Vincent van Gogh, in one of the rare films about an artist that rings true. Not to mention *Invasion of the Body Snatchers*, a film as frightening and relevant today as it was then. Or *Forbidden Planet*, a masterful science-fiction movie that is basically the retelling of Shakespeare's *The Tempest*. Or the seemingly less serious *Rock Around the Clock*, which affected millions of teenagers' lives around the world. All of them equally vintage offerings of 1956.

As it was with the arrival of photography in France in the 1860s, how could painters compete when the old purposes of art, the manifestation of myth and of social meaning, had migrated to film? The answer, in the case of the Abstract Expressionists, was by exceeding the limits of what had been thought of as pictures. And by keeping their story moving, by proving that there were 'second acts' in the life of American art, that the terms of what counted as art could keep changing. As far as such renewal was concerned, younger artists like Frank Stella, who had his first solo exhibition at Leo Castelli Gallery in September 1960, saw themselves as intimately linked to Abstract Expressionism, but were inclined to step back from its metaphysical concerns and the grandiose claims of some of its practitioners, notably Clyfford Still. In his obituary of the sculptor David Smith, Motherwell referred to the Abstract Expressionist generation, their suffering and their labours, as having made things 'easier, but not realer' for the next generation. It is an intriguing distinction, or hesitation. To which he later added, 'And if they liked it cool, we liked it warm.'

The fifties were the real decade of change, and the sixties its unruly love-child. If American life in the sixties was more protean and brightly lit, more fluent about what it wanted, the landscape was formed by earlier tectonic shifts.

At one level the fifties were simply the Great Migration. Eighteen million Americans, ten per cent of the population, moved from city to purpose built suburbs. Cars and construction boomed, and a new roadside world of consumerism emerged. By the end of the fifties Americans owned more cars than the rest of the world put together, riding an interstate freeway system which was kick started by the Eisenhower administration's Federal Aid Highway Act of 1956. A mobile republic of drivers, and the synergy of suburb and automobile shaped American optimism as a lifestyle.

Eisenhower became President in 1953, and his reassuring mix of Capitalism and consensus kept him in the White House for the rest of the decade. Many Americans found their feet under his avuncular smile and became middle-class, with the understanding that everyone else was doing the same, that an entire nation was converging on a future the other side of diversity. Social mobility was driven by gasoline and by full employment, but also by the G.I Bill, which ran from 1944 to 1956, so that a generation, which would never otherwise have gone to college found itself doing just that.

Average incomes had doubled since the war and would triple before the middle of the following decade. A blue-collar worker could now provide for his entire family, and the lives of ordinary white Americans were transformed. This was the permanent revolution for which economist J.K. Galbraith in 1958 coined a phrase, 'the affluent society', defined as one in which 'no useful distinction can be made between luxuries and necessaries'. A coherent workforce was also a captive audience, but it needed to be shown how to aspire, and advertising rose to the challenge. Like the music and the movies, fifties advertising was all about casting spells, allaying fears, implanting ambitions, and then selling us back to ourselves. It preached sameness, but in the paradoxical form of an endless struggle to keep up with your neighbours. And from this paradox the unconscious of the decade was forged.

For the upbeat fifties was equally defined by their darker side, as a mirror by its backing. Not merely the Cold War, with its low hum of constant fear. Nor the crusade against subversion which dominated public life with such paranoiac intensity in the early years and threatened civil liberties. There were more subtle intolerances at work, in a popular culture with little room for divergent views. And there was a matching anxiety among many Americans that their lives were becoming somehow more constricted. When the political writer I. F. Stone published a collection of his investigative journalism from those years he entitled it *The Haunted Fifties*, haunted because of what was suppressed by a public culture so self-congratulatory and blandly intolerant.

In the midst of plenty, the fifties were beset by doubts, voiced in a series of best-selling and influential works of sociology, a discipline whose moment had arrived. As early as 1950, David Riesman in *The Lonely Crowd* warned that postwar society was producing a new breed of conformist man. If Americans had formerly been inner-directed, defining themselves through their own goals and sense of worth, the successful individual was now 'other-directed' and

preoccupied by 'getting along', whether with his suburban neighbours or within the hierarchy of the workplace. Six years later, in *The Organization Man*, William Whyte exposed the conformity and bureaucracy of the workplace itself, where success could be achieved only at the expense of the individual, who struggled to retain any autonomy. As a side-effect of processing the American Dream, from television to affordable cars, fast food, suburban lifestyles, even space travel, corporate America was producing a workforce of alienated conformists, addicted to the prevailing norms, risk-averse and fearful of initiative.

In *The Hidden Persuaders*, written in 1956, Vance Packard turned the guns on the advertising industry itself, and its use of motivational research by psychologists in order to target subconscious hopes and fears. Advanced marketing techniques gave greater access to what people thought, and greater control over what they bought. Not without reason is there a much-thumbed copy of *The Hidden Persuaders* visible just behind Don Draper's right ear on his office shelf in *Mad Men*.

Fifties self-criticism was not restricted to diagnosing male anxiety. A different and eventually more explosive take on middle-class America came from feminism. Betty Friedan's famous survey *The Feminine Mystique* appeared in the early sixties, but was written and researched in the late fifties. Married with children, living in suburban New York and working as a freelance writer, Friedan decided to travel the country in 1957 and interview her former Smith College classmates from fifteen years earlier. Nearly all of them were married, with children, living in prosperous suburbs. They were acting to perfection the roles of wives, mothers and homemakers, and responded to her questions with bright reports of happy fulfillment. Beneath which Friedan nevertheless detected an unease, which could hardly be named, but was written into the roles imposed on these women. A 'comfortable concentration camp' was how she summarised the suburban idyll of identical houses, bored commuting husbands, medically tranquillised housewives and materialistic children. 'The feminine mystique,' she concluded, 'has succeeded in burying millions of women alive.'

Betty Friedan's book did not appeared until 1963, and the sixties took the credit for feminism, but it was fermented in the fifties. Again, it was in 1957 that William Masters hired Virginia Johnson as a research assistant at Washington University to undertake what became an epic and comprehensive study of sexuality. Their findings were published only in the mid-sixties, at which point *Masters and Johnson* became part of that decade's hypnotic belief in its own originality and its appointed mission to drive out taboos.

The fifties was a bad time for dissent but a good time for unease. A more educated workforce was no doubt less 'ruggedly individualist' in Hoover's phrase than once upon a time, but it was also finally less biddable. Intolerance of nonconformity served to nurture nonconformity, and a counter culture proper began to emerge with the Beats, a group of younger writers and artists drawn mostly from the middle classes but preferring to stand-alone. Published in 1956, Allen Ginsburg's *Howl* became their mantra, attacking corporate America, its technology, its militarism, its racism, its suburbs, its materialism, its fantasies of rationality, its ideas of progress, its delusions about itself.

The Beats were a side-show until the *Howl* obscenity trial a year later brought them to national attention, as did Kerouac's *On the Road*, released in 1957, with its provocative account of aimless wandering back and forth across the country. The war against blandness was now out in the open,

and it went mainstream in movies like *Rebel Without a Cause*, *The Wild One*, and *Blackboard Jungle*. The critical moment in rock history perhaps took place on February 22nd 1956, when Elvis Presley, a close student of James Dean, released *Heartbreak Hotel*. – 'And although it's always crowded, you still can find some room.' Given their lead, teenagers embraced alienation as eagerly as they had embraced cars, highways, fast food outlets and drive-in movies.

In retrospect it has been too easy to underestimate this decade and its rumblings, as a tame presage of what was to come. But the walls of the city were breached in the fifties. Moreover the energy and naïve glamour of fifties America was carried forwards. When it came to imagery, especially Pop imagery, the sixties raided and recycled the past. If there were fifties icons, such as tail fins, they became iconic only in retrospect. But the sixties invented its icons, and to do so it reached backwards for its imagery.

The easing of the crisis mentality in the mid-fifties had allowed advanced artists to make works that referred, however implicitly, to the everyday American scene, which Abstract Expressionism had attempted to see beyond, if not to bypass. The succeeding wave of Johns, Rauschenberg, Oldenberg, Lichtenstein and Warhol were openly and unashamedly fascinated by the surfaces of American life. Their instincts were Dadaist, but with a new twist, since the public was rapidly becoming unshockable. As ever, Marcel Duchamp had the last word, remarking of the sixties that 'Today there is no shocking. The only thing shocking is no shocking.'

It was an iconoclast's admission of check, at least, if not checkmate. Instead of an outrage, Dada was becoming an attitude to life, part of modern sensibility. Motherwell was deeply interested in the original Dada movement, on behalf of the Abstract Expressionist venture, and like John Cage, whose manifold influence was now felt at large, Motherwell took seriously Dada's denunciation of art as 'elitist and falsely existential'. Cage himself was notably critical of the Abstract Expressionist venture in its more aggrandising vein, while remaining in close sympathy with the work of individual practitioners, Motherwell in particular. They had spent time together teaching summers at Black Mountain in the late forties, and they shared a suspicion of the gesturings of authority, whether on the part of politicians or painters, along with a preference for the ludic anarchism and lucid spirit of Marcel Duchamp.

This spirit was to be sorely tested. If Color Field abstraction involved a turning away from all trace of the hand, or the brush, with its dangerous excesses of affect, and preferred to soak thin washes of paint into the canvas in the interests of an idealised flatness, Pop Art went a step further by rejecting all visible indications of the creative process – all improvisation, all introspection, all gesture, all painterly afflatus, preferring impassivity and distance. It went further than Minimalism, too, in dispensing with Modernism's ingrained urge to abstraction. Its embrace of the actual was open-armed from the outset: 'all the great modern things', in Andy Warhol's mantra. Or as Frank O'Hara famously said, 'I can't even enjoy a blade of grass unless I know there's a subway handy, or a record store or some other sign that people do not totally *regret* life.'

Pop Art claimed to be about recycling images that had already been produced, while in fact slyly reinventing them. Mechanical techniques were not borrowed from commercial art so much as stolen. Similarly, Pop Art's mockery of the immediate past was more complex than simple.

Roy Lichtenstein's 'brushstroke' paintings may parody the gesturalist painters by depicting an excessively violent brush stroke using stencilled dots, but they are also a homage. For what were the originals if not symbolisings of brush strokes, of the fact that art is art? All of which suggests, not the mileage the following generation had put between themselves and Abstract Expressionism, but the length of the latter's overcoat, 'from which we all emerged', as Dostoevsky said of Gogol. Artists like Stella were self-determined, but also self-conscious about continuities, unwilling to lose what had been gained. 'The simplest way to see my paintings is in the way I cannot help seeing them, even now – that they are just very simply extremely closely related to Abstract Expressionism. Their weight, and the whole feel of them, and the whole way you experience them, is sort of the way you would have to experience the American painting of the late fifties.'

———————————————

Motherwell retained an unthinking gift for being in step, and his continuing presence at this new juncture was helped by Frankenthaler, who introduced him to a wide circle of younger artists. Equally important was his innate curiosity about art in all of its manifestations, along with his early and ongoing commitment to the teaching of art. He had worked unassumingly in the graduate department of Art and Art History at Hunter College throughout the fifties, and his summer sessions at Black Mountain College in North Carolina, 'America's college for the avant-garde', were especially conducive to keeping an open mind. Especially when he had students like the young Rauschenberg and Cy Twombly, whose work he had supported from the outset, even writing the catalogue essay for Twombly's first exhibition at the Kootz Gallery in December 1951.

As his range and output continued to expand, Motherwell's identity as an artist could no longer be bounded by Abstract Expressionism, which had lost what coherence it possessed as a grouping. As Robert Hughes would remark much later, reviewing the Motherwell retrospective in Buffalo in 1988, 'the achievements of the Abstract Expressionists have become so encased in legend, so fetishised by the market, that their work has assumed a somewhat fabled air. Like grizzled bison in a diorama, they suggest a lost age of American pioneering. This process has proved particularly unfair to Motherwell, because his full maturity came after the Abstract Expressionist period – in fact, after 1960 – and his career illustrates the perils of generalising about decades, groups or movements.'

Marriage to Frankenthaler opened onto this unexpected second life of Motherwell's art. When they met he was depressed, painting fitfully and drinking heavily. But her diligence and fecundity as an artist, 'which moved me more than I was aware of at the time', was something to steer by, and she encouraged him on many fronts. In the use of acrylics, or in experimenting with pouring and staining techniques, where washes of oil paint diluted in turpentine were applied to un-primed canvas. Or in working with still larger formats and a bolder palette, producing works of a more relaxed horizontal logic, such as *The Voyage: Ten years After*, now in the Guggenheim Bilbao, which measures 70 by 200 inches.

None of this blurred the distinctive differences between their endeavours. Whereas Frankenthaler's paintings suggest flux and a luxuriance of possibility, as if possibility were their very subject, Motherwell's images remain complete in themselves as individual utterances, however much they might formally resist closure and finish, keeping the tension between impulse and thought which remained his personal idiom. His new work was to extend this relation between openness of form

and brevity of statement, and in the most important of his later series, the *Opens*, he would revert to primed canvas to avoid any effects of staining and its continuities.

These contraries, the walkabout of experiment and then the stab of gesture, are played out above all in Motherwell's works on paper. Here, once more, Frankenthaler encouraged him to experiment, and in spring 1961 he made his first lithographs, which marked the beginning of an intense and abiding engagement with print-making. There was a renewed emphasis on collages and paintings on paper, and in 1965 he would remark that 'to this day the majority of my oil paintings are done on paper, not on canvas.'

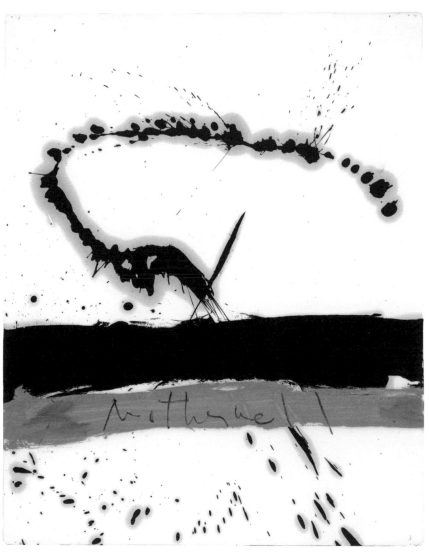

Beside the Sea No.3, 1962
Oil on paper
73.7 x 58.4 cms / 29 x 23 ins

In the summer of 1962, the second summer he spent in Provincetown with Frankenthaler, Motherwell bought a cottage overlooking the bay, on a site where they planned to build their own studios. Here he would sit after a day's painting, on the steps of the unoccupied property, and watch the concrete sea wall being lashed steadily by the incoming tide. Deciding it would make a subject to paint, a premise for experiment, he began by imitating the force of the sea striking the seawall. At first without success. 'It then occurred to me to use nature's own processes. . . so with dripping brush I hit the drawing paper with all my force.' But in doing so he split the paper, and so with thicker five-ply sheets of laminated paper, buckets of thinned oil paint and brushes fixed to yard-long handles, 'I hit the laminated paper with the full force of my hundred eighty pounds, with the brush moving in a six-foot arc. . . like cracking a bullwhip.'

It was a moment of discovery, giving rise as always to a serial exploration of the consequences. Inspired in part by the recent Monet show, *Seasons and Moments*, at MoMA, which focused on Monet's paintings of a single motif under changing conditions, Motherwell pressed on with this new series, and called it *Beside the Sea*. It was his first intensive use of oil on paper, the oil binder spreading and conspiring with the paper, creating a halo effect around the colours. As with the later *Lyric Suite*, in which 'the pictures literally continued to paint themselves as the ink spread in collaboration with the paper'. The haloes seem both to describe the sea spray, and yet describe nothing other than paint itself, its untranslateability. Image after image, about forty works in all, which transmit a throwaway elegance of gesture guided by what Motherwell called the 'natural automatism' of the sea. Taken together, they mark a new commitment to experiment, spontaneity and the possibilities of paint on paper which continued for the rest of his life.

In the same summer of 1962 the Sidney Janis Gallery's group exhibition *The New Realism*, featuring Jim Dine, Robert Indiana, Claes Oldenburg, Lichtenstein and Warhol, marked the definitive arrival of Pop Art in the uptown art establishment. Sidney Janis was Motherwell's dealer, of course, and Motherwell spoke up for what was happening with alacrity and a touch of playfulness: 'I'm all in favour of "pop" art. For one thing, certain parasitical imitators will get off the back of Abstract Expressionism. And I'm glad to see young painters enjoying themselves, which the Pop artists are obviously doing… And I prefer their solution, natural and unforced, to the variously forced, pseudo-Renaissance and naturalistic modes of painting that figure in our time. Bravo for the young! I hope they keep their energy. Energy alone can find the new.'

This was a far cry from the 'You Ruined It For Us' response, which several of Motherwell's peers were tempted into, Rothko in particular being fearful of and fearsome towards younger artists. Far from running out of energy, or being threatened, Motherwell was relieved, and was soon to start in on the second major phase of his career, the *Opens*, by now looking more Madison Avenue than Greenwich Village.

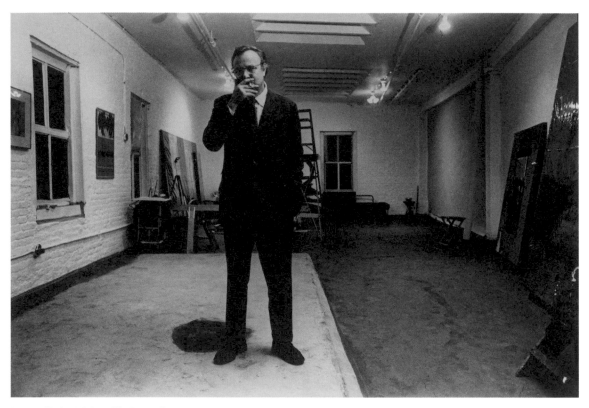

Portrait of Robert Motherwell by Ugo Mulas, 1967

1967: Second Acts

Please do not understand me too quickly

-Andre Gide

It was in March 1967 that Motherwell was stopped in his tracks by the sight of a recent painting, *Summertime in Italy*, propped against another significantly larger canvas in his studio. There was something compelling about their juxtaposition, which caught his attention by 'studio chance', as he expressed it. As always, the studio was the space of revelation. For all his sociability and engagement with the public world, he admitted on several occasions that he felt essentially awkward outside the studio and only comfortable inside its solitude, that his real discoveries were made in direct contact with his materials.

> I had a vertical canvas about seven feet by four feet and had decided not to use its white ground, so had painted it a flat yellow ochre. By chance, leaning against it was a smaller canvas with its back side showing – the wooden stretchers – and in looking at the chassis of the smaller rectangle against the larger one, the two together struck me as having a beautiful proportion. So I picked up a piece of charcoal and just outlined the smaller canvas on the larger one.

At first he planned to introduce free forms or abstract figuration, whether inside or outside the charcoal-marked 'door' or opening, but realised that as it stood this work was all that a finished painting should be, 'that it was a picture in itself, a painted surface plane, beautifully if minimally *divided*, which is what drawing is.' He decided against modifying the canvas further and called it *Ochre Door,* a large quiet work, the rectangle enclosed by a carefully drawn but subtly varying charcoal line, as if feeling its way forwards, which is exactly what it is doing.

That summer, during which he lost his good friend Ad Reinhardt from a heart attack at the age of fifty-four, he decided to move out of the studio he was sharing with Rothko and in October found much larger premises on East Seventy Fifth Street. He brought over some paintings he had stored at the Santini Brothers warehouse in Brooklyn, but he had the large ochre canvas delivered to his home, to see if it was indeed finished or not. He now realised that he liked it better inverted, with the small rectangle descending from the top edge instead of ascending from the bottom. The effect of the rectangle within the plane of blank coloured wall now suggested a window instead of a door, a window opening on itself. It was now a more effortless-seeming image, numinous with possibility, the lines ascending rather than descending, the cage airy, porous and spare. He retitled it *In Yellow Ochre, with Three Lines*.

In the months that followed he explored the possibilities suggested by this first step, as one large canvas after another established the terms for a series. In some of them he used a different colour within the rectangle from that of the surrounding picture plane, balancing the claims of figure and ground. In others, the 'window' is truncated and the verticals reach only part of the way to the top edge. From the outset he was looking for variation, thinking in colour, finding expressive

alternatives within the imposed limitations, trying to get his original idea to speciate, seeing how large a family of forms this new marriage of colour and line might produce. As yet it had no name, nor were the individual offspring numbered.

The idea of calling the series *Opens* would not come about until early in 1969, when Motherwell was preparing for his first exhibition at the Marlborough-Gerson Gallery, by which time he had completed over forty large and thirty smaller canvases in the series. For the draft press release they were still referred to under the general title of *Windows*, until Motherwell happened to come across the eighty-two definitions in the *Random House Unabridged Dictionary* for the word *Open*. These now became eighty-two compelling reasons for the new works to be called the *Open* series. 'For me, those entries are one of the most beautiful poems in modern English, filled with all kinds of associations.' A found poem no less, in the best traditions of Dada and Surrealism.

At the same time, the *Opens* are rooted in Motherwell's evolving story so far, in the changes of direction prompted by his marriage to Frankenthaler, by his response to the new art he was seeing around him, and equally by a return to his earliest most instinctive resources. Another catalyst for change was the major 1965 MoMA retrospective, whose risk of dictating or foreclosing upon his future as an artist was matched by Motherwell's alertness to precisely these dangerous possibilities.

In retrospect, the *Lyric Suite* drawings of 1965 are an act of resistance and rehearsal which helped clear the path to the *Opens*. In April 1965 Motherwell came across some new and intriguing paper while shopping in Chinatown. As always in his descriptions of breakthroughs or discoveries, the moment is told as a story, but also as the opposite of a story: a sudden lesson in chance, an eruption of contingency. 'On impulse one day in a Japanese shop in NYC, where I was buying a toy for a friend's child, I bought ten packets of one hundred sheets each of a Japanese rice paper called Dragons and Clouds... Some weeks later it came to me in a flash: to paint the thousand sheets without interruption, and above all without revisions or additions. Give up one's being to the enterprise and see what lies within, whatever it is. Don't look back.'

The idea of a return to pure automatism, to first principles, was in part a response to being forced to think about those principles by Frank O'Hara at MoMA and Bryan Robertson of the Whitechapel Gallery in London, who were to curate his first major retrospective scheduled for the autumn. Their questions increased Motherwell's awareness of his procedures, and triggered a corresponding urge to return to the unawareness of automatism, together with the wish to say something new before his life's work was 'taken in, in a few glances, in a few seconds', which is how he thought about the retrospective.

A further stimulus was provided by an invitation from Walter Gropius to produce a mural for the planned John F. Kennedy Federal Building in Boston. These thousand sheets of rice paper would allow Motherwell to work on ideas for the proposed mural, and their spontaneity might counterpoint the cool rationality of Gropius's architecture.

Over the course of six weeks in April and May he produced hundreds of drawings, using black and then coloured inks. He set to work in his New York studio, a converted pool hall on Third Avenue, and began to explore how the splashed ink responded to this thin paper, and how the

paper allowed the ink to bleed, creating the haloed effect familiar from his earlier adventures with paint and paper. Each picture would change, would continue to paint itself *after* he had finished with it, a chance meeting of gesture, ink and medium. He worked rapidly through late spring, which was unusually hot in the city that year, so that he often worked naked, his spectacles dimmed with perspiration. The sheets were laid out on the floor, in rows, so that he could move between them blindly, so to speak, without hesitation or correction. As with his account of the origin of the *Beside the Sea* series, Motherwell remarked that the strokes were made 'with as much violence as possible without tearing the paper'. And once again we are made to reflect on the gap between their violent making and their grace or self-containment as images.

Motherwell called the series *Lyric Suite*, after the string quartet by Alban Berg which he played over and over during those weeks in the studio. Like Berg's atonal music, they are indeed works of pure abstraction, in step with the dictates of chance, the painter's sole intention being 'to avoid intentions'. That they should also seem pitch-perfect, as free marks on a small rectangle, is their paradox or mystery. Perhaps his most unrestrained experiment in automatism, the *Lyric Suite* confirmed Motherwell's sense of himself as first and last an intuitive painter.

He took a short break after completing nearly six hundred of the sheets, driving with Helen Frankenthaler to Bolton Landing in upstate New York, the home of their mutual friend the abstract sculptor David Smith. Motherwell returned to New York to continue work on the series. A week later Kenneth Noland phoned from Bennington College to say that Smith had been in a road accident on his way to the private view of an Anthony Caro exhibition, and had been taken to hospital. Motherwell later recalled, 'I drove Helen at ninety miles an hour in the dark night to the hospital, where Tony Caro met us at the door and quietly told us David had died a few minutes before.' The premature death of this closest of friends and artistic allies deeply affected Motherwell. His appreciation of Smith, written for *Vogue* just a few months earlier, reads, in the words of Robert Hughes, as 'one of the most moving valedictions ever offered to a dead artist by a live one'. Having intended to complete all one thousand sheets, he stopped at 600, and produced no more paintings for several months, until after the MoMA retrospective in September. In a sense the unfinished state of the *Lyric Suite* transformed the sequence into another elegy.

Some of the *Lyric Suite* drawings were included in the 1965 MoMA exhibition as examples of his most recent work. The retrospective was long in preparation, Motherwell having spent some of the previous summer in Provincetown in discussions with Frank O'Hara. Helen Frankenthaler had introduced Motherwell to O'Hara shortly after their marriage. At this point O'Hara had recently published his inimitably left-handed *Lunch Poems*, and a monograph on Pollock, and was now assistant curator of exhibitions at MoMA. He and other 'New York School poets' (a parallel universe to the painters) such as James Schuyler and John Ashbery, had been impressed by the *Documents of Modern Art* series, and actively influenced by Motherwell's landmark *Dada Painters and Poets* anthology. Invited to make a choice of curator for his retrospective, Motherwell opted for O'Hara, as a 'poet among painters' who would hopefully share his instincts. 'What I did not want was a historical show, but a show of what I thought, within the boundaries of my work, were the most radiant examples. And I thought I'd have a much better chance of bringing this about with a poet than with an art historian. In fact, O'Hara – maybe because it was his first show fell right back into the art historian thing'. In other words, fell back into what seemed to Motherwell an over-inclusive documentary retrospect of the *oeuvre* to date.

At the same time, the installation was not arranged chronologically but juxtaposed work of different periods, causing possible confusion as well as some doubtful hanging decisions, not least that the large *Elegies* were set side by side on the same wall and overwhelmed each other. The catalogue included statements by the artist based on aphoristic comments made in a long letter to O'Hara, sent while Motherwell was travelling in Europe during the summer, and intended to help O'Hara's block about writing the catalogue essay. These private statements were included in the exhibition, somewhat against Motherwell's wishes, and they rekindled old prejudices about the painter's intellectualism. All in all, 'I felt the show should be smaller, more selective, less verbally detailed'.

His most keenly felt reservation was that he was not allowed to 'edit' certain works for the purpose of the show. 'You can have a beautiful passage in a picture and want to retain it at any cost but ultimately realise that, beautiful as the passage is, it's hurting the picture as a whole, and then you paint it out'. Motherwell was more interested in the idea of a retrospective as an aesthetic whole, with all the self-criticism this entailed, than as a monument to himself or an artistic biography. 'My art is about feeling, organised in a certain way, and there's no point in showing anything that doesn't do that, at its maximum intensity. And that's all I wanted the show to be.'

O'Hara in turn came under fire from his downtown friends for putting on the show in the first place, since Motherwell's paintings were seen by detractors as lacking the violence and home-grown authenticity of Pollock or de Kooning. Too uptown, in other words – too finished, too School of Paris. The reviews were mixed, but they agreed in confirming Motherwell's importance, his unignorable centrality not merely as a painter from the recent and now heroic Abstract Expressionist past, but as a contemporary artist of major achievement and intelligence. 'At fifty, he is entering his prime. The next years may well be his best.'

For the Abstract Expressionists of Motherwell's first generation, or for those referred to dismissively as 'second generation', the mid-sixties were a difficult time, when not only Pop Art but Minimalism with its pre-prepared finish and impersonality, or Color Field painting with its bleached amorphous veils, seemed to define themselves by displacing Abstract Expressionist precepts and practices. The silent questions posed by Motherwell's 1965 retrospective were whether he would remain merely successful – and subtly marginalised – or whether he would find new directions without cutting himself off from his sources.

By now the painter is walking a fine line between celebrity status and something more enduring. He and Helen Frankenthaler would walk along Madison Avenue, the storied art couple, just like Scott and Zelda Fitzgerald from an earlier time, as Lise Motherwell had said. The *New York Times* is asking him for his favourite recipe for their Christmas edition, *Newsweek* publishes an in-depth profile, Alexander Liberman is photographing him in his studio for the autumn edition of *Vogue* and the handsome couple are attending previews of plays, private screenings of new movies, launches of books, private views, with Motherwell delivering lecture upon lecture, Nelson Rockefeller asking for his new painting to be delivered, Peggy Guggenheim wanting the couple to visit her palazzo in Venice.

The New York art world had changed, beyond recognition, from the earnest early fifties to the consumerist hedonism inaugurated to some extent by the opening in 1957 of the brash and dynamic but tiny Leo Castelli Gallery. Upstairs in a brownstone townhouse on plush Seventy Seventh Street, just between Fifth and Madison Avenues, the Castelli space was where a new kind of collector could see the monthly changing exhibitions of Warhol, Lichtenstein, Rosenquist, Jasper Johns, Rauschenberg and Stella. Elsewhere the non-Castelli artists were proliferating, artists such as Tom Wesselmann with his *Great American Nude* series, or Robert Indiana with his *Love* sculptures and ubiquitous screen prints, or Claes Oldenburg with his giant soft sculptures of kitchen appliances and hamburgers. In this new world of money, glamour and eclecticism, Motherwell still cut a fine figure, with Frankenthaler exhibiting her spacious abstractions a few blocks away at the André Emmerich Gallery in the mid-town Fuller Building, along with a more sedate group of painters like Morris Louis and Kenneth Noland, virtually her disciples, and the West Coast giant Sam Francis, the young and hip Larry Poons, who had earlier shown his 'dot' paintings at the Castelli Gallery, the young British sculptor Anthony Caro, Jules Olitski – basically the Greenbergian Color Field school, who were somewhat closer to Motherwell's concerns than the Pop artists uptown.

With his inveterate curiosity and his quick responsiveness, Motherwell had paid close attention to all of these Minimalist and other new departures, and was ready to explore more pared-down possibilities for his own work, while at the same time trusting to his innate conviction about what to paint and which aesthetic ideas to drive forward. When the moment came, and the lightning of happy accident struck once more, he was ready if not waiting. 'The problem for the artist,' he had written in a draft preface to the magazine *possibilities* in 1947, 'is to *wait* until reality speaks to him…'.

———————————

After his initial experiment with *Ochre Door*, later to be renamed *Open No. 1* (which stayed in the collection of Frankenthaler until her death in 2011), Motherwell spent the summer of 1967 in Provincetown, working mostly on collages. Many of which were loosely geometrical, rectangles inside rectangles, old wrapping paper, envelopes, labels, cigarette packs, as if using collage to think through his recent intimations of a new road to be taken. He completed 'about forty joyful and colourful collages' during these months, an activity which he now felt to be 'less austere' than painting, even 'a form of play'.

Beginning in the forties, and inheriting this quintessential modern medium, from Cubism to Dada to Surrealism, from Picasso to Schwitters to Ernst, Motherwell had at first been inspired by what he could *include* in a collage, the variety of materials he could combine – maps, wallpaper, art papers, wood veneers, sandpaper, sand, cloth – and the range of available media: oil paint, gouache, ink, crayon, watercolour. And inspired too by the 'quotations' and allusive effects enabled by the smash-and-grab of collage.

But in the newer compositions an increasingly personal note enters. Motherwell now worked with what might be *excluded*, clearing away much of the external reference, working closer to home and more directly. The same elements are in place, but they are subject to the autobiographical impulse, with its glancing reference to the flotsam of everyday life, both his own life as an artist

and the common culture of the time. He described this anti-heroic and quotidian strain in collage as 'a modern substitute for still life'. If the studio was the place of solitary discovery for Motherwell, his collages now became a way of bringing the world into the studio; the symbolic as well as 'accidental' presence in these later works of the paraphernalia of mail and post and delivery, found objects representing the free exchange of ideas across borders, the arrival of news from elsewhere.

Any individual life is a sequence of the random and unforeseen, 'a swarm of possibilities', to quote Henry James. A biography on the other hand is an arrangement, a stilled life. In real life Motherwell smoked Lucky Strikes, but in his collage life he smokes Gauloises, around whose blue packets he now organises one composition after another, 'exotic to me precisely because in the normal course of things I don't smoke French cigarettes'. And by incorporating Gauloises packets he makes deft and condensed allusion to 'French blue': to the Mediterranean and the palette of Matisse, to Paris and the café society of post-war Existentialism, to the smoke curling upwards in a Cubist assemblage. All of which is subordinated to the present tense of the impulse to arrange, to play. Which in turn adds up to a portrait of the artist in middle age.

If the sixties collages have an airy certainty of gesture, which set the tone for the rest of Motherwell's prolific career as a collagist, those of the late fifties had been more personally fraught, reflecting his period of depression, when he often resorted to using torn papers. 'Drawing by tearing', so to speak, with all this implies by way of violent submission to uncontrol. *The Tearingness of Collaging* is the title of perhaps the most important of these works, whose subject is its very own procedures, at a time when Motherwell came to regard jaggedness, 'the torn rather than sharp or cut-out edge', as his main contribution to the medium.

But his real contribution was something more than this. He had become the only artist since Matisse to alter significantly the syntax of the medium, not least by virtue of his awareness of Matisse and other precursors. Where his Abstract Expressionist colleagues had worked to eliminate everyday evidences, and to move beyond the burden of the European past, Motherwell was at his most original when seeking to assimilate his influences. The obliqueness of collage, above all, breeds unconscious reflection upon earlier art, as well as previous experience – resonances which Motherwell referred to as 'after-images', as if collage were their visual trace. Taking his cue from Mallarmé, he described this art of evocation as 'the effort to express the content of human experience by indirection'.

The *Opens* are equally rooted in earlier influences, starting with self-influence. Motherwell once defined painting as both wall and window, closed and open, and this dialogue had been present in his work since 1941, as early as *The Little Spanish Prison* or the remarkable *Spanish Picture with Window,* just as the *Elegies* started from and kept a strong architectonic impulse, dividing and separating the spaces, however free the expressive means in individual instances.

The metaphor of a window onto a world had of course been the Renaissance model of the perspectival picture, and the *Opens* contain after-images of other artists, whether Piero's

compositional volumes or the memory of Mondrian, whose art had meant so much to the young Motherwell. But above all, the *Opens* are the most evident examples of his dedication to Matisse, the most admired of all Modernists, whose window imagery is especially relevant, particularly in two paintings seen for the first time anywhere in public, in a New York MoMA exhibition of 1966: *Open Window, Collioure* and *View of Notre Dame*, both painted in 1914. The first was perhaps the most abstract work ever painted by Matisse, a vertical composition with four flat planes of colour, blue and black, grey and green, placed in silent apposition. The second canvas is a luminous field of blue brushwork bisected by black lines. Echoes of both are present in the earliest of the *Opens*.

After some nervous postponement, *Robert Motherwell: Open Series 1967–1969* was presented at the Marlborough-Gerson Gallery in May 1969. The show included fourteen of the new paintings, none of which had been seen before, announcing a major new direction in Motherwell's work. It was a brave moment, his first Marlborough exhibition, and the first time he had dedicated a solo exhibition to paintings which were all variations on a single theme. His anxiety was that they would be seen as revealing an artist-in-waiting for an idea, or an artist who had run out of ideas. But younger painters and sculptors, Donald Judd and Dan Flavin, Frank Stella and Larry Poons, or the slightly older Kenneth Noland and Jules Olitski, quite naturally absorbed the new work as addressing actual challenges with which they were familiar. Motherwell in turn was well aware of the efforts and ambitions of his contemporaries. The *Opens* are both a response to Minimalism and an act of resistance to its objectifying of abstraction as a matter of pure optics, which Motherwell referred to obliquely in his eulogy on Rothko, as having the mere vacancy of 'coloured sailcloth rectangles'. Rothko went to see the new paintings at the Marlborough with Irving Sandler, who was suitably impressed but turned to the painter and said he wasn't sure if they were 'felt'. Rothko replied that yes 'it's felt'.

Motherwell's *Opens* explored contemporary questions of form without sacrificing expressive and painterly means. Their brushwork enlivens and complicates even the most apparently monochrome canvases. 'The painting always remains a painting', in the words of H.A. Arnason, one of their most attentive critics – a painting rather than a theorem or a thesis. And how intuitively and rapidly they were executed, despite their often large format, or however 'cool' they might appear. Motherwell said they involved as much of a 'throw of the dice' as his more openly gestural works. And in effect the use of acrylic put an end to editing, for nothing could be changed in these thin stains of colour without disturbing the whole field.

The paintings were slow to sell, but the Marlborough show had good reviews, as demonstrating the historical strengths and ongoing centrality of abstraction. These included a major essay by Rosalind Krauss, one of the leading supporters of Minimalism, which was the cover story in *Artforum*. Motherwell's production accelerated in the months following the exhibition, and he produced forty-seven new canvases, bringing the total at that stage to one hundred and twenty-two paintings, executed over a two-year period. This concentrated outpouring of energy and ideas from 1967 until 1975 testified to what a man alone in his studio is capable of. From drawing just three lines in charcoal - the barest emblem of nature, and placing them on a field of colour - the barest essence of culture, Motherwell eked out a small statement that grows in conviction, until the *Opens* now seem as a series to be among the defining American or for that matter European visual adventures of the twentieth century.

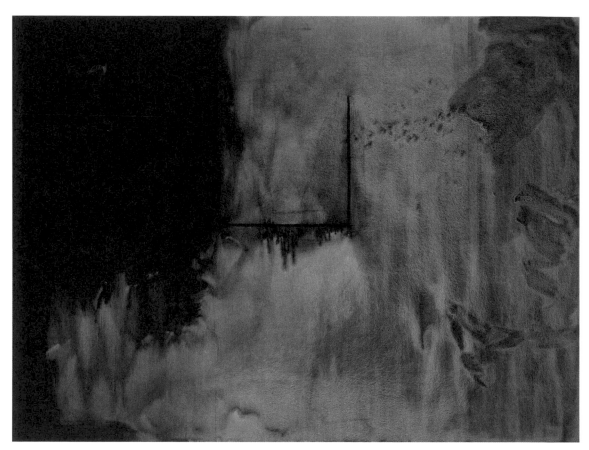

In Plato's Cave No. 1, 1972
Acrylic and charcoal on canvas
182.9 x 243.8 cms / 72 x 96 ins
National Gallery of Art, Washington, D.C.

1974: In Plato's Cave

He was not painting but he was meditating.
In the darkness and this half-silence which, compared
to his previous experience, seemed to him the silence
of the desert or the grave, he was listening to his own heart.
The sounds that reached the loft did not seem to concern him now,
even if they were addressed to him. He was like those men
who die at home alone in their sleep, and when morning comes
the telephone rings and keeps ringing, urgent and insistent,
in the deserted house, over a corpse forever deaf.

-Albert Camus "The Artist at Work"

Until about 1950, the idea that more than a few people would ever form an audience for their work would have surprised or dismayed the original Abstract Expressionists. In Motherwell's words, 'we never expected a general audience'. This is easily forgotten and even difficult to grasp, in view of what was to come, in view of the way we live now. By the seventies, public awareness of abstract art had changed from a rumour to a sounding cataract, not least in the wake of a notorious New York art world scandal which ran its course through the early years of the decade. More generally, the flight of speculative capital to the art market altered forever the way painting and sculpture were experienced, more so than any shift in style or movement. Art prices started to display a spiralling, potentially limitless irrationality. As has often been remarked, only when an object is useless can money regard it as priceless. The favoured artists now found themselves in a hall of mirrors, and their sense of their contract with an audience was subject to new pressures and confusions, especially where they believed themselves not to have entered into any such contract in the first place.

In October 1964 the performance artist Allan Kaprow had published a startling polemic in *Art News* entitled *Should the Artist Be a Man of the World?* His answer was emphatically, yes! The Pollock-inspired version of the heroic, rebellious visionary had been replaced by a Warhol-derived image of the artist as social adept, both celebrity and businessman. 'If the artist was in hell in 1946, now he is in business. The best vanguard artists are rich, just like the middle-class collectors they now socialise with and cultivate.' It was clear that the situation of the successful artist had changed radically. Artists had learned to work the art machine, with whatever diffidence or enthusiasm, and were on their way to knowing as much about the promotion of art as about its production. Conversely, the art machine now worked in increasing symbiosis with the art it purported merely to serve and represent.

In February 1970 Mark Rothko, who was more troubled than any other artist by these transformations, by the 'golden roar' of his own critical success, and by how all of this might affect his work or betray its meanings, committed suicide by slicing his arms. A few months later in the summer of 1970 Barnett Newman was to die of a heart attack in New York. The list of those

who had gone was lengthening. Pollock in 1956, Kline in 1962, Baziotes in 1963, David Smith in 1965, Reinhardt in 1967, and now Rothko and Newman. At the end of his brief tribute to Bradley Walker Tomlin, as early as 1957, Motherwell had signed off with sombre finality, 'Choose any direction on the compass you like, all roads lead to death'. Motherwell's greatest prose gift was as a memorialist. He wrote two short pieces on Rothko, one before and the other after Rothko's death, in which, with his usual clarity, observation and quick insight, he describes the painter's character, what his studio looked like, what his talk was like, his secretiveness, his indifference to the world of objects, his formality, his brutality. Motherwell then considers the paradoxes. That Rothko was a great colourist who banished all natural light from his studios. That he was an abstract painter who insisted his work was pure subject matter. That he was a great painter who 'rather than being compelled, chooses how to treat his subject', and yet this subject, a many-sided despair, chose him and was forced upon him. Motherwell concludes with the words 'Rothko is very real to me, like the people in nineteenth century Russian literature'. It is a remark which typically blends life and art, and Motherwell manages to make Rothko seem no less real to us.

A month before Rothko's death, Motherwell bought an old carriage house with outlying studio in Greenwich, Connecticut, at a moment when his marriage to Helen Frankenthaler was increasingly troubled. In fact Frankenthaler took a new studio in New York at the very moment he completed his purchase of the Greenwich property. In the autumn he moved there part-time, and on Christmas Eve 1970 Motherwell and Frankenthaler decided to separate. They were quickly divorced, after which she kept the house in New York, where he had lived since 1953, and he moved full-time to Greenwich, where he would live and work for the rest of his life.

The move to Greenwich would have decisive consequences for his work in all media, but especially printmaking, which now preoccupied Motherwell more than ever before. In the winter of 1972, after the divorce, he established his own print workshop, buying an etching press and a lithographic press. Here for the first time he was able to set up a studio in his home, with master printers and assistants. He could have his prints made and editioned in the same place, so that comparison with his paintings could occur naturally and organically. He hired master printer Catherine Mosley to work with him in the studio, and began publishing his own editions. She worked with him for almost twenty years until his death in 1991. Print-making is an inherently collaborative process, and Motherwell took creative advantage of a newly-felt need for dialogue. 'I painted alone in my studio for twenty-five years, and it got damn lonely. As I grow older, I feel the need of collaboration and comradeship.'
Motherwell had started printmaking as early as 1943, and in the sixties had produced his first lithographs at Russian exile Tatyana Grosman's Universal Limited Art Editions on Long Island. Now in the early seventies he came to rely on the expertise and sensitivity of master printers such as Grosman, or Ken Tyler, who was renowned for his virtuosity. Printmaking is one of the things that distinguish Motherwell from other artists of the New York School, many of whom made prints, but he was alone in considering this activity equal in seriousness to his other work, in close dialogue with his other productions and in conversation with the Modernist explorations of printmaking by Picasso or Miró.

Motherwell's works on paper, and the exploratory role of drawing, were key to his printmaking, which resulted in over five hundred editions with numerous collaborators. He showed that prints can have the same fluidity as paintings, and the transfer of media was, for him, astonishing. The different stages of a print fascinated him, and he brought to bear his experience and instincts when it came to exploring process and possibility.

Motherwell's large-scale mixed-media collages of the seventies were one outcome of this activity, not least the collaged prints he produced with Ken Tyler, incorporating lithographic reproductions of labels and cigarette packages. The collaboration intensified through the seventies, especially when Tyler moved from Los Angeles and opened his own workshop in Bedford, upstate New York, a short drive from Motherwell's home in Greenwich. 'Print-making is my hobby,' he wrote, 'my mistress'. Discussing their working methods as a team, Tyler described Motherwell's imagination as ruminative, circular and eddying, 'taking its time'. In other words, that the voyage rather than the arrival was what mattered most.

The pinnacle of Motherwell's career as a printmaker in fact occurred quite soon after his move to Greenwich, with the *livre d'artiste* entitled *A la pintura*, based on a poetic sequence of the same name by the Spaniard Rafael Alberti, 'a text whose every line set into motion my innermost painterly feelings'. It was his first artist's book, and he chose to illustrate the poem with variations drawn from the *Open* series, each responding to the short poems in which Alberti celebrates the painter's colours and lines, his brush, his paints and inks. It is Motherwell's truest act of collaboration, in which his images match the verbal resources of each poem in turn, improvising upon them, finding visual equivalents within the straightened resources of his *Opens* vocabulary, and interpreting the poems with considerable imaginative tact. Tatyana Grosman suggested a combination of aquatint and sugar-lift etching to capture the rich colour, hand-drawn lines and brushwork of the paintings. Work commenced in May 1968 and the book was published by Grosman in September 1972 as a suite of twenty one etchings, after four years of exacting work.

Perhaps immersion in the give and take of a printmaking studio, with its tranquil industriousness, was also an unconscious reaction to the compulsions of the marketplace and the race for art as quintessential property. In other words, here was a form of production distinct from the unique work of art as the *raison d'etre* of the gallery system. Here was a place where meanings might yet be safe from the fetish of scarcity value, and Motherwell referred affectionately to the cluster of studios in Greenwich as his 'cottage industries'.

In November 1971 the Rothko family filed a double lawsuit against Frank Lloyd, owner of Marlborough Galleries, and against the executors of Rothko's will. Lloyd and the Rothko executors, who included Motherwell's early friend and advisor Bernard Reis, were accused of conspiracy and conflict of interest in regard to their sale and consignment of the eight hundred paintings left to the estate at Rothko's death. The lawsuit claimed that the gallery had paid significantly less for these paintings than their actual value, and under terms that were disadvantageous to the family.

Motherwell was fully aware of the ethical problems posed by the case, and its personal implications. He had signed up with Marlborough in 1963, following the group resignation of older artists after the 1962 Sidney Janis Gallery *New Realists* exhibition, or rather after Janis's subsequent and wholesale adoption of younger Pop Art figures such as Jim Dine, Claes Oldenburg and Tom Wesselmann. Frank Lloyd jumped at the opportunity to sign up the disaffected artists, and Marlborough became Motherwell's exclusive dealer. But the gallery gave him only two shows in nine years, and he would eventually move to the Knoedler Gallery in 1972 at the invitation of its visionary new director, Lawrence Rubin. Motherwell later said of Frank Lloyd, 'If you are in his power he is ruthless. He knows everyone has his price – Lloyd's potency is money,' adding that 'the degree of sadism at the gallery was unbelievable even for a big corporation. They were catty, bitchy, humiliating, and they treated you like a schoolboy standing in a corner.' Motherwell was in no doubt that Lloyd was the adversary, a watershed figure who prided himself on telling *The New York Times* magazine, with brave New World bravura: 'Why should an art dealer be different? If someone's a dealer, he's a dealer. Many art dealers are hypocrites – they say they're here to educate the public. I don't believe it. For a business, the only success is money. ' Or, as he provokingly told one reporter during the trial, 'I collect money, not art.'

Lloyd certainly believed in living by the sword. In the event, after four years of litigation the Rothko family won their case. All contracts between Marlborough and the estate were declared void. The judge assessed damages of nearly ten million dollars against Lloyd, Marlborough, and the Rothko executors, excluding legal fees. It was on all counts an unprecedented affair, and the most punitive outcome ever to involve an art dealer. Lloyd left the city under a cloud and retreated to Nassau, where he would end his days. A number of artists, including Motherwell and the Pollock Estate, abruptly departed the Marlborough Gallery.

The Rothko Conspiracy, as it came to be called, consolidated in symbolic form and amid a blaze of publicity the new understanding between art and money, a process which had perhaps begun as early as 1957 when the Leo Castelli Gallery opened in New York and within ten years became the financial hub for Pop, Minimalism and Conceptualism. As Motherwell had written in 1954, talking in the present but speaking to the future: 'One *can* understand, though it is curious to think this way, that a Picasso is regarded by speculators as a sounder investment than French Government bonds; but what a peculiar responsibility or circumstance for a solitary artist. Indeed our society, which has seemed so passive in its attitudes towards the artist, really makes extraordinary demands upon him: on the one side, to be free in some vague spiritual sense, free to act only as an artist, and yet on the other side to be rigorously tested as to whether the freedom he has achieved is great enough to be more solidly dependable than a government financial structure.'

Early on in the unfolding Rothko affair, and with his innate sense of timing, Motherwell accepted an appointment as distinguished professor at Hunter College for the academic year 1971-72. For much of the forties and fifties he had been a dedicated teacher as well as a working artist, and earlier had undergone eight years of university studies. When asked in an interview about this aspect of his life, he acknowledged that the university was a respite from the venalities of reputation-making and the market-place, or the monopoly of opinion wielded by art critics in a visually naïve world. In effect Motherwell treated the university and the market as two sides of a triangle, remarking of his academic affinities, 'I come in as my own man, and because I'm in no way a threat to them, I'm treated as my own man.' Avoiding the politics of college life, but equally

establishing an interval away from the New York art scene and the realities of Fifty Seventh Street. 'I move back and forth, in the same way as I go from Europe to America on occasion to get a perspective, to get a relief from the immediacy of the struggle or whatever.' These were among his defences against the logic which cornered Rothko and others.

In autumn 1971 Motherwell began living in Greenwich full-time. Shortly afterwards he met a German photographer, Renate Ponsold, in the company of Jasper Johns and Bob Rauschenberg. They soon began dating and, with Motherwell's usual decisiveness, were married the following August in Provincetown. Away from New York, calmer and happier, his work proliferated once more, in painting as in other media. In the same month he made one of his most resonant and allusive works, a large black *Open* painting originally titled *Dark Open*, which he later re-titled *In Plato's Cave No. 1*. It is a *grisaille* study, in smoky greys and ashen whites, which preserves the form of the *Opens*, but communicates a different emotion. Its heavily modulated surface, achieved by applying thin washes of black acrylic paint and then rocking the canvas to allow the paint to spread fitfully across the surface, suggests shifting and imponderable depths, as if some momentous and populous but inscrutable event were unfolding before our eyes. In places the coarse texture of the canvas shows through, or is elsewhere obscured by layers of paint. We are in Plato's cave, a realm of shadows where ghostly semblances parade before viewers who are doomed to mistake the images they see for realities.

In the summer of 1974, as a large new loft-like space was being completed in Greenwich, referred to by Motherwell as 'my New York studio', he suffered an acute attack of pancreatitis and was hospitalised for several weeks. Surgery was scheduled for the autumn. During the Provincetown summer he continued to paint as though each day were his last, creating thirty works in two months. He began four significant new *Elegies*, which he would complete on returning from hospital, but during this time he also produced new *Opens*, one after another, 'elegant, light-filled, exquisitely formal and seemingly effortless works' with titles like the apprehensive *Premonition Open with Flesh over Grey*, or the opulent *Summer Open with Mediterranean Blue*. The second is a horizontal tone poem about sea and sky and light, not in the least descriptive of such things and yet extraordinarily communicative and eventful, an atmospheric blue masterpiece as airy and down to earth as a Matisse.

In October he underwent a series of five operations at Mount Sinai Hospital in New York, including the removal of his gallbladder and the installation of a temporary pacemaker, as his heart rate had jumped to over one hundred and sixty beats per minute. During these procedures he nearly died, but within two weeks was well enough to return home. Shortly he would be celebrating his sixtieth birthday, ten years after his MoMA retrospective and ten years before his Guggenheim retrospective. In between, in the summer and autumn of 1977, the Musée d'Art Moderne in Paris mounted their own retrospective. It was Motherwell's most comprehensive exhibition anywhere to date, one hundred and forty three works in all media, including many which had never been seen before. Significantly the show received proper coverage in the New York press, one review entitled *Paris's Prodigal Son Returns*. It was as if Motherwell's dual artistic citizenship had finally been accepted and ratified by America.

In November 1974 he had been invited to paint a large mural for the new East Building of the National Gallery of Art in Washington, to be sited near two other commissioned works, a large mobile by Calder and a tapestry by Miró. Working intensely between November 1977 and February 1978 he completed the mural, which he called *Reconciliation Elegy,* and in June the building was opened to the public. The work was expanded from a small rapidly executed sketch, and Motherwell came to feel that its monumental finished scale stood in an uneasy or unresolved relation to its spontaneous origins, a problem which preoccupied him perhaps for the first time in his career. It was the problem of Picasso's *Guernica*, in a sense, that of the public work of art in an age when the artist no longer has a natural position in society, something Motherwell had thought about for all of his working life. The example of *Guernica* remained crucial to him throughout his career, even if in the early forties he had already decided that the preliminary drawings represented Picasso's true voice, and that *Guernica* as such was something else, an expression by Picasso of solidarity with his fellow men. And that here precisely lay its difficulty as a work of art. The problem was now more present for Motherwell and more exacerbated than ever before, and *Reconciliation Elegy* could restate it but could not resolve it.

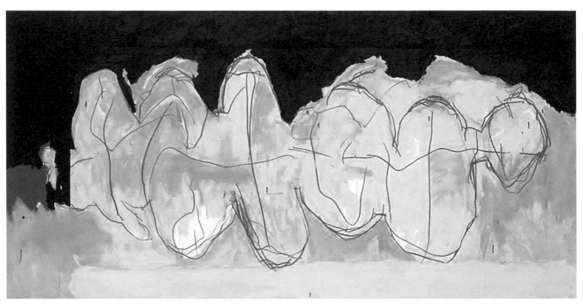

The Hollow Men, 1983
Acrylic, charcoal and graphite on canvas
223.5 x 447 cms / 88 x 176 ins
Art Gallery of Ontario

1983: The Greatest Adventure

We are the hollow men
We are the stuffed men
Leaning together
Headpiece filled with straw. Alas!

— *T.S. Eliot, 'The Hollow Men'*

Motherwell produced major works until the very end, with gusto and concentration. Each decade had produced its own crop of images, changes of direction, shifts of emphasis in terms of media and materials, and the eighties were no exception. Between February and April 1983 he painted a canvas he called *Ulysses' Crew*, then retitled it *The Hollow Men*, the first of a new series which would be the last addition to his family of forms.

Seven feet high by fifteen feet long, *The Hollow Men* is a parade of ghostly shapes, jostling each other horizontally from left to right, mere outlines in charcoal, eviscerated and yet filled with straw-coloured or ochre-coloured or brilliant yellow acrylic, full of texture and tonality. The ovoid shapes are loosely defined, threaded together with looping charcoal and graphite tracery, all of it set against an uneven backdrop of black infinity.

Motherwell remarked on these figures as having the look of people, 'not only straw men, but a funny kind of group resignation', and his working title evoked the passive, easily dispirited but mutinous companions of Ulysses on his disaster-prone voyage home in Homer's *Odyssey*. Behind Motherwell's final title is of course T.S. Eliot's twenties poem of 'paralysed force, gesture without motion'. And behind the arras of that poem lurk the 'hollow men' of Shakespeare's *Julius Caesar*, a conspiracy of figures blinded by their cause, or undone by the arbitrary nature of human allegiances, men who make a show of solidarity but 'sink when tried'.

Motherwell's abstracted figures are linked or chained together in a drama of doomed mutuality. They may refer to many aspects of contemporary reality or the marketplace. But it is an unspoken drama. They do not stray into the realm of figurative meaning, and Motherwell's resistance to figuration lasted until the end. While engaged on this work, in March 1983, he gave a lecture at the Cooper Union in New York entitled 'Kafka's Visual Recoil', which focuses on a forgotten episode from 1915, when Franz Kafka's publisher proudly announced that he had commissioned an illustrator to do a frontispiece for the story *Metamorphosis*. Kafka was horrified, and pleaded: 'The insect itself cannot be drawn. Please, not that – anything but that!' Motherwell reflects on the significance of this moment for a painter of his generation, and on how his own lifelong aversion to figuration was itself a version of Kafka's 'recoil'. Both reflect the promptings of inner necessity, but are also responses and resistances to what the age tried to demand of them as artists.

The commitment to abstraction unites all of Motherwell's styles. It is their family face, their point of essential convergence. The linked curvilinear shapes of *The Hollow Men* evolve directly out of the *Elegies*, whose solid ovals and verticals now become transparent, drained or emptied

out. The subsequent canvases and numerous sketches in *The Hollow Men* series explored these connections, and were made in tandem with new additions to the *Elegies*, so that the two series become intricately related over the course of this decade.

The oval shapes of *The Hollow Men* have quite different connotations to the *Elegies*, but the same expressive rules are being followed and tested, as is likewise true of the *Opens*. It is as if, rather than ending where it did, Abstract Expressionism started something that could be played out in moods and contexts quite different to its original moment – in the here and now of an endless and continuously restated questioning of form. This is surely the only adequate way to understand the persistent afterlife of the movement.

––––––––––––––––––––––

In October 1983 The Albright-Knox Art Gallery in Buffalo presented the first full-scale retrospective of Motherwell's work in the United States since 1965. It travelled to Los Angeles, San Francisco, Seattle, Washington D.C., before closing at the Guggenheim Museum in New York in December 1985, in expanded form. It was not a huge affair in terms of the number of exhibits, but the virtues of a life's work were more distinctly in evidence for being uncluttered, and viewers registered its breadth, subtlety, discipline and lucidity, early and late, its polarities of gesture and geometry, spontaneity and structure, awkwardness and elegance.

Apart from de Kooning, by now suffering from Alzheimer's disease, Motherwell was the only member of the original New York School still at work in the numbed, knowing and ironic wasteland of American art in the eighties. Arthur Danto's 1985 review of the Guggenheim exhibition countered any suggestion that the heroic approach to art exemplified by Motherwell's triple career as thinker, maker and intermediary was in any way refuted or diminished by what happened in art after Abstract Expressionism. 'It is a sobering thought that the words of appraisal one wants to apply to these works – elegant, thoughtful, austere, intellectual, critical, aristocratic. . . are almost terms of studied abuse in the art world of our time. In this sense Motherwell's paintings stand as a mirror of our age: in their grace we see our tawdriness.'

While helping to install the Albright-Knox exhibition Motherwell suffered severe heart palpitations and needed to be flown home before the opening. The productive years that followed were punctuated or interrupted by ailments and operations, and by warnings from his doctors that he must quit drinking and smoking. Which amounted to asking that he abandon his solitude and his studio, his most engrained habits of being and working. Concerning which he once remarked to Bryan Robertson, 'It never occurs to me to have a figure doing anything in my work, its presence is sufficient; and I suppose it rarely occurs to me to do anything much in daily life except feel my own presence'. It is the most obliquely revealing remark he ever made about the strangely successful union of his productivity and his personality, 'his raising of a magisterial syntax of form over an undrained pond of anxiety', in Robert Hughes's words.

Motherwell's lifelong involvement with sea and shore permeate his art, whether in the Provincetown series *Beside the Sea* or in the collages and paintings of his *Summertime in Italy* series, done in Liguria in 1960. He responded to light and colour with unthinking immediacy, but he also took long views. The subjective life of these images is quite different from that of the Impressionists, who sought to preserve in its freshness the first moment that something is seen. Motherwell aimed instead to register the look of something after it has been seen, in recollection. He said in an interview, 'I am often affected by places *after* I leave them. When I was in Oregon, I painted France; and Mexico for a time became dominant in my painting after I returned to the USA. It takes me a long time to absorb impressions of place…'

Put differently, he thought of what was here and now, or even of what was to come, as an after-image of what had been. More than any other artist of his time, he attempted to situate the moment in which he participated, as if to include its rejections of the past, and no other artist has considered the nature of abstraction with more dedication, intellectual determination and candour. He would have been unsurprised by the claim that the triumph of American art in the sixties could not have happened without the 'heroes of the forties'. It is a subject on which Motherwell should have the last word, as it was given to him to have the longest view as a survivor:

> 'I suppose most of us felt that our passionate allegiance was not to American art, or in that sense to any national art, but that there was such a thing as modern art: that it was essentially international in character, that it was the greatest painting adventure of our time, that we wished to participate in it, that we wished to plant it here, and that it would blossom in its own way here, as it had elsewhere, because beyond national differences there are human similarities that are more consequential.'

1991: The Heart is a Lonely Hunter

In the summer of 1941 the twenty-six-year-old Robert Motherwell was travelling in Mexico having met his muse, the vivacious and mercurial Maria Emilia Ferreira y Moyers, whose portrait he was already painting and whom he would marry the following August.

Fifty years later he was in an ambulance rushing to the local hospital on Cape Cod but would die from heart failure on his way there. On July 16th, at four in the afternoon, he had a major stroke. It was all too late. A life of drinking and heavy smoking and of stress had finally taken its toll and although his doctors insisted he immediately stop the drinking and smoking, following a minor stroke ten months earlier, he would not give up his lifestyle.

At the time of Motherwell's birth in 1915 even the very best American art was completely in the shadow of European art. By the end of his journey in 1991 the situation was reversed, European art had become dwarfed by American art, very much due to the giants Motherwell, Pollock, de Kooning, Rothko, Newman, Still, Kline and a handful of others.

Motherwell was unusual among his peers in treating the past with nothing less than the full power of his creative attention. The past was never a foreign country for him and he would return to it all his life, searching for clues. He understood that the future is unreachable without looking backwards.

At first, in the early years, he was in the shadow of the bigger names in the Abstract Expressionist movement. He never thought of art as a competition but as a conversation among equals. In this sense he was the prince travelling incognito. The thinker, the traveller, the collagist, the hesitant painter on a grand scale and in the grand tradition, the bon viveur, the serial monogamist, the connoisseur, the master printmaker, the loner, the shy individual, the stylish public figure, the accomplished poker player, the impassioned educator, the depressive with alcoholic tendencies. He was all of these people.

These artists, from all over Europe and also California and even New York, a brave and elegant Band of Brothers, somehow got together in a small corner of Manhattan and fought off the enemy, held the citadel of a courageous, innocent and noble new art, held it fast, made a new art, forged it from their very own blood and sweat, most losing their lives prematurely, some taking their lives prematurely, leaving Motherwell the last warrior fighting to the bitter end, with a strange set of rules of their own, a particular kind of integrity and honesty and love but a far deeper one than that of so many who just talk of it and hide. Who loved their wives and mistresses in a strange unorthodox sort of way.

Every one of them gone, with the exception of the sturdy little Dutchman, Willem de Kooning, now suffering with the advanced stages of Alzheimer's disease, all heroic straws in the wind, their work now done but their paintings and sculptures destined to survive for future generations, with Motherwell's paintings and drawings and collages dating from 1990 and well into 1991, the final testament of a great moment.

Motherwell never lost his faith in Modernism, with him it was more than just a style, rather an ethical way of living, and as time has gone by, decades since his death, it becomes more clear that he is a greater artist than he is merely an Abstract Expressionist. He can transcend his own time or school and

become an artist in his own right in the long tradition of art making. Not the most attentive husband perhaps, or father for that matter, but like all the great artists, whether in painting or music or words, he poured every part of his mind and body into creation. He never wavered, even when he did take time out on several occasions from excessive drink or deep depressions, from his beliefs. Constantly going in and out of focus – but always coming back into focus.

The vision was multifaceted. His desire to get to the truth scattered in so many directions - as we step back from the half-century of his career it becomes clearer and clearer that the whole venture holds together like a giant jigsaw puzzle and we ourselves have to put the pieces in place, the various techniques and materials he worked with, the enormous outpouring of words he produced, the generous lectures and talks and tutorials he delivered, the vast tomes he edited – but it all centred around one expanding vision he brought to the world that mainly was his making of art, whichever way he decided to make it. As it involves so many different works and approaches to these works, more time needs to go by to absorb the whole story, perhaps yet a further half-century.

It is only seventy years since Motherwell and his friends began making their contribution to the story of art, so it is too soon to decide which of them will survive permanently and it is certainly much too soon to place them in any order of importance. At the end of the day it will be the pictures that survive, as the stories become less and less well known. The paintings will eventually have to take their place alongside their predecessors and the interested public will have to make up its own minds.

For many decades to come the names can be rejigged by the professionals, but in time they too have little relevance. Whether from wisdom or anger, many creators of art or music or literature have felt themselves raw and exposed. In recent times we can recall the hurt Cézanne felt when he said: 'Professors are bastards, eunuchs and jackasses; they have no guts.' Or Hemingway exclaiming 'To hell with the critics.' And to be so unforgiving to the non-creative fraternity there is Picasso's remark 'Dealers are a necessary evil.' Some will say it too soon or too much out of anger, but time eventually becomes the greatest critic.

It will take more decades before there is a decent answer to questions such as was Motherwell the best of the New York School, or was Abstract Expressionism as great as the forties and the fifties champions of the movement declared? It just seems that Motherwell's images resonate more intelligibly and powerfully than those of his fellow artists and that in time the world will see it more clearly. But that is just one person's point of view.

We will have to enter a cathartic era of unlearning, a purgation of what the art world scholars and scribes laid down in their wordy texts. In fact, we are surely in it already. The royal days of the New York School's brooding intellectualism of the forties and the fifties are over; followed by perhaps more popularised art of the sixties and the seventies, right into the eighties when the New York scene has started to lose some of its huge power, certainly in the international world of art.

Motherwell saw it all coming. He was central in bringing the new American art in, way back then in the forties and he lived long enough to witness its slow–dying days in the eighties when money became the deity and the arbiter of all value. *The Hollow Men*, which took up much of the eighties for him, is evidence that he saw and understood what lay ahead for him and also America. And his lament was that 'the artist's function is to retain integrity in a corrupt world which seduces and destroys all of us.'

But what American culture brought to the world from the turn of the last century until late into that hundred year period was enough to inspire the world, probably until the end of the twenty-first century.

Nobody knows if it would be able to compete with the miraculous age of ancient Greece and Rome but it surely has a level of protean glamour, energy and innocence such as the world had never seen before, with its sub-plots, of Hollywood, the musical, recorded music, photo-journalism, television. And, banal as it may seem, to put this particular age against perhaps man's greatest achievements, there is definitely something uncanny and awesome about an age that gave itself and the rest of the world so much. Many of those who made America so American have probably never even heard of Robert Motherwell or worse still, don't give a fig about his work, but they should feel lucky to know that he was there and what he achieved. It lies in the very fabric of twentieth-century America, passionately rooted in the best of the Old World and the best of all the world for that matter, and will go forward into a happy and brave and thrilling future.

But the artist has left us a big clue. If you look with care at the paintings made during those last months of his life you can catch a glimpse of a man entering a deeper greatness, not unlike late Rembrandt and Titian, and see the power and tragedy of approaching death. You can see it in *Elegy to the Spanish Republic No 172 (with blood),* which is one of the most powerful and moving in the entire series. Or even closer to his death, *The Grand Inquisitor*, a huge canvas in *The Hollow Men* series. And, nearer still to his last days, the magnificent *Mourning Elegy* and the gigantic *Mexican Past*, on to the frightening *Either* and then, the last known completed work, *Massive Image*. Or even like in late Matisse, you can see the very joy of life in *Mediterranean Door*. The Mediterranean, a place Motherwell perhaps yearned to revisit, in the full knowledge that it is the cradle of our civilisation and aware too, of our insignificance in the whole story, with its aching sense of space and light, sun and sea. These clues show his true greatness, something not to be seen in any of those other giants.

The way to the beach is just through the alleyway. You can easily see it through the privet hedges and the extremely tall and lean young man ambles down to the water to look back at the promontory, a narrow curving spit of land surrounded by sea. Here they would scatter Robert Motherwell's ashes, on his beloved Cape Cod soil and on the lawns of his home and studio in Greenwich, Connecticut.

Coda

I have been one acquainted with the night.

– Robert Frost

The material world slips away, the world of friends and foes, ex wives and his last, Renate Ponsold, academia, responsibilities, and now it is early evening and Robert Motherwell slips into the lonely, private and magical cocoon of his Greenwich studio. The world now disappears. Renate had made him dinner and he has sat and eaten with her, but now it is time to escape into his real world, one that he has already fought and won battles in. This is his domain and nobody and nothing can touch him here. The artist, constantly restless and inquiring, has his brushes of various thicknesses and widths and his canvases of various lengths and heights and his tubes of colour that go to his very soul, his blues, his greens, his ochres, his reds and especially his blacks, all are ready for him. He will be here, alone, virtually every night, to find his visual truths. This is now the nineteen eighties and he is alone more than ever before. So many of his friends and colleagues are now dead, his fellow artists from the distant forties and fifties, Jackson Pollock and Mark Rothko and Barnett Newman, Clyfford Still and James Brooks and David Smith and Arshile Gorky. The list seems endless and it weighs heavily on his heart, which is the most vulnerable organ in his huge body, the most vulnerable in both emotional and also in physiological terms too. One other giant remains and that is Willem de Kooning but he now has just started to succumb to Alzheimer's disease. Tragically alone in his private space, which can become huge and free and full of optimism can also a week later or a month later, or even an hour later, be like a prison which he has built for himself. The inspirations will surely come and go as his moods swing around in his head. The word *genius* is quite possibly hovering in this room, a word saved for giants such as Beethoven and Rembrandt and Shakespeare, but this particular artist is striving for or is in a state of genius, a pitch for true greatness that had eluded his now dead colleagues but which he reaches out for and has the chance to attain. As he struggles with his existing themes of the *Elegies* and the *Opens* he begins to enter a new subject, one based on the enigmatic and multi layered poem *The Hollow Men* by a true genius of the twentieth century, his fellow American T.S. Eliot. The poem, which can have many interpretations and so many different meanings, with its cunning passages and separate meanings, has got its hold on the artist, who is now approaching his seventies and can identify with its dark truths. It could well be that he felt the people around him were hollow men, stuffed with straw. Skeletons and scarecrows. Where is Jackson? Where is Barney? Where is Mark? Where is David? The studio is his channel to pass all these feelings, to wrestle with life and death. Even his distant romance with Lorca is right here in the studio and he is one with him. The primitive spear fisherman stands erect and tall and vulnerable, waiting for the perfect fish to skewer, the artist in his perfect environ, waiting, patiently, for the ideal intersection of subject, idea, materials and conviction. *The Hollow Men* feels so right to him. As he told his assistant, John Scofield, in an unguarded moment, by being a painter he was at least his own man, unlike his father who had to answer to those above him at Wells Fargo Bank. Even though he was the President he had to defer to those above him, those Hollow Men. His enormous fear of death is strong inside him, even from a young age when he suffered severely from asthma, and although he would continue to drink heavily all his life and remain virtually a chain smoker, although the elegant Californian of high breeding could probably never quite bring himself to light one cigarette from the embers of the previous one. He had escaped the drudgery of the life of a banker, just as his hero Paul Cézanne had avoided his

father's wishes to take up the same decent career, just as Cézanne's hero Piero della Francesca had slipped away from the network of his father's successful world of trading. He had outlived all the others but he had outflanked them all too. The young man from California had risked everything to move to New York City to be with these artists, some nearly a whole generation older than himself, to be their ally and rival and eventually to go where they had not gone and make paintings that surpassed his and their work of the forties and fifties and sixties, until he reached a new height and new territory, from the primal *Elegies* to the cool and contemplative *Opens* and then - now - the final outburst of *The Hollow Men*, when he looked death straight in the eye, not the death of the tragic Spanish people of the Civil War but his own inevitable death. Motherwell has chosen an American poet as his inspiration for what will become his last and most tragic series of paintings but the poet, although from his own continent, was as much a European as anyone could be and very much a poet of the world, living in London, steeped in ancient languages and religions and especially Buddhism, a poet endlessly circling the very substance of existence in today and also obsessing over matters of life and death. This painter's subject is always of life and death and his shared vision European, from Lorca's diabolical duende to Matisse's joyful cut-outs from the master's last years, when his hands had closed dramatically from advanced arthritis but his soul so open, and filled to the brim with tearful joy. The painter is adopting and adapting a lifetime's learning and looking at these masters and he takes his own bearings to make his personal continuation along the path to the truth. And so he chips away at the great tradition of making a great universal art and takes some minuscule and timid steps forward, not the jagged rupture of Pollock but more a link, a seamless trajectory from Matisse and Kandinsky and Malevich and Mondrian to the next turn of the path. Motherwell never for a second questions or doubts the one and only path of abstraction he knows he is 'right'. And so in his unwavering confidence that abstraction is indeed the only path forward he paints *The Hollow Men*, tentative and fragile works of high art. Like skeins of yarn pirouetting across an emptied out *Elegy*, dancing lightly across strong yellows and ochres with hints of maroon red and yet practically overpowered by his faithful black, the ochres of the earth and the blacks of power and inevitable death. The small talk and the camaraderie of the day have passed and alone he moves the brushes of various thicknesses across the canvas. This is the night, and the day's staff have long left the Connecticut studio and while they sleep after an evening of fun in Greenwich itself or maybe New York City, the artist is grappling with mortality and the need to eke something out of the basic but powerful forms and just using yellow, ochre, black, red, or rather joy, earth, death and blood. All he can do is struggle and wait for the right moment to strike, or sit anxiously, light another cigarette and hold lightly onto his glass of scotch, occasionally amble over to his trusted friends his books and skim *The Waste Land* or *Ulysses*. He has recently adopted the habit of having an afternoon nap and this recharges his energy levels for the long and demanding evening ahead. Nobody is ever present in these hours, filled with fear and joy, frustration and euphoria, anxiety, discovery and waiting and hoping for a breakthrough, pains and aches after years of ill health, victories and losses. He must continue to keep all his options open, to allow the inspired moments to just pour in and to take full advantage of them when they do arrive. Even Clyfford Still and Philip Guston are gone now, both dead in 1980. One from cancer and the other from a heart attack. They weren't the closest of his friends from those earlier days but they had become his soul mates. Some of these are extremely large canvases, some very small. Some seem quite empty and slight, ghostlike. Eliot's *Hollow Men* can have endless meanings depending on how you read it, or want to read it. Soul mates. Yes, they were on the same team, fighting the same cause. They felt it was America's moment to replace Europe, especially Paris, and make New York City the new hub for Modernist art and so modern art, even art itself. They had the collective talent and intelligence and they had the necessary vision, a new art with various names such as Abstract Expressionism but it was the title, the New York School, named by Motherwell himself that made the most sense. But that

was long, long ago and they were all dead now, except for Motherwell and the sadly debilitated Willem de Kooning. The age had ended and the forties and fifties are now a chapter in modern art history already, but that was nearly thirty years ago and even the movements that followed this heroic period, Color Field painting, Pop Art and Minimalism are now also history. The weight is so heavy on the last man standing that a lesser artist would collapse under the pressure. But Motherwell is made of much tougher stuff. His enormous intellectual powers, his will to continue and especially the vision still flowing fast and furious, enables him to go to the studio each night and paint it out. They were all dead but him now. Just about every one of them victims of alcohol abuse followed by suicide in one form or another. But still he fought on. His older daughter, Lise, said that he told her he felt he should go the same way as Pollock and Rothko and Smith and many others but he wasn't brave enough to take his own life. She said that he told her that he chose the slow route with alcohol and smoking, which his doctor forbade him to do on many occasions and which ended in the heart attack that did in fact kill him. The reason more likely was that, unlike his friends he had plenty more to say on the canvas. He was able to re invent himself over and over again, with steel-trap intellect and with his phenomenal knowledge of things ancient and modern, and so the juices continued to flow. And now, on what would be the home stretch, he carved out a vision of the *Hollow Men* and he patiently sits in this vast studio and waits. He doesn't socialise an awful lot these days and anyway he hates private views. He is a quiet and private man and what is seen as aloofness is in actual fact just his shyness. Why go to openings? For which artist? Just about every one of them whom he truly admires is dead now anyway. Perhaps the odd reception to receive another doctorate or accolade or a party given by his neighbour on Cape Cod, Norman Mailer. He still yearns for acceptance and he swings from having a high opinion of himself to having a low one, both personally and also of his work. It does seem unlikely that any of his forties and fifties friends, if they had survived into the eighties, would have had new things to say on the canvas or even unlikely that they would have had the inner strength to go deeper into their subject, or even meet the high standards they set themselves decades earlier but Motherwell alone is achieving this daily, this complicated and haunted man is reaching new and great heights again. When he and his friends were starting out on the path they were young and their eyes and minds were wide open to the necessary change and they all knew the difficult path they needed to take. But youth has the ability to cut through the brambles and reach the summit. It can be heroically heightened by the genius of Einstein or by the true greatness of artists in a hurry such as Keats who coughed up dark red blood, that told him he was dying of tuberculosis, or the youthful Chopin who also knew he hadn't long to live, due to the same disease. With full urgency these young Americans sparked ideas off each other continually. In reality they were well beyond youth and were adults who had kept their youthful traits and probably bought into Brancusi's mantra which said that when you are no longer a child you are dead. Just like the actor dressing up as Napoleon can seem foolish to himself thinking he may actually be Napoleon, so these Abstract Expressionist artists, now in their thirties and some even well into their forties would have moments of doubt that making abstract marks on a canvas is enough for a grown man to do with his life. Perhaps that was why so many of them decided to take their own lives, but Motherwell now continues on the road he decided to take some forty years ago, from the monody of the *Elegy* of the forties, through the cool and ultra Modernist *Opens* of the sixties through to now, the dark and tragic world and the hollow vale of *The Hollow Men*. From his very early upbringing he was never one for jostling with the hoi polloi in the forum, never one for guff, although he does remain humble and filled with doubts. He may need a strong drink to get him through the long night. The fine lines dangle and dance across the bold yellow shapes, strokes as fine as a hairspring and, he always the full artist, the compositions can be read not just as tragedies of old age but also paeans, and whole groups of fragile marks on the canvas can so easily go phut but all that he has learned and wrestled with come into play and he can hold the

whole work together as if by magic, he the tightrope walker, suspended loosely, he the meta-physicist, the scholar of religions and philosophies and literatures ancient and modern, he the lover, the big and tall man so full of passion and unshakeable beliefs, he the humble artist so full of doubts, alone and anxious, the brushes and tubes of paint, of colours of the land and sky and colours of life and death, perhaps a dash of untouched mauve may save the day here, thoughts of Aberdeen on the West Coast far away in both time and space, where he was a happy child on the beach, calling up everything he has ever known, but he does not pour it out onto the canvas in huge globs of paint and melodramatic emotion but distils it so carefully and lets it loose with enormous dignity and respect, like a chemist in his laboratory who treasures his chance discovery, like a gold prospector in the Klondike, and just like them he cherishes the moment. He rushes across the studio floor to find a wider brush for a passage of black to cover a substantial portion of canvas and on the way back to the canvas he passes a postcard of a Piero della Francesca pinned to the wall and another, Mont St Victoire by Paul Cézanne. The painting is now going well. A new force of adrenalin gushes through his body. The painting will be really big, fairly slim and very long and actually a new colour for this artist appears, a sort of corn-colour, no, more straw-coloured. Although it is an insignificant "thing", it is also a pale yellow colour. His mood swings are strong and never-ending, finding his strength to go forward and possibly enter a funk and losing the choice to push on for a while. But now it is good, very good. He doesn't need to "catch at a straw" to try, a hopeless expedient in desperation. The inspiration is high and slightly overwhelming. I can see the painting! I can feel where it needs to go! Yes, it is all falling into place. The painting will in a sense be quite literary in its various submerged and indirect references. The yellow is as of a straw in the wind, that is a hint of future developments. Everything is now spinning and he is on fire. Yes, and his heart was going like mad and yes I can he said yes I will, yes. The capacious studio is now cosy. The darkness outside is his friend and the artist lets the creations just flow from his wrist and body. Eliot certainly understood a thing or two. What was he getting at here? *The Hollow Men*? Did it come from Joseph Conrad's central character, Kurtz, in *Heart of Darkness* as hollow in some way, a hollow sham, or even better hollow at the core? Was he referring to the art world, rotten to the core? No, that's just my interpretation. I must be careful here. I must not let the painting get too literal. I will just give enough away with some tiny dots for eyes. Empty eyes staring at you. He opens a fresh packet of cigarettes. I know that some people think it comes from Shakespeare's actual words in *Julius Caesar*. Oh, we'll never know I guess. One thing is for sure, that there has always been and always will be hollowness in society. Shakespeare got it. Brutus and Cassius were deeply evil Romans, overwhelmed with ruthless ambition, envy, but also malice, to murder Caesar. Or is it Dante who understands it better? When he goes through the Three Kingdoms of afterlife. The first two, Hell and Purgatory, he is taken by Virgil, through to the last, Heaven itself, in a pilgrimage designed by Beatrice, his former lover, with the idea to take him through and deliver him from sin and damnation and convince him to change his life so that after seeing Beatrice in Heaven he will want to join her, but only after his own death? Virgil! He passes the plan chest filled with paper of all shapes and qualities, collages on the go and completed, random photographs, wads of drawings for future ideas, and takes *The Eclogues* down from the shelf and pours himself a drink and sits and reads Virgil. His mind has now wandered, way away from T.S. Eliot and the canvas inspired by *The Hollow Men*. The artist has gone into his room, his studio, his study, with very few pre-conceived ideas as to how the painting will look. He does have the advantage that *The Hollow Men* is important to him, always has been important to him and now has become even more important to him, in his old age. He goes into the studio alone and he will after a few hours come out of it alone, just as one does in life itself. There is no hope of help here, at least not mental help. He simply has his ambitions and wishes, a wish list of ideas, trenchant feelings and aesthetic and intellectual developments to pursue. He will not be rescued from this insular space until some kind of comprehension can be brought to

bear on the hundreds of ideas that he is attempting to express to further his understanding of this strange predicament we are all dealt - life. The artist has devoted his entire life to the blank canvas. The artist comes with a self-awareness honed over many years of working in a physical way as well as letting that physical manipulation develop and advance his mental direction. The artist is blessed with the great luxury of pursuing and investigating his own awareness. The Church has not commissioned this man, nor has the State. So this is more self-indulgent, but by the same token there is no Pope or King looking over his shoulder. His audience is all dead colleagues, and especially himself. This artist is more a philosopher, alone in his room, as painter Antonello da Messina portrayed St. Jerome in his study, rigorously examining a new thought, over and over and over, in order to clarify that original concept. This artist has abstracted virtually everything descriptive from his canvas, other than his inner thoughts. He has become selfish and yet selfless in the same moment, self-effacing without being self-defeating, self fulfilled without being self important, and so anxiously left with self, the id. This painting, new to his followers and so new to himself as well, may be completed tonight, although it may need another day, or even another week or month. It may well become one of those canvases he will have to discard for a year or two, or forever. If the artist likes it enough and so completes and then signs it with his R.M., it will be a gift. That is not to say he will actually give it away, or that it will necessarily go into the world of commerce, but it will be a gift. We are in his domain right now and no one can say a word, not even breathe too loud. Madison Avenue is a million miles away. When Stravinsky poured his energy and soul into *The Rite of Spring*, the composer later commented that he was merely the vessel through which the music passed, he gave us a gift, because he too was given a gift. When F. Scott Fitzgerald gave us *The Great Gatsby*, he also gave us a gift because he too had a gift, a certain something that he cherished and guarded like a precious diamond in his hand. There is even the gift of love. And the work of great art functions in two highly differing economies, a market place economy and a gift economy. A true work of art can survive without the market but where there is no gift there will be no art. Because you cannot buy love, although in the market place you can buy sex and although prostitutes may be essential to society, artists as whores destroy art, like an exquisite rose trampled by a passing car. And the artist must balance life and work, and protect the gift. This gift is in reality an extremely rare quality, which the artist will hand on to you, make you possibly cry with joy or make you feel that anything is possible for you to achieve. The ultimate can be like the nightingale in Oscar Wilde's short story *The Nightingale and the Rose*, that grew the perfect red rose by singing in the moonlight and pressing its chest against the thorn until it pierced its heart and the redder the rose became the fainter the nightingale's voice became until finally going quiet and dead. But do you deserve the gift? Those artists so close to perfection and beatitude, Dylan Thomas, Charlie Parker and Jackson Pollock could take their friends and family, those closest and dearest to them, to the brink of despair on so many occasions, but to utter bliss too. This particular artist we are in the studio with right now, is actually a civilised man, one who would not want to hurt you at all, but he too strives for that deeper beauty, and of course, those *Hollow Men* would not understand that. His gift is not for them, unless they too would reveal their deepest feelings, as he does. His painting, which he is now struggling with, may possibly sell, but maybe as a trophy or an investment, though this is something Motherwell, or any serious artist for that matter, doesn't want to think about right now. A hint of light appears outside. Bob is very tired but also he is exceptionally happy. He goes to the window to see if any of the sun has arrived yet. He stares into the eyes of a young deer and neither he nor the beautiful animal move. They just continue to look into each other's eyes. The sun is indeed rising for another day and it already begins to play with the leaves in the trees. Calm covers the land. I don't want to die. I do not want to die. He turns around eventually and casts his eye carefully over the unfinished painting. I have this painting to complete, and many more. Bob leaves the studio and goes to bed.